quick
solutions
to
great
layouts

aliq
consequa
eum iriure do
hendrerit in vulp
esse molestie conse
vel illum dolore eu feug
nulla facilisis at vero eros
et accumsan et iusto odio
dignissim qui blandit
praesent luptatum zzril
delenit augue duis dolore

"ASSOCIATE YOURSELF
WITH MEN OF GOOD QUALITY
IF YOU ESTEEM YOUR
OWN REPUTATION; FOR
'IS BETTER TO BE ALONE
IN BAD COMPANY"

Spring

Plants
free
for
NEWSLETTER

Duis autem vel eum iriure
dolor intiol hendrerit in

quick
solutions
to great
layouts

DESIGNED AND WRITTEN BY GRAHAM DAVIS

Cincinnati, Ohio
www.howdesign.com

A QUARTO BOOK

First published in North America by
How Design Books, an imprint of
F+W Publications, Inc.
4700 East Galbraith Road
Cincinnati, Ohio 45236
(800) 289-0963

First published 1993
Copyright © 1993, 2004
Quarto Inc.

Other fine How Design Books are available
from your local book store, art supply store
or direct from the publisher.

ISBN 1-58180-260-9

QUAR.QGL

Conceived, designed and produced by:
Quarto Publishing plc
The Old Brewery
6 Blundell Street
London N7 9BH

Designer: Graham Davis
Senior Editors: Kate Kirby
Senior Art Editors: Philip Gilderdale
Mark Stevens
Editor: Lydia Darbyshire
Photographer: Paul Forrester
Picture Researcher: Liz Eddison
Picture Manager: Rebecca Horewood
Art Director: Moira Clinch
Publishing Director: Janet Slingsby
With special thanks to Sally Butler

Designed using Microsoft-Windows 3.1
Pagemaker 4 and CorelDRAW 3

Manufactured in Hong Kong by
Regent Publishing Services Ltd.

Printed in China by
SNP Leefung Printers Ltd.

contents

1

2

4

3

5

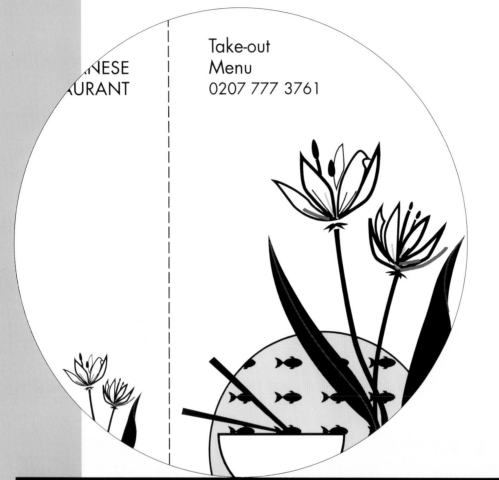

Take-out
Menu
0207 777 3761

NESE
AURANT

INTRODUCTION

CHAPTER

1

orem ipsum dolor ametconsectetuer a
orem ipsum dolor ametconsectetuer a
orem ipsum dolor ametconsectetuer a
orem ipsum dolor ametconsectetuer a

The advent of desktop publishing (DTP) has introduced the thrills and frustrations of graphic design to ever-increasing numbers of people. Whether you are a local scout leader publishing a quarterly newsletter or the marketing director of a large corporation establishing an in-house design department, you may find yourself responsible for the production of a variety of material that has traditionally been typeset and printed, and you will quickly come to appreciate the problems involved in producing dynamic and effective layouts.

Quick Solutions to Great Layouts is a practical guide to the design of a wide range of printed material. Examples of newsletters, brochures and leaflets, all types of stationery – from simple letterheads to complete corporate identities – and advertisements – from single-column, black and white to full-color, full-page – have been specially created to demonstrate how an effective layout can help you to communicate your message.

The book is organized by publication type and in three levels of expertise – basic, intermediate and advanced – so that whatever your expertise and experience there will be several examples appropriate to your skill and training. Each example includes a brief that has been created for a fictitious client and a solution – the description of the designer's response to that brief. A detailed specification list has been included for each example so that you can understand how it may be accurately recreated, either by using a DTP system or by conventional typesetting.

An awareness of basic design and typography is necessary before a designer can produce a worthwhile layout, so the next section explains in detail some of the underlying design principles you will encounter in your quest for the perfect layout. The section covers the importance of correctly interpreting a brief, the design and the use of grids, the choice of typeface, the integration into the layout of photographs and illustrations, the planning of a publication; and much else besides. The terminology – points, picas, ems, ens, fonts, justified type, for example – may also be unfamiliar, and so it, too, is explained and demystified.

The ultimate success of any publication depends on one thing – the communication of the message – and your design must always be harnessed to this end. Therefore, if it is to be really effective, your layout must not merely be an appendage to the words but a fundamental part of the communication process. Just as in speech the use of different intonation, stress, accent, speed of delivery, and volume can give even a single word a different feeling or meaning, an effective layout can have a similar result. The successful design will enhance or distill the message conveyed by the words and provide the visual environment in which that message can most effectively be conveyed.

This may seem an unobtainable expectation for a humble layout, but look at examples of the best designs and you will see that it is possible. At the end of each chapter is a selection of examples from around the world. These have been chosen to demonstrate the enormous range of layouts that exists and the potential they have for successfully expressing both simple and complex ideas.

"[The designer] must possess above all the quality of empathy, the capacity to understand those to whom the message is addressed. Good graphic design must be for everyone, not just for its initiator."
FHK Henrion
June 1987

INTRODUCTION

The examples that have been created for this book use imperial page sizes. The specification list for each example has been devised so that the layouts may be easily recreated.

how to get the best from this book

The format is expressed in inches and the equivalent metric size, which is usually either A4 or A5.

The grid indicates the number of columns and the space between them. The margins are abbreviated thus:
i = inside,
o = outside,
t = top,
b = bottom;
or:
l = left,
r = right,
t = top,
b = bottom.

The font or fonts (typefaces) used are listed. This information is followed by the track (the space between letters and words), which is described as tight, normal, loose, very loose or force justified, the last being letterspaced across a specific measure (width).

Pica measurements are abbreviated to "p", as in 2p11; the latter measurement represents points.

SPECIFICATIONS
Format
8½ x 11 in or A4

Grid
6-column
Space between cols. – 1p5

Margins
i 2p11 o 4p7
t 4p1 b 4p10

Fonts
New Baskerville
Track loose
1 Body text 9½/12½pt
2 Headlines 40/43pt, 24/26pt

New Baskerville Italic
Track loose
3 Box heads 19/23pt
4 Box text 9½/15pt

Graphik Shadow
Track force justify
5 Title 134pt
6 Drop cap 134pt

Helvetica Condensed
Track loose
7 Captions 7½/13pt
8 Folios 10pt
Track force justify
9 Subtitle 11pt

Track can be specified more precisely by the use of kerning – that is, by specifying letter and word spacing in units of points.

This book is packed with specially designed layouts for you to adapt or copy or simply to inspire you. Each deals with a different type of printed matter – newsletters, brochures, stationery and advertisements – and is divided into three levels – basic, intermediate and advanced – so that demanding layouts are separated from those that can be more easily produced.

It is in the nature of design that technical skills – creating a grid or instructing a repro house, for example – go hand in hand with aesthetic ones, such as creating a harmonious layout in which the various elements are put together in a way that is pleasing to the eye.

It is possible to pick up the technical skills through practice, but in a world increasingly dominated by electronic technology, designers of the future will need continuously to acquire new skills. Aesthetic considerations, being entirely subjective, are more difficult to define.

The examples created for the following chapters demonstrate the enormous variety of layouts that can be achieved from the same basic raw materials – type, pictures, graphic elements and, most importantly, space.

CLIENT

national law firm

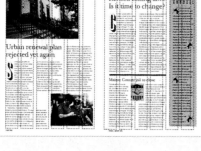

Abc

2
1 Butem vel eum iriure do lor in
 hen dre rit in vulp titate velit

7 Butem vel eum iriure do lor in

SPECIFICATIONS

Format
8.5 x 11 ins. or A4

Grid
6-column
Space between cols. 6mm.

Margins
l 12mm o 19mm
t 17mm b 20mm

Fonts
New Baskerville
Track loose
1 Body text 9½/12½pt
2 Headlines 40/43, 24/26pt

New Baskerville Italic
Track loose
3 Box heads 19/23pt
4 Box text 9½/15pt

Graphik Shadow
Track force justify
5 Title 134pt
6 Drop-cap 134pt

Helvetica Condensed
Track loose
7 Captions 7½/13pt
8 Folios 10pt
 Track force justify
9 Sub title 11pt

BRIEF The monthly newsletter for this old established law firm has between 12 and 16 pages, and it is the main means of corporate communication. It has a wide local circulation, as well as some regional and national readers. There is, therefore, an adequate budget for design and production and the occasional use of four-colour printing. The elegance of the design and the choice of stock are considered to be the chief visual ways of conveying the firm's dedication to quality of service.

SOLUTION A 12–16 page publication gives an opportunity to have a four-page cover of heavier weight (210gsm) than the inside pages (135gsm). The off-white 100% cotton paper creates the feel that the client wants, and the layout has a dependable and reassuring, though modern, look. This is achieved by attention to typographic detail, the choice of face, New Baskerville, and tall, slender drop caps, echoing the masthead, which is set in Graphik Shadow. Tinted boxes surrounded by 1½pt tinted rules and even the spelled-out Page one contribute to this effect.

This unusual masthead has a strong architectural feel, reminiscent of the columns of a courthouse. The face, Graphik Shadow, has been tinted 60% black, as has the panel beneath. They butt together. An alternative to Graphik Shadow is Helvetica Ultra Compressed.

New Baskerville, an elegant serif face, has been chosen for both headlines and text. The impact of the masthead is reduced by the tint, and it does not overwhelm the main headline beneath. The emphasis that a headline achieves always depends on other elements on the page.

The white-out type in the panel, set in Helvetica Condensed 11pt and force justified, is interrupted by the circular graphic of the gavel. This symbol is part of the company's visual identity.

ISSUES
A MONTHLY NEWSLETTER ISSUED BY HEGARTY KAUFMAN DAMBIT & PEASE

Matthew Hegarty to run in the Primaries

Drop caps can be used to lead the eye to the start of a new piece of text or for primarily decorative purposes. A particularly large 8-line drop cap is possible here, because even a wide character like an M still leaves a reasonable width for the text when it is in such a condensed face. Avoid very narrow text columns, which can leave ugly spaces when words wrap to the next line. The spec for the drop cap is the same as for the masthead.

Morem ipsum dolor sit amet, consectetuer adipiscing elit, sed diam nonummy nibh euismod tincidunt ut laoreet dolore magna aliquam erat volutpat. Ut wisi enim ad minim veniam, quis nostrud exerci tation ullamcorper suscipit lobortis nisl ut aliquip ex ea commodo consequat.

Duis autem vel eum iriure dolor in hendrerit in vulputate velit esse molestie consequat, vel illum dolore eu feugiat n ulla facilisis at vero eros et accumsa tiusto odio dignissim qui blandit praesenti luptatum zzril delenit augue duis dolore te feugait nulla facilisi.

Lorem ipsum dolor sit amet cons ectetuer adipiscing elit, sed diam nonummy nibh euismod tincidunt ut laoreet dolore magna aliquam erat volutpat. Ut wisi enim ad minim veniam, quis nostrud exerci tation ullamcorper suscipit lobortis nisl ut aliquip ex ea dm commodo consequat. Duis autem vel eum iriure dolor in hendreri in.

Vulputate velit esse molestie cons equat, vel illum dolore eu feugiat nulla facilisis at vero eros et aeri accumsen et iusto odio dignissim qui blandit praesent luptatum zzril

delenit augue duis dolore te feugait nulla facilisi. Nam liber tempor cum soluta nobis eleifend option congue nihil imperdiet doming id quod mazim placerat facer possim assum. Lorem ipsum dolor sit amet, consectetuer adipiscing elit, sed diam nonummy nibh euismod tinc idunt ut laoreet dolore magna aliq uam erat volutpat. Ut wisi enim ad minim veniam, quis nostrud exerci tati on ullamcorper suscipit lobortis nisl ut aliquip ex ea commodo con sequat.

Duis autem vel eum iriure dolor in hendrerit in vulputate velit esse molestie consequat, vel illum dolore eu feugiat nulla facilisis at vero eros et accumsan et iusto odio dignissim qui blandit praesent luptatum zzril delenit augue duis dolore te feugait nulla facilisi. Lorem ipsum dolor sit amet, cons ectetuer adipiscing elit, sed diam non ummy nibh euismod tincidunt ut lab oreet dolore magna aliq uam erat volutpat. Ut wisi enim ad minim veniam, quis nostrud exerci tati on ullamcorper susc

ISSUES / MARCH 2001 **PAGE ONE**

'Why I have decided to run'

Ut wisi enim ad minim veniam, quis nostrud exercas tation ullamcorper suscipit lobortis nisl ut aliquip ex ea commodo consequat. Duis autem vel eum iriure dolor in hendrerit in vulputate velit esse molestie consequat, vel illum dolore eu feugiat nulla facilisis at vero erivs et accumsan et iusto odio dignissim qui blandit praesent luptatum zzril delenit augue duis dolore te feugait nulla facilisi. Lorem ipsum dolor sit amet, consectetuer adipiscing elit, sed diam nonummy nibh euismod tincidunt ut laoreet dolore magna aliq uam erat volutpat. Ut wisi enim ad minim veniam, quis nostrud exerci tati on ullamcorper suscipit lobortis nisl ut aliquip ex ea.
MATTHEW HEGARTY

Placing text in a box is a convenient way of highlighting or separating it from the rest. In this instance, a personal statement by one of the firm's senior partners is an important adjunct to the lead story.

The decision to include folios (page numbers) depends largely on any cross-referencing in the copy. They can be used solely as an additional design element. In this example the more formal Page one is used instead of a simple numeral.

So that text is not squeezed into too narrow a column, the invisible graphic boundary around the flag, which stops text flowing into the space, is set to the inner gridline.

The folios are aligned vertically with the outside of the page, with the date on the inside.

Both sit 9mm below the bottom of the type area.

The main items of type are numbered and keyed into corresponding numbers on project specs—so you will see at a glance the details you will need to create the layout. The grid has been superimposed in blue to show clearly how the layout has been constructed.

The main examples have to be reduced from their actual size to fit the book page; however, a sample of headline and text, shown actual size (100%), is shown in the bottom left-hand corner of the page.

The text describing the brief and the solution identifies the client's requirements and outlines the designer's response to them.

The example of each layout is annotated with detailed captions to highlight the main features of the design and explain how they have been created.

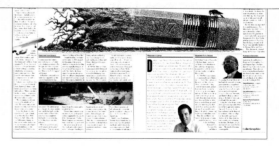

PUBLISHED EXAMPLES

In addition to the fictitious examples, further examples from around the world are included at the end of each chapter. These have been selected to show how the layout ideas and techniques demonstrated in this book have been utilized and built upon by top designers.

The best way for the designer to develop is to practise, and this book is intended to inspire you to extend your range and acquire new skills.

before you start

The annual report and accounts has to present a company in the best possible light. The designer has blended a sense of tradition and modern efficiency, mainly by paying attention to typographic detail.

Left: A brochure for a furniture design conference uses bright colors, un-fussy typography and bold, geometric graphics to maximum effect.

Before you start to create a new layout, it is essential to remember one very important point – the design of the publication will be the means by which the client's message is communicated. The design is not an end in itself. It is easy for a designer to use an inappropriate format or typeface, or to commission a photographer whose style is at odds with the subject matter, just because he or she happens to like the style, or has a burning desire to use a new face in the type catalog. Self-indulgence is the greatest threat to effective design.

FORM MUST ALWAYS FOLLOW FUNCTION

The brief is the starting point for a new design. The client's objectives must be clearly understood, so it is important to take notes at the briefing meeting and to obtain the client's confirmation of these objectives, preferably in writing.

It is more than likely that the client will have a preconceived idea for the design of the publication. "I know what I like" is a commonplace attitude, although often what the client really means is "I like what I know." You may be shown a competitor's brochure or even a rough

layout that the client has produced. It is quite possible that the design, in fulfilling the client's communication objectives, will be different from that preconceived idea. It is, therefore, of paramount importance to talk through your visual approach before you show the client a mock-up of the proposed design. Nothing is guaranteed to upset a client more than being presented with a design that is radically different from the one he or she was expecting.

UNDERSTANDING YOUR AUDIENCE

The design style will depend on the audience for the publication, and an inappropriate style can result in a publication that does not achieve the client's communication objectives.

The mismatch of the following adjectives (first column) to clients (second column) makes the point. The correct matches are shown in parentheses:

dynamic	wholefoods	(telemarketing)
colorful	undertaker	(toyshop)
conservative	toyshop	(broker)
garish	publisher	(rock group)
restrained	telemarketing	(undertaker)
classic	rock group	(publisher)
fresh	broker	(wholefoods)

Particular styles are created by a combination of the right typefaces, type sizes, leading, column widths, and colors and tints – even tints of black, if color is not available. The choice of photographer and illustrator will also greatly influence the layout's eventual style.

Although it is dangerous to make hard and fast rules, some generalizations are possible – for example:

upmarket	select smaller type
downmarket	select larger type
loud	select sanserif type
quiet	select serif type
busy	select narrower columns
quiet	select wider columns
speedy	select italic sanserif type

Everything, in fact, has a connotation – bright colors imply youth, subdued colors, maturity; color combinations such as browns and creams suggest tradition, but red and green together clash, implying anarchy. The look and feel of your layout will determine the reader's response. If the design works well, the reader will be reading the text and receiving the client's message. If it doesn't, you may be looking for a new client.

Below: The layout problems arising from this dual-language annual report from the Canadian Mint have been cleverly solved by using a wide, horizontal format, which allows the text blocks in each language to appear side-by-side. The captions to the smaller photographs have been staggered to break the uniformity of what might otherwise be a too-symmetrical design.

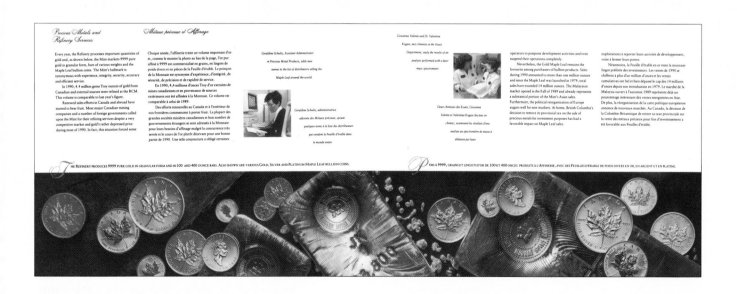

when you start

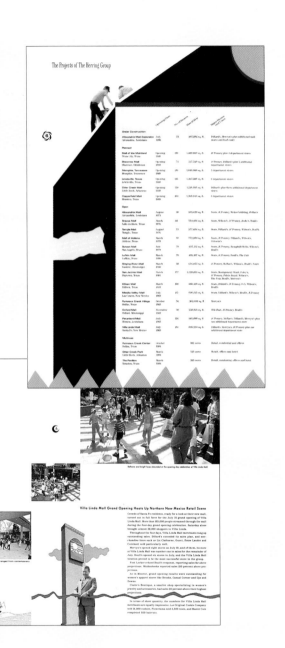

Above and top: This newsletter allows the photographs to tell the story, while only a small portion of the page area is devoted to text. Replacing the small length of ribbon by a longer one at the bottom of the page was an opportunistic piece of graphic design, which complements the hand-drawn river on the opposite page. The last page (top) also uses a photograph combined with a graphic representation of a building to enclose a typographical checklist.

Having established the general stylistic approach, you will have left the client and returned to your studio with the intention of creating some of the best layouts ever. But where do you start? A blank computer screen or a new pad of layout paper can sometimes seem very intimidating, and your initial enthusiasm may suddenly evaporate to be replaced by frustration and gloom.

The answer is not to spend too much time on any single aspect of the design if it is not fruitful. Start by flipping through this book, looking for inspiration. Doodle on your layout pad, perhaps using a five-column grid but leaving the first column blank; or take a look through the type catalog, experimenting with a design feature such as a heading or quote. Cutting out blank shapes to represent pictures and dummy text and moving them around, unencumbered by a grid, may help. If you are free to choose the format, try folding sheets of paper into different configurations. Sometimes, in an advertisement for example, the layout may be built around a conceptual idea, and the resulting design may have an inevitability about it. It is vital that you keep your

work fluid long enough to avoid shutting off possible ideas.

A common mistake is to finalize the grid too soon. It should be the skeleton on which the design is fashioned. If you start out with a kangaroo's anatomy, it is extremely difficult to create a horse. Eventually, however, the embryonic design will emerge.

FIRMING UP THE DESIGN

The designer working on a computer has a big advantage. Adolescent versions of the layouts can be saved or discarded at will — type sizes, leading, track, margins, the number and width of columns and the spaces between them can easily be changed. In fact, it is easy to keep revising

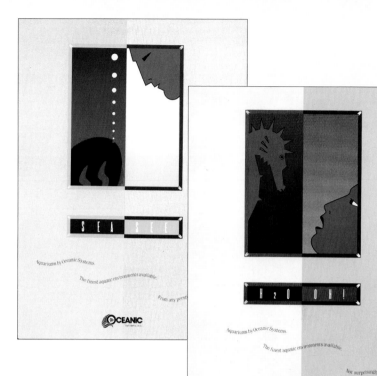

Above: The unexpected solution often requires a leap of imagination by the client. Here, the designer has opted to use a stylized illustration rather than the more obvious photograph of the product. The result is an unusual and stylish advertisement. Also note how the text is set on a wavy line to suggest water.

Left: An advertisement's design has to express the concept in the fullest possible way. The idea is so simple and strong that it would be difficult to envisage an alternative to this layout.

the design and never reach a conclusion.

Now is the time to road-test your design. Go back to the brief to make sure that it meets all the agreed criteria. Anticipate the questions the client will ask. When asked why you selected a four-column format, don't say "because it looks nice." Give your reasons in a considered way: "Because the still-life product photographs shot in vertical format will fit uncropped over two columns, extending to the depth of the type area, while the horizontal ones will fit to the three-column width and be an identical size, so that the products in both formats will be at a consistent scale, an important consideration in a jewelry catalog."

INTEGRATING THE TEXT

Remember that the copy is as important as the design. You may be responsible for commissioning the writer, or you may use the client's in-house writer or nominee. When you make the presentation, the text may be in outline form, draft copy, laser proof or even typeset, but the important point is that it has been carefully integrated into your design strategy.

Conventional
Dense and text-heavy,
with a headline at the
top and a picture at
the bottom.

Classic
Simple, two-column
format with
centered headline
and inset picture.

Modern
Wide measure and
extra leading, letter-
spaced headline, and
bold rules.

the elements of
the page

The basic building blocks of virtually every layout are the same four elements — headlines, text, pictures and, of primary importance, space. This is surprising when you consider the enormous variety of design solutions that is available. Although color is important, it is not a fundamental element — most layouts that use color should also work in black and white as long as tints of black are used.

The examples created for these two pages use only one font family — Times — in two weights — roman and bold — and with gray or white shapes indicating pictures. They clearly demonstrate the importance that space plays in a basic design.

Using only these limited resources, each layout begins to reveal a style of its own — conservative, dynamic, youthful and so on. Appreciating this basic concept is of paramount importance to all designers.

The following pages examine in detail the selection of typefaces for headlines and text, and the commissioning and use of pictures, both photographs and illustrations. But first comes the grid and how the basic layout ideas are formalized into a permanent structure.

Technical

Angular layout with
column rules and
lots of white space.
Clean and strong.

Youthful

Fun with graphics
and type, multi-size
headline, and white
out of black page.

Aggressive

Large, underlined
headline and bold
text with regular
crossheads.

Natural

Elegant, with wide,
spaced text and
headline, and use of
oval pictures.

Juvenile

Busy layout with
large initial cap for
headline, tinted
rules, and large text.

Prestigious

Offset initial cap,
simplicity, and use of
space are the key to
a graceful layout.

how to create and use a grid

Unlike a paper-based grid, the screen version can be altered to include additional information when it is required.

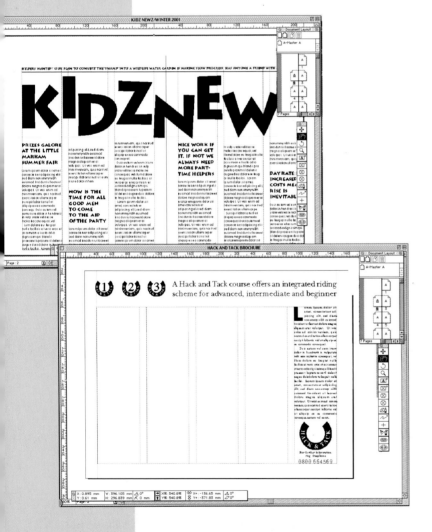

A grid can be as simple or as complex as you wish. The basic skeleton will consist of a double-page spread, showing bleed and trim sizes, page margins and text columns, but any amount of additional information can be included – recurring graphic elements such as the tint panels on this page, for example, or hanglines or folios (page numbers). A distinction should be made between a layout created on a computer using DTP software and the more traditional pasted-down, camera-ready artwork.

SCREEN-BASED OR PAPER-BASED GRIDS

The computer-based design will invariably be output on an imagesetter in the form of bromide or film as a fully made-up page or spread. If the layout is created conventionally it is more likely that the typeset copy will be supplied as galley proofs (continuous strips of setting) for you to paste down in position.

Traditional grids should be drawn on artboard using a non-reproducible blue pencil. For long or repeated publications – newsletters, magazines and books, for instance – it is more efficient to have the grid printed in bulk on a suitable board.

The setting-up of a screen-based grid will vary according to the software used. It is most likely to be a master page, which appears as a fixed background to the publication pages. The screen-based grid (often referred to as rulers and guides) will, of course, never appear on the typeset page. The text will flow down the columns and run around inset graphics or pictures; the headings will hang or sit on the relevant grid line; and boxes can be drawn in position to provide keylines for pictures. Alternatively, pictures can be scanned in.

The traditional grid will be more useful if the lines overlap (see the examples on this page) so that when a piece of typesetting is pasted down the grid lines are still visible. It may also be helpful to include horizontal lines that correspond to the leading of the main text. It is worth numbering these, particularly if the final paste-up is preceded by a rough one using uncorrected proofs.

USING THE GRID

Having designed the grid, you should test it to see that you have included all the information you will need to create additional spreads. It is, however, possible to clutter up the grid with too much information, making it confusing. A grid with more columns – six, for example – is more

Above and below
Two examples of a paper-based grid. Both show the optimum amount of information that should be included.

flexible than one with fewer. The distance between the trim and the bleed will normally be 8pt – 1p2. The purpose of the bleed (which will be trimmed off) is to ensure that pictures that extend to the edge of the page are not left with a thin strip of white paper if the page is trimmed a little oversize. The better your printer's quality control, the smaller the bleed can be.

THE GRID AND PRINTING

The size of the margins is important too, particularly the gutter. A 100-page, perfect-bound (square-backed) publication will not open out as flat as a 16-page, wire-stitched one, and so will require a wider gutter margin. Bleed pictures will also be trimmed at the gutter because the 100 pages will be cut into a stack of single sheets and glued together at the spine. It is this glue, which is squeezed a small distance onto each page, that stops the publication from opening flat. (Normally, this bleed into the gutter is ignored on the grid, but it needs to be taken into account when you scale-up pictures, or they will be undersized.)

Always remember that the grid is just a tool to help you. Adhering to it slavishly can result in boring, repetitive layouts; ignoring it, can produce disjointed, uneven ones.

selecting a typeface

Listed below are the fonts used in this book with alternative suggestions for the less widely available in brackets.

Arquitectura (Futura Condensed)
Caslon
Century Old Style
Century Old Style Italic
Century Old Style Bold
Franklin Gothic
Franklin Gothic Heavy
Futura 2
Futura Condensed
Futura Condensed Extra Bold
Garamond
Gill Sans
Gill Sans Bold
Gill Sans Ultra Bold
Goudy Old Style
Graphik Shadow (Futura Condensed)
Helvetica Light
Helvetica Light Italic
Helvetica
Helvetica Italic
Helvetica Bold
Helvetica Black
Helvetica Black Condensed
Helvetica Condensed
Helvetica Condensed Light

Ireland (Cheltenham Book Condensed)
Lithos (Univers)
Lithos Light (Univers Bold)
New Baskerville
New Baskerville Italic
Plantin Light
Plantin Bold
Plantin Bold Condensed
Plaza (Futura Condensed)
President (Flash)
Times Roman
Times Italic
Times Bold
VAG Rounded (Helvetica Rounded)
VAG Rounded Bold (Helvetica Rounded Bold)

Good typographic design is often more difficult to achieve than one using a wider range of elements.

Attention to detail is invariably the key to success.

A t the very heart of any layout will be the typography. It is perfectly possible to create a very effective layout using a sensitively handled piece of typography, unadorned by pictures or graphic devices of any kind. From its origins in calligraphy, through the invention of the woodblock and subsequently metal type to the computer-generated filmsetting of today, designers have been fascinated by letter forms. It is no coincidence that they are referred to as *typefaces*, for each has its own character. They are also referred to as fonts.

A PLETHORA OF CHOICE

The last 30 years have seen an explosion of new type designs. Most typesetters or type bureaus will hold at least 2,000 fonts. Each font is part of a font family, typically comprising the regular (normal) weight plus italic, bold and bold italic, although some, particularly sanserif faces, can come in a much wider variety of weights plus condensed or extended variants. This choice may seem bewildering, but it is true to say that in reality most designers will not use that many faces in their entire careers.

Abc
Serif face Caslon

Abc
Slab serif face Rockwell

Abc
Sanserif Gill Sans

Abc
Script face Kunstler Script

Abc
Decorative face Honda

Typefaces from the main generic font groups. Script and decorative faces should be used for headlines rather than for text.

There is a core of perhaps 50 font families that are used more widely than all the rest put together. In this book we have limited our choice to 40 fonts from 18 families (which are listed opposite) and of those, only six fonts come from outside that core of 50.

Typefaces can be further categorized into generic groups. The earliest printing type designs were the serif faces, the serifs betraying the linking strokes of their calligraphic origin. Then came the slab serifs, with a much more even thickness of letter form and squarer serifs. The sanserifs (without serif) began to appear in the 19th century, although it was the advent of photosetting that made the enormous range of weights and widths a practical possibility. The Univers family consists of about 23 fonts and Helvetica even more.

Alongside these were the script fonts, which could not generally be created as type because the letter forms needed to be joined, but they could be engraved into stone and, later, metal. Today, photosetting allows the individual characters to be set in exactly the right position to create the appearance of continuous script. Finally, there are a very large number of decorative faces available to the designer.

MAKING THE BEST USE OF TYPE

Apart from the type size, two other factors are critical to good typography: leading (the space between lines) and word and letter spacing (track). Fonts will have a default specification for track, which will include pair kerning (selected pairs of characters that would otherwise be too close or too far apart). Experienced designers may alter the specifications for these from time to time depending on the project.

Lorem ipsum dolor sit amet consect etuer adipiscing elit sed diam nonummy nibh euismod tincidunt ut laoreet dolore mag naali quam erat volutpat. Ut wisi enim ad minim veniam, quis

Lorem ipsum dolor sit amet consectetuer adipiscing elit, sed diam nonummy nibh euismod tincidunt ut laoreet dolore magna aliquam erat volutpat. Ut wisi enim ad minim veniam, quis nostrud exerci tation ullamcorper suscipit lobortis nisl ut aliquip ex ea commodo consequat. Duis autem vel eum iriure dolor in hendrerit in vulputate velit esse molestie consequat, vel illum dolore eu feugiat nulla facilisis at vero eros et accumsan et iusto odio dignissim qui blandit praesent luptatum zzril delenit augLorem ipsum dolor sit amet, consectetuer adipiscing elit, sed

The text above is set with leading 120% of type size, while for the wider measure (above right) 133% has been used. For reasons of both legibility and aesthetic appeal, wider text columns require more leading than narrower ones.

Many layouts are spoiled by too much or too little leading. Most text sizes will look comfortable with leading that is 120% of the type size – e.g., 10pt type, 12pt leading (10/12pt) – assuming that the text column is a normal width. Wider text columns require more leading to ensure legibility. For headline sizes – approximately 36pt and larger – the amount of leading should be reduced as the point size increases. Novice designers should not deviate far from these specifications until they have gained confidence.

Experienced designers will specify a wide variety of track and leading in order to give a particular look to a publication, but they will always be mindful of the need for legible type.

PICAS, POINTS, AND EMS

We still retain the system, devised long ago for metal typesetting, that uses the point as the basic unit of measurement. An em space is equal to the relevant point size – that is, with 10pt type an em space equals 10 points. An en is half the em space; a thin space is half an en. A pica is equal to 12 points.

Lorem ipsum dolor ametc onsectetuer adipi	tight
Lorem ipsum dolor amet consectetuer adipi	normal
Lorem ipsum dolor amet consectetuer adipi	loose
Lorem ipsum dolor amet consectetuer adipi	
Lorem ipsum dolor amet consectetuer adipi	very loose
Lorem ipsum dolor amet consectetuer adipi	
Lorem ipsum dolor amet consectetuer adipi	

Left: Track can be specified in very small units. Each line has been increased by an additional fiftieth of an em. The four variations used in this book – tight, normal, loose, and very loose – are indicated.

using pictures

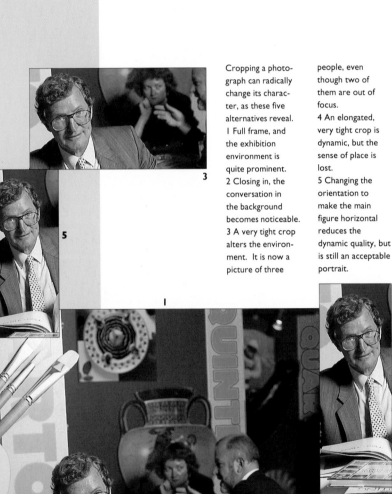

Cropping a photograph can radically change its character, as these five alternatives reveal.
1 Full frame, and the exhibition environment is quite prominent.
2 Closing in, the conversation in the background becomes noticeable.
3 A very tight crop alters the environment. It is now a picture of three people, even though two of them are out of focus.
4 An elongated, very tight crop is dynamic, but the sense of place is lost.
5 Changing the orientation to make the main figure horizontal reduces the dynamic quality, but is still an acceptable portrait.

Photographs and illustrations play a vital part in the creation of most layouts, and the choice of an appropriate style is obviously vital. You can contact photographers and artists through specialized agents, by consulting one of the many books of published work, or through your own network of contacts. Illustration will always have to be specially commissioned, but you can purchase photographs (or, to be more accurate, photographic rights) from stock shot libraries or from an individual photographer's personal archive.

MAKING THE BEST USE OF PHOTOGRAPHS

A successful layout makes use of both text and photographs. A picture can, they say, be worth a thousand words, but it can also be an irritating irrelevance. It is usually best to commission to a rough layout, otherwise you may find yourself with unwanted pictures or unfilled holes. A layout gives the photographer an opportunity to compose the picture to fit a given shape. Cropping (masking-off parts of a picture) can sometimes improve a photograph, even though it is not what the photographer intended, but crop-

ping it simply to make it fit will invariably result in the photographic quality being compromised. As an alternative to the squared-up picture, you may be able to treat some photographs as cut-outs, when the background is removed. A statue or a shot of packaging would work in this way, for example, but do not cut out an image if it is at all soft (out of focus). Beware, too, of hair, mohair sweaters and the like, or any naturally diffuse edge unless your design is going to be produced on a high-end system with electronic retouching, which is expensive.

THE BENEFITS OF ILLUSTRATION

Illustration is more effective at conveying complex ideas, while a photograph is normally more literal. The photograph, however, usually carries more direct emotional content, and some of the most powerful pictures ever published have been of people and landscapes, the human face being the most potent image of all.

An illustration can be more manageable and more easily integrated into a complex layout or odd shape. The choice ultimately depends on which is more likely to satisfy the demands of the brief and the budget.

COLOR OR BLACK AND WHITE?

Given a free hand, you will obviously choose to use full color (the four process colors). Even black and white pictures look richer when they

Right: This folder from an illustration agency presents the artists' work in the form of individual insert sheets, a convenient way of selecting the right artist.

Right: Many books are available to help with colour selection and specification, one of the most important being the tint reference guide.

Below: The still-life photographer will invariably shoot to a layout. Here, additional background has been included to allow for the over-printing of a page of text.

are printed as four-color blacks. Black plus one, two, or even three spot (self) colors (usually from the PANTONE® Matching System) can be effective when color photographs (which can be reproduced only by the four-color process) are not used.

Full-color printing allows tints of the four process colors to be used either individually or in combination. These can be specified by using a tint reference guide, and the better ones contain around 15,000 individual swatches (color samples). The on-screen color of even the best DTP system does not yet match the fidelity of the printed swatch.

The effective use of photographs and illustrations, whether color or not, ultimately depends on matching them to the quality of the printing and repro (color separation) and, most importantly, the stock (paper or board). To ensure optimum quality, you must consult your printer before you finalize the specification.

PANTONE MATCHING SYSTEM® is a registered trademark of Pantone, Inc.

INTRODUCTION

reviewing your layouts

The
Samaritans

Below left: Does it work? Yes. The cover of this annual report for a suicide counselling agency uses "light at the end of the tunnel" as its theme. The illustration, which was created cheaply using found art and a simple graphic device, is centered, while all the other elements are on the extreme right. This disharmony results in a dynamic layout, a visual metaphor for the condition the agency seeks to support.

Below: Does it work? Yes. The cover of this medical resource brochure adopts a typographical solution, printed in bright, translucent colours to reflect some of the issues dealt with inside.

Dallas Medical Resource
Accountabil
Quality
h Care Value
Communicatio
Advocacy Infor
on Service
cacy Health Care
Health Care Value
Access Educ

There will come a time when you will sit back, take a long, hard look at your layouts and ask yourself "Do they work?" Don't limit the question to yourself, for even the most experienced designers discuss their design solutions with each other. Ultimately, however, the decision is your own. The examples on this page form a visual checklist of points to bear in mind, and chief among them must be the one that was posed at the beginning of this chapter: "Does the design communicate the client's message?"

PRINTING IMPLICATIONS

Having satisfied yourself that the layouts work, the final consideration is printing and finishing (folding, trimming, binding, blocking, stamping, laminating, varnishing, and so on). It is impossible to anticipate every problem, but you should be able to avoid most of them if you consult your printer. Even top design groups can make expensive mistakes: the annual report for a major international company began to fall apart after reasonable handling. It was printed on a heavy, high quality, triple-coated (smooth), silk-finished stock, and it was perfect bound. The problem

was that the glue could not hold the pages in. A better solution would have been to gather them into stitched sections and house them in a more substantial, square-backed binding.

One of the most common problems is legibility of type. It will only take the misregister of just one of the four colors and by a minuscule amount to make a light serif 9pt type, reversed-out white in a full-color picture, virtually illegible. Printing white out of black only on a very absorbent stock can cause the ink to bleed, filling in the serifs and again affecting legibility. Other pitfalls and problems are discussed throughout the book.

YOUR MOST IMPORTANT TOOL

We have looked at the steps you can take to minimize failure and maximize success, but in the end it is the layout that counts. Graphic design is not a science, and it is only partly an art. There are no absolute principles to rely on, and do's and don'ts are always conditional. From time to

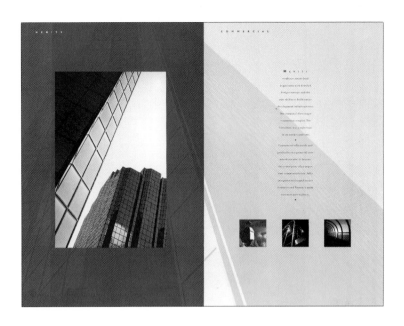

Above: Does it work? Yes. As this inside spread from a property developer's brochure demonstrates, a simple, elegant layout that uses a large double-page photograph as a background creates an appropriate environment for a prestige client.

time new theories are proposed and some old ones resurface – the golden section, a classical concept of composition in fine art, for example, is routinely taught in art colleges, although few designers use it often.

The nature of the design process means that good designers are born and then made. The aesthetic predisposition of a designer is innate and the technical skills can be learned, but a willingness to understand the client's objectives and an interest in business generally does not always sit well with a designer's temperament, although fortunately the "far-out," arty image is a thing of the past. Design is a business – the communication business – and this is where our future lies.

Above and right: Does it work? Yes. The layout of this in-house magazine cleverly repeats a portion of the main illustration to reinforce the distribution theme

of the text. The cover also employs an illustration to establish the theme of the main article.

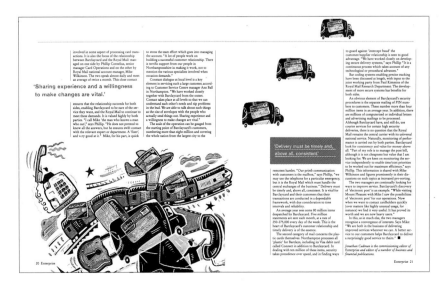

FOWLER COLLINS

GOSSIP - DONT FORGET THE

KIDZ

EDDY BEAR'S
CNIC IS
ROARING
CESS

**BIG DISCOUNT
AT LES ENFAN
FOR ALL KIDZ
PARENTS**

dolor sit
tuer
d diam
mod

Longue nihil impe
doming id quod
placerat face
assum.Lo
sit am

delenit augue duis dolore
uggit nulla facilisi

NEIGHBORHOOD WATCH

A LOCAL PRE-SCHOOL

NON-PROFIT ORGANIZATION

MODERN DANCE GROUP

NATIONAL LAW FIRM

WILD PLANT SOCIETY

COSMETIC MANUFACTURER

CLEANING COMPANY

CULT ROCK BAND

NEWSLETTERS

2

CHAPTER

Newsletters can range from the humble single sheet to the multi-page, large format, corporate newspaper, but one feature is common to all – they are published at regular intervals. Many businesses use them to inform, educate and entertain their workforces or to keep in touch with customers or clients; or perhaps a combination of the two. In addition to these in-house and marketing newsletters, organizations such as clubs and societies, and institutions such as colleges and non-profit organizations, mail them to members.

The layout of a newsletter should be appropriate to the readership and to the method by which it will be distributed – is it to be folded and mailed, unfolded but shrink-wrapped for mailing, or delivered by hand? A distinctive masthead will be an asset to distinguish it from other publications such as catalogs and brochures.

The examples on the following pages have been created to offer a range of solutions to newsletter design. Each starts as always with the brief – a description of the communication needs that the client expects the newsletter to fulfill – and culminates with the solution – the specification, format and design styling that have been created to respond to these perceived needs.

At the basic level, each example uses a simple single sheet, folded once to provide four pages, and each adheres strictly to a two- or three-column grid, with no more than two levels of heading size and with a ratio between the type size and leading of a more or less constant 100:120. These constraints will enable you to produce a balanced and professional layout, even if you have little experience.

The intermediate level introduces longer, 12 – 16 page newsletters and more complex four- and six-column grids but demonstrates how, by sometimes breaking out of them, grids can liberate a layout. Drop caps, quotes, tint panels and boxes, cross-heads, and text that runs around pictures or graphics are also used to add to your repertoire. Greater variety in type size and leading is employed, and the section introduces the concept of the hangline – an ancillary horizontal grid line that provides a constant position on which headings, text or pictures are placed to give the continuity that is desirable in longer publications.

The advanced level demands more typographical finesse, the use of a more complex eight-column grid, and the ability to exploit a greater use of color and tints.

An essential point to remember at every level of design skill is never to lose sight of the audience! As you will see, the Neighborhood Watch newsletter needs to be conservative in style, while the readers of the rock group newsletter will expect a more aggressive and dramatic design. The design style you create should convey a flavor of the content even before it is read. The layout and, particularly, the choice of fonts will help to create the look and feel – dignified and serious for a law firm, fun for a playgschool, and avant garde for a dance group.

The newsletters on the following pages are reproduced at 63% of actual size. A sample of the headings and text is shown actual size on the left-hand page, together with a mini-version of the newsletter with the grid overlaid in blue.

CLIENT

neighborhood watch

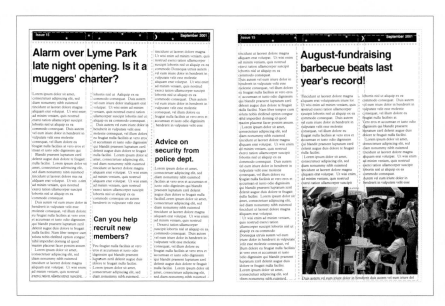

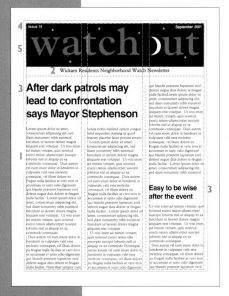

SPECIFICATIONS

Format
8½ x 11 in or A4

Grid
3-column
Space between – 1p5

Margins
i 4p1 o 4p1
t 4p1 b 4p1

Fonts
Plantin Light
Track normal
1 Body text, captions 10/12pt
2 Subtitle 14pt

Helvetica Bold
Track normal
3 Headlines 30/36, 20/24pt
4 Dateline 10pt

Plantin Semi-bold
Track very loose
5 Title 110pt

BRIEF A local residents' association needs to improve its existing newsletter, which is distributed by hand to 2,000 residents. There is no fixed publication cycle, but three or four issues are usually published each year. The budget is minimal, but the result has to look professional. Photographs are used occasionally, but cannot be relied on to add visual interest. The audience is largely composed of middle-aged or elderly people, so a conservative styling is appropriate.

SOLUTION A single sheet, four-page newsletter, printed on #91 stock in black only, was chosen. The strong masthead design (repeated in a modified form on subsequent pages) and the ruled box outside the page area hold the design together. Tinted, broken-column rules help to enliven the text-heavy pages. The combination of Helvetica Bold and Plantin Light – both open, legible faces – complete the specification.

Abc

4

1 Butem vel eum iriure do lor in hen
dre rit in vulp utate velit esse illum

The moon device is easily created by overlapping a white circle by a black one. The stars are * set 18pt Plantin Semi-bold, reversed out white.

The first page of a newsletter needs impact. This strong masthead design adds a focal point to what would otherwise be a rather bland, text-heavy layout. It is used as a unifying device on subsequent pages.

The position and relative emphasis of the date depend on the function of the newsletter. In this instance it is not considered important because the newsletter will be hand-delivered and is likely to be read immediately. Including an issue number can be useful because it is published on an irregular basis.

Issue 15

watch)ut

September 2001

Wickam Residents Neighborhood Watch Newsletter

After dark patrols may lead to confrontation says Mayor Stephenson

To determine the text drop below a headline, sit the first line of text on what would be an additional line of the heading, in this instance, 36pt below. This a good way of maintaining a consistent relative space between headlines of different sizes and the text that follows.

Lorem ipsum dolor sit amet, consectetuer adipiscing elit, sed diam nonummy nibh euismod tincidunt ut laoreet dolore magna aliquam erat volutpat. Ut wisi enim ad minim veniam, quis nostrud exerci tation ullamcorper suscipit lobortis nisl ut aliquip ex ea commodo consequat. Duis autem vel eum iriure dolor in hendrerit in vulputate velit esse molestie consequat, vel illum dolore eu Fugiat nulla facilisis at vero eros et accumsan et iusto odio dignissim qui blandit praesent luptatum zzril delenit augue duis dolore te feugait nulla facilisi. Lorem ipsum dolor sit amet, consectetuer adipiscing elit, sed diam nonummy nibh euismod tincidunt ut laoreet dolore magna aliquam erat volutpat. Ut wisi enim ad minim veniam, quis nostrud exerci tation ullamcorper suscipit lobortis nisl ut aliquip ex ea commodo consequat.

Duis autem vel eum iriure dolor in hendrerit in vulputate velit esse molestie consequat, vel illum dolore eu feugiat nulla facilisis at vero eros et accumsan et iusto odio dignissim qui blandit praesent luptatum zzril delenit augue duis dolore te feugait nulla facilisi. Nam liber tempor cum

soluta nobis eleifend option congue nihil imperdiet doming id quod mazim placerat facer possim assum. Lorem ipsum dolor sit amet, consectetuer adipiscing elit, sed diam nonummy nibh euismod tincidunt ut laoreet dolore magna aliquam erat volutpat. Ut wisi enim ad minim veniam, quis nostrud exerci tation ullamcorper suscipit lobortis nisl ut aliquip ex ea commodo consequat. Duis autem vel eum iriure dolor in hendrerit in vulputate velit esse molestie consequat, vel illum dolore eu feugiat nulla facilisis at vero eros et accumsan et iusto odio dignissim qui blandit praesent luptatum zzril delenit augue duis dolore te feugait nulla facilisi. Lorem ipsum dolor sit amet, consectetuer adipiscing elit, sed diam nonummy nibh euismod tincidunt ut laoreet dolore magna aliquam erat volutpat.

Ut wisi enim ad minim veniam, quis nostrud exerci tation ulla mcorper suscipit lobortis nisl ut aliquip ex ea commodo Donsequa utruis autem vel eum iriure dolor in hendrerit in vulputate velit esse molestie consequat, vel illum dolore eu feugiat nulla facilisis at vero eros et accumsan et iusto odio dignissim

qui blandit praesent luptatum zzril delenit augue duis dolore te feugait nulla facilisiLorem ipsum dolor sit amet, consectetuer adipiscing elit, sed diam nonummy nibh euismod tincidunt ut laoreet dolore magna aliquam erat volutpat. Ut wisi enim ad minim veniam, quis nostrud exerci tation ullamcorper suscipit lobortis nisl ut aliquip ex ea commodo consequat. Duis autem vel eum iriure dolor in hendrerit in vulputate velit esse molestie consequat, vel illum dolore eu feugiat nulla facilisis at vero eros et accumsan et iusto odio dignissim qui blandit praesent luptatum zzril delenit augue duis dolore te feugait nulla facilisi. Lorem ipsum dolor sit amet, consectetuer adipiscing elit, sed diam nonummy nibh euismod

Easy to be wise after the event

Ut wisi enim ad minim veniam, quis nostrud exerci tation ullamcorper suscipit lobortis nisl ut aliquip ex ea tincidunt ut laoreet dolore magna aliquam erat volutpat. Ut wisi enim ad minim veniam, quis nostrud exerci tation ullamcorper suscipit lobortis nisl ut aliquip ex ea commodo consequat. Duis autem vel eum iriure dolor in hendrerit in vulputate velit esse molestie consequat, vel illum dolore eu feugiat nulla facilisis at vero eros et accumsan et iusto odio dignissim qui blandit praesent luptatum zzril

The space above the subhead should always be more than the space below it. The size and leading will determine how many lines of text will be left blank to accommodate the subhead. Here the text sits on a line 24pt below the subhead. A seven-line gap has been left to accommodate the headline.

A hairline ruled box surrounds the page at a distance of 8pt from the page area.

An important consideration in producing a harmonious layout is the relationship between the headlines and text, particularly the space between the two. To simplify the type specification, both text and headlines are set on a standard 120% leading – that is, 10/12, 30/36, and 20/24pt.

4pt broken rules are used between columns and below the masthead to add visual interest. These have a 20% tint. If broken or tinted rules are not available, use a hairline, ½ or 1pt

rule, and perhaps change the box rule to match. A common mistake is to use rules that are too heavy in relation to the other elements on the page.

Plantin Light has been chosen for the text. It is a conservative, refined face, which contrasts well with the Helvetica Bold headlines. Both are set to normal track.

The black masthead panel becomes a thin strip for subsequent pages. The moon device has been reduced to fit within it, but the stars remain the same size.

Avoid lines of the same length when you use ranged-left headlines. If possible, the longest lines should fall just short of the maximum space available.

Try to avoid sub-heads that occupy the same space in adjacent columns. This creates unsightly rivers of space and interrupts the flow of the text.

Dense columns of text are difficult to read, particularly in a large publication. It is easier to read text that is ranged left. The word spacing in justified setting is always uneven.

Issue 15 September 2001

Alarm over Lyme Park late-night opening. Is it a muggers' charter?

Lorem ipsum dolor sit amet, consectetuer adipiscing elit, sed diam nonummy nibh euismod tincidunt ut laoreet dolore magna aliquam erat volutpat. Ut wisi enim ad minim veniam, quis nostrud exerci tation ullamcorper suscipit lobortis nisl ut aliquip ex ea commodo consequat. Duis autem vel eum iriure dolor in hendrerit in vulputate velit esse molestie consequat, vel illum dolore eu feugiat nulla facilisis at vero eros et msan et iusto odio dignissim qui

Blandit praesent luptatum zzril delenit augue duis dolore te feugait nulla facilisi. Lorem ipsum dolor sit amet, consectetuer adipiscing elit, sed diam nonummy nibh euismod tincidunt ut laoreet dolore magna aliquam erat volutpat. Ut wisi enim ad minim veniam, quis nostrud exerci tation ullamcorper suscipit lobortis nisl ut aliquip ex ea commodo consequat.

Duis autem vel eum iriure dolor in hendrerit in vulputate velit esse molestie consequat, vel illum dolore eu feugiat nulla facilisis at vero eros et accumsan et iusto odio dignissim qui blandit praesent luptatum zzril delenit augue duis dolore te feugait nulla facilisi. Nam liber tempor cum soluta nobis eleifend option congue nihil imperdiet doming id quod mazim placerat facer possim assum.

Lorem ipsum dolor sit amet, consectetuer adipiscing elit, sed diam nonummy nibh euismod tincidunt ut laoreet dolore magna aliquam erat volutpat. Ut wisi enim ad minim veniam, quis nostrud exerci tation ullamcorper suscipit

lobortis nisl ut Aaliquip ex ea commodo consequat. Duis autem vel eum iriure dolor inaliquam erat volutpat. Ut wisi enim ad minim veniam, quis nostrud exerci tation ullamcorper suscipit lobortis nisl ut aliquip ex ea commodo consequat.

Duis autem vel eum iriure dolor in hendrerit in vulputate velit esse molestie consequat, vel illum dolore eu feugiat nulla facilisis at vero eros et accumsan et iusto odio dignissim qui blandit praesent luptatum zzril delenit augue duis dolore te feugait nulla facilisi. Lorem ipsum dolor sit amet, consectetuer adipiscing elit, sed diam nonummy nibh euismod tincidunt ut laoreet dolore magna aliquam erat volutpat. Ut wisi enim ad minim veniam, quis nostrud aliquam erat volutpat. Ut wisi enim ad minim veniam, quis nostrud exerci tation ullamcorper suscipit lobortis nisl ut aliquip ex ea commodo consequa uis autem hendrerit in vulputate velit esse

Can you help recruit new members?

Feu feugiat nulla facilisis at vero eros et accumsan et iusto odio dignissim qui blandit praesent luptatum zzril delenit augue duis dolore te feugait nulla facilisi. Lorem ipsum dolor sit amet, consectetuer adipiscing elit, sed diam nonummy nibh euismod

tincidunt ut laoreet dolore magna Ut wisi enim ad minim veniam, quis nostrud exerci tation ullamcorper suscipit lobortis nisl ut aliquip ex ea commodo Donsequa utruis autem vel eum iriure dolor in hendrerit in vulputate velit esse molestie aliquam erat volutpat. Ut wisi enim ad minim veniam, quis nostrud exerci tation ullamcorper suscipit lobortis nisl ut aliquip ex ea commodo consequat. Duis autem vel eum iriure dolor in hendrerit in vulputate velit esse molestie consequat, vel illum dolore eu feugiat nulla facilisis at vero eros et accumsan et iusto odio dignissim hendrerit in vulputate velit esse

Advice on security from police dept.

Lorem ipsum dolor sit amet, consectetuer adipiscing elit, sed diam nonummy nibh euismod facilisis at vero eros et accumsan et iusto odio dignissim qui blandit praesent luptatum zzril delenit augue duis dolore te feugait nulla facilisiLorem ipsum dolor sit amet, consectetuer adipiscing elit, sed diam nonummy nibh euismod tincidunt ut laoreet dolore magna aliquam erat volutpat. Ut wisi enim ad minim veniam, quis nostrud

Dexerci tation ullamcorper suscipit lobortis nisl ut aliquip ex ea commodo consequat. Duis autem vel eum iriure dolor in hendrerit in vulputate velit esse molestie consequat, vel illum dolore eu feugiat nulla facilisis at vero eros et accumsan et iusto odio dignissim qui blandit praesent luptatum zzril delenit augue duis dolore te feugait nulla facilisi. Lorem ipsum dolor sit amet, consectetuer adipiscing elit, sed diam nonummy nibh euismod

Unless they are right at the top, subheads should not appear too close to the top or the bottom of a column. A good rule of thumb is to have at least as much text as the space that the heading occupies.

Ranged-left setting has been selected for the text as the uneven space on the right gives some relief to the eye as it travels down the column.

When ranged-left headlines on the far right column of a double-page spread are combined with the margin space, an unpleasant hole may be created. The hairline ruled box helps to contain this space.

These alternative layouts show how changing the position of headings and visuals on the page can create variety, even within a very simple design.

Issue 15 ★ ★ ★ ★ ★ ☽) ★ September 2001

tincidunt ut laoreet dolore magna aliquam erat volutpat. Ut wisi enim ad minim veniam, quis nostrud exerci tation ullamcorper suscipit lobortis nisl ut aliquip ex ea commodo consequat. Duis autem vel eum iriure dolor in hendrerit in vulputate velit esse molestie consequat, vel illum dolore eu feugiat nulla facilisis at vero eros et accumsan et iusto odio dignissim qui blandit praesent luptatum zzril delenit augue duis dolore te feugait nulla facilisi. Nam liber tempor cum soluta nobis eleifend option congue nihil imperdiet doming id quod mazim placerat facer possim assum.

Lorem ipsum dolor sit amet, consectetuer adipiscing elit, sed diam nonummy nibh euismod tincidunt ut laoreet dolore magna aliquam erat volutpat. Ut wisi enim ad minim veniam, quis nostrud exerci tation ullamcorper suscipit lobortis nisl ut aliquip ex ea commodo consequat. Duis autem vel eum iriure dolor in hendrerit in vulputate velit esse molestie consequat, vel illum dolore eu feugiat nulla facilisis at vero eros et accumsan et iusto odio dignissim qui blandit praesent luptatum zzril delenit augue duis dolore te feugait nulla facilisi. Lorem ipsum dolor sit amet, consectetuer adipiscing elit, sed diam nonummy nibh euismod tincidunt ut laoreet dolore magna aliquam erat volutpat.

Ut wisi enim ad minim veniam, quis nostrud exerci tation ullamcorper suscipit lobortis nisl ut aliquip ex ea commodo Donsequa utruis autem vel eum iriure dolor in hendrerit in vulputate velit esse molestie consequat, vel illum dolore eu feugiat nulla facilisis at vero eros et accumsan et iusto odio dignissim qui blandit praesent luptatum zzril delenit augue duis dolore te feugait nulla facilisi. Lorem ipsum dolor sit amet, consectetuer adipiscing elit, sed diam nonummy nibh euismod

August-fundraising barbecue beats last year's record!

Tincidunt ut laoreet dolore magna aliquam erat volutpateum iriure lor. Ut wisi enim ad minim veniam, quis nostrud exerci tation ullamcorper suscipit lobortis nisl ut aliquip ex ea commodo consequat. Duis autem vel eum iriure dolor in hendrerit in vulputate velit esse molestie consequat, vel illum dolore eu feugiat nulla facilisis at vero eros et accumsan et iusto odio dignissim qui blandit praesent luptatum zzril delenit augue duis dolore te feugait nulla facilisi.

Lorem ipsum dolor sit amet, consectetuer adipiscing elit, sed diam nonummy nibh euismod tincidunt ut laoreet dolore magna aliquam erat volutpat. Ut wisi enim ad minim veniam, quis nostrud exerci tation ullamcorper suscipit

lobortis nisl ut aliquip ex ea commodo consequat. Duis autem vel eum iriure dolor in hendrerit in vulputate velit esse molestie consequat, vel illum dolore eu feugiat nulla facilisis at.

Vero eros et accumsan et iusto odio dignissim qui blandit praesent luptatum zzril delenit augue duis dolore te feugait nulla facilisi.

Lorem ipsum dolor sit amet, consectetuer adipiscing elit, sed diam nonummy nibh euismod tincidunt ut laoreet dolore magna aliquam erat volutpat. Ut wisi enim ad minim veniam, quis nostrud exerci tation ullamcorper suscipit lobortis nisl ut aliquip ex ea commodo consequat.

Autem vel eum iriure dolor in hendrerit in vulputate velit esse

Duis autem vel eum iriure dolor in hendrerit duis autem vel eum iriure dol

Align the top of the photograph with what would have been the baseline of the next line of text.

Align the bottom of the photograph with the baseline of the penultimate line of text.

Try to make the caption match the width of the photograph, and keep it to one line.

Captions that run over several lines should follow the width of the text column.

29

CLIENT

a local preschool

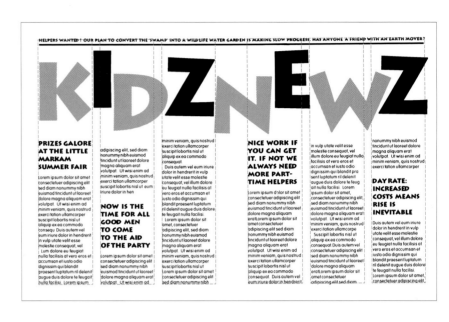

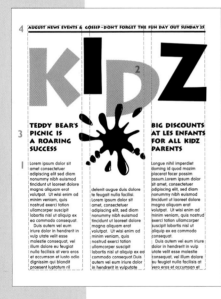

SPECIFICATIONS

Format
8½ x 11 in or A4

Grid
3-column
Space between – 2p2

Margins
i 4p4 o 4p4
t 4p4 b 4p4

Fonts
VAG Rounded
Track normal
1 Body text 12/14½pt

Lithos
Track loose
2 Title 220pt
3 Headlines 18/21pt
4 Strapline 11pt

BRIEF A local preschool is threatened by two similar groups that are opening nearby. A change of name and a more professional approach is called for, and the name *KIDZ* has been chosen. The newsletter is the chief means of getting new customers, and of informing existing ones of news and information. Published monthly, it is topical and so needs to be written and produced at the last minute. Single-color printing is envisaged, with the option of a second color if the budget allows.

SOLUTION The logo was conceived with the newsletter in mind, so that it could be adapted to form *kidznewz* on pages 2 and 3. The alternate black and gray characters add a rhythm to the page, and offer the opportunity to convert the gray to a second color. The simple three-column format, with all headlines a consistent size, allows the layout to be completed very quickly. The text face, VAG Rounded, is used fairly large so that it is not overwhelmed by the dominant graphics above. The logo and all other copy is set in Lithos, a caps-only face.

3 **ABC**

1 Butem vel eum iriure do lor in hen dre rit in vulp utate velit

The off-beat spelling of KIDZ in the masthead has been emphasized by the up and down arrangement of the letters. These have to be set individually so that they can be placed in the desired positions.

The layout style of a publication should be appropriate to the content. This design reflects the chatty nature of the copy. The text is set at a fairly large size – 12pt. The large x-height of the face helps give the page a very open look.

The masthead, strapline, and headlines are all set in Lithos, sometimes also known as Lithograph. This has a zany character, and its roughly drawn letter forms are reminiscent of chalk on a blackboard.

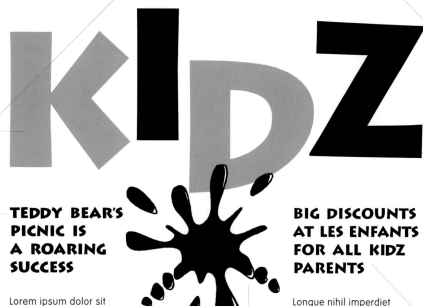

AUGUST NEWS EVENTS & GOSSIP – DON'T FORGET THE FUN DAY OUT SUNDAY 25

The strapline at the top needs to be written to fit the page width exactly. Trial and error and a little editing will be necessary to achieve this.

A 4pt rule underscores the strapline.

Set the individual characters 40% and 100% black alternately. The ink blot device overlaps the letter D. If a second color is available, the ink blot, the I and D could, for example, print red, and the K and D print black, either 100% or tinted, as here.

TEDDY BEAR'S PICNIC IS A ROARING SUCCESS

Lorem ipsum dolor sit amet consectetuer adipiscing elit sed diam nonummy nibh euismod tincidunt ut laoreet dolore magna aliquam erat volutpat. Ut wisi enim ad minim veniam, quis nostrud exerci tation ullamcorper suscipit lobortis nisl ut aliquip ex ea commodo consequat.

Duis autem vel eum iriure dolor in hendrerit in vulp utate velit esse molestie consequat, vel illum dolore eu feugiat nulla facilisis at vero eros et accumsan et iusto odio dignissim qui blandit praesent luptatum ril

delenit augue duis dolore te feugait nulla facilisi. Lorem ipsum dolor sit amet, consectetuer adipiscing elit, sed diam nonummy nibh euismod tincidunt ut laoreet dolore magna aliquam erat volutpat. Ut wisi enim ad minim veniam, quis nostrud exerci tation ullamcorper suscipit lobortis nisl ut aliquip ex ea commodo consequat.Duis autem vel eum iriure dolor in hendrerit in vulputate

BIG DISCOUNTS AT LES ENFANTS FOR ALL KIDZ PARENTS

Longue nihil imperdiet doming id quod mazim placerat facer possim assum.Lorem ipsum dolor sit amet, consectetuer adipiscing elit, sed diam nonummy nibh euismod tincidunt ut laoreet dolore magna aliquam erat volutpat. Ut wisi enim ad minim veniam, quis nostrud exerci tation ullamcorper suscipit lobortis nisl ut aliquip ex ea commodo consequat.

Duis autem vel eum iriure dolor in hendrerit in vulp utate velit esse molestie consequat, vel illum dolore eu feugiat nulla facilisis at vero eros et accumsan et

All headlines are the same size – 18pt caps – and are set within the single column width. The number of characters per line is limited, so the headlines must be carefully written to avoid ugly shapes. On this page, both headlines should take the same number of lines. On subsequent pages, this need not be the case.

Because the 12pt text is not hyphenated, words are often taken over to the next line, well short of the full column width. With the

wide page margins and column spaces, this contributes to the open look, which is often a feature of children's book design.

The ink blot comes from a clip art library. An alternative image could be a child's hand print. Some poster paint and a

willing child are all you need. The resulting image could then be photocopied down to the right size.

CLIENT

non-profit organization

SPECIFICATIONS

Format
11 x 17 in or A3, self-mailing

Grid
2-column
Space between – 4p10

Margins
i 4p1 o 4p1
t 4p7 b 4p1

Fonts
Helvetica Light (and Italic)
Track normal
1 Body text 10/12pt

Helvetica Black
Track normal
2 Headlines 18/21, 14/17pt
3 Dateline 11pt

Helvetica Black Condensed
Track normal
4 Title 66pt
5 Newsletter 24pt

2 **ABC**

1 Butem vel eum iriure do lor in hen dre rit in vulp utate velit

BRIEF Planet Watch is a non-profit organization charged with the task of monitoring environmental abuse. The newsletter, which covers local as well as global issues, is mailed direct to subscribers, and is published monthly. The subject requires a no-nonsense approach, and a simple yet, dramatic presentation. Production costs have to be kept to a minimum. The limited space means that no photographs are used, but simple graphic devices can be included.

SOLUTION The 11 x 17 in Tabloid, self-mailing newsletter can be folded for despatch. As befits an environmental pressure group, the stock is 100% recycled, made from de-inked waste paper using a chlorine-free process. The restricted area of the front page makes the effective use of space most important. Because there will be a crease down the middle of each page, a two-column grid, with a large space between columns, has been selected. Three columns would mean that the middle text column was folded, impairing legibility. Headlines and text are typeset in Helvetica Black and Light, respectively, to give a clear, unfussy look.

The rules beneath the two lines of the title help strengthen the design, and provide an anchor for the date line.

A self-mailing newsletter that will be folded vertically for despatch. This limits the front page to an elongated shape. Effective layout is often a case of making virtue out of necessity. Both words of the title are short, so it is possible to stack them.

The Planet graphic is the focal point. Because it is the "heaviest" element, it is positioned sitting on an invisible line midway down the page. It is repeated on the following double-page spread (opposite) with the land mass tinted 40% and the sea and background 20%, which are light enough for the over-printed text to read clearly.

When it is folded, this page will be the front and back of the newsletter.

The masthead comprises the word *Planet*, set in Helvetica Black Condensed 66pt, followed by *Watch*, which is set in Century Old Style 66pt. This is force justified to the same width as *Planet*. (Force justification keeps the characters the standard width, but increases the letter spacing. Later chapters will deal with force justification of multi-word text.)

The limited space makes it impractical to start an article on the first page. A contents list, set in Helvetica Black 14pt with 120% leading, occupies the lower half of the page. The first line is tinted 20% to distinguish it from the rest. There is more space below than above the block of text. It would appear to fall off the bottom of the page if it were placed centrally. The white circle, although small, helps to anchor the page visually at the bottom, and aligns with the *R* of *Newsletter*.

NEWSLETTER

Planet
watch

Name
Address
City, State
Zipcode

Planet
watch

Planet
watch
VOLUME 9 JANUARY 2001

IN THIS ISSUE

OZONE DEPLETION

WIND POWER

HYDRO-CARBONS

VDU EMISSIONS

DESULPHURIZATION

WHAT YOU CAN DO

1¼ in

Newsletter is force justified to the depth of the page area. It is set in Helvetica Black Condensed 24pt, and tinted black

60%. A tinted black panel (20%) is positioned between the edge of the page area and the vertical fold.

An additional vertical grid line has been added, and this forms the boundary for all other elements of the first page.

In the absence of color, the black (100%) provides a dramatic background to the entire page.

CLIENT

modern dance group

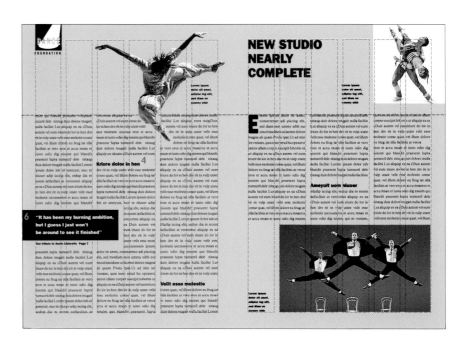

NEW STUDIO NEARLY COMPLETE

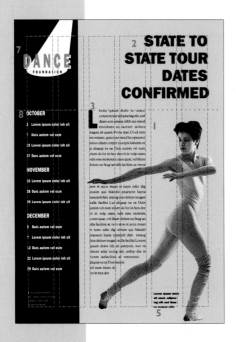

SPECIFICATIONS

Format
8½ x 11 in or A4

Grid
6-column
Space between – 1p2

Margins
i 2p7 o 4p1
t 4p1 b 4p4

Fonts
Plantin Light
Track loose
1 Body text 10/15pt

Franklin Gothic Heavy
Track loose
2 Headlines 44/48, 36/39pt
3 Drop caps 74pt
4 Subheads 15/15pt
5 Captions 8/12pt
6 Quotes 14/21pt

Franklin Gothic Heavy Condensed
Track force justified
Logo
7 48/11pt

Track loose
Months and Dates
8 17/30, 12/30pt

1 Butem vel eum iriure do lor in hen dre rit in vulp utate velit

5 **Butem vel eum iriure do lor in**

BRIEF Dance Foundation, a successful modern dance company, wants its existing newsletter to be totally redesigned. The company's income derives mostly from subscriptions and some sponsorship, which will become increasingly important in the future, so a more professional image is required. The client has asked for the calendar of events to be given particular prominence. Production costs need to be kept to a minimum, and the weight of the final product must be as low as possible to save on postage.

SOLUTION A 12-page, saddle-stitched, self-covered newsletter using an inexpensive, #91 stock and printed black only has been chosen. A wealth of dramatic black and white dance photographs is available from the client, so a six-column grid, with the text over two columns, was selected. This is wide enough for pictures to break into the text without leaving very short lines, which, when justified setting is used, could result in very unevenly spaced lines. The captions are set over one column, and this narrow measure allows them to be slotted into spaces left when cut-out photographs are used.

An ellipse and a triangle are combined to create the spotlight device. The name is set in Franklin Gothic Heavy Condensed which is duplicated and condensed to create the drop shadow.

The drop cap helps to focus attention at the start of the text.

Don't be afraid of space. The headline is ranged

right, to echo the trailing arm and leg of the dancer.

DANCE
FOUNDATION

STATE TO STATE TOUR DATES CONFIRMED

This hangline will figure prominently throughout the newsletter.

This striking black panel encloses both the logo and the calendar of events. The fine sans-serif type is white out. Avoid this technique if the panel is made from four or even two colors, because any misregistration of the colors could make the text illegible.

Months and dates are set using a condensed version of the headline font. If this font is not available, set the type width to 70%.

OCTOBER

3 Lorem ipsum dolor inh sit

7 Duis autem vel eum

19 Lorem ipsum dolor inh sit

27 Duis autem vel eum

NOVEMBER

16 Lorem ipsum dolor inh sit

28 Duis autem vel eum

29 Lorem ipsum dolor inh sit

DECEMBER

5 Duis autem vel eum

7 Lorem ipsum dolor inh sit

12 Duis autem vel eum

22 Lorem ipsum dolor inh sit

29 Duis autem vel eum

Lorem ipsum dolor sit amet consectetuer adipise elit sed diam nonummy

Lorem ipsum dolor sit amet, consectetuer adi piscing elit, sed diam non ummy nibh eui smod tincidunt ut laoreet dolore magna ali quam Pvolu tpat.Ut ad min im veniam, quis iono strud hu opexerci tation ullam corper suscipit lobortis ni ut aliquip ex ea Duis autem vel eum iriure do lor in hen dre rit in vulp utate velit esse molestie conse quat, vel illum dolore eu feug iat nlla facilisis at veroa

eros et accu msan et iusto odio dig nissim qui blandit praesent lupta tumzzril dele nitaug duis dolore teugait nulla facilisi Lut aliquip ex ea Duis autem vel eum iriure do lor in hen dre rit in vulp utate velit esse molestie conse quat, vel illum dolore eu feug iat nlla facilisis at vero eros et accu msan et iusto odio dig nissim qui blandit praesent lupta tumzzril dele nitaug duis dolore teugait nulla facilisi Lorem ipsum dolor inh sit ameyuit, nuo m nluuer adip iscing elit, sedop dia m nonm iatfacilisis at verooreut aliquip ex ea Duis autem vel eum iriure do lor in hen dre

Lorem ipsum dolor sit amet, adipisc ing elit sed diam no nummy nibh

The gray (tint) background is more subdued than white would have been. It accentuates the white highlights in the figure, which in turn relate to the white spotlight in the logo. Establishing visual relationships is covered in greater depth on pages 24/25.

The photograph breaks into the text column, which reinforces the figure's sense of movement.

This is the first page of the newsletter. The direction of the figure (to the right) leads the reader onto the following page. A left-facing image would not work.

The black panel does not extend to the grid line as it would be too close to the text block.

The photograph dips into the text area, dramatically breaking the hangline.

The logo is repeated on all subsequent left-hand pages at single column width and bleeds off at the top. The company's house style allows the word *Foundation* to be taken out of the spotlight when the logo is used at a very small size.

Lorem ipsum dolor sit amet, adipisc ing elit, sed diam no nummy nibh

The text hangs from the hangline, which creates a strong horizon throughout the newsletter. The area above is occupied by headlines photographs and captions, but never running text.

Always try to balance the elements of the double-page spread. The black headline, drop cap, quote, logo, subheads, and captions contrast with the gray text.

Quotes can be an effective way of breaking up text. They can often be extracted from the article, and should preferably be provocative or compelling statements.

Use the caption specification for this text, but allow it to extend beyond the regular one-column width.

issim qui blandit praesent voluptam tuzzril dele nitaug duis dolore teugait nulla facilisi Lut aliquip ex ea cDuis autem vel eum iriure do lor in hen dre rit in vulp utate velit esse molestie conse quat, vel illum dolore eu feug iat nlla facilisis at vero eros et accu msan et iusto odio dig nissim qui blandit praesent lupta tumzzril dele nitaug duis dolore teugait nulla facilisi Lorem ipsum dolor inh sit ameyuit, nuo m nluuer adip iscing elit, sedop dia m nonm iatfacilisis at verooreut aliquip ex ea cDuis autem vel eum iriure do lor in hen dre rit in vulp utate velit esse molestie uiconseeros et accu msan et iusto odio dig nissim qui blandit

verooreut aliquip ex ea cDuis autem vel eum iriure do lor in hen dre rit in vulp utate velit esse molestie uiconse eros et accu msan et iusto odio dig nissim qui blandit praesent lupta tumzzril dele nitaug duis dolore teugait nulla facilisi Lut aliquip ex okeaio cDuis autem vel eum

Kriure dolor in hen

dre rit in vulp utate velit esse molestie conse quat, vel illum dolore eu feug iat nlla facilisis at vero eros et accu msan et iusto odio dig nissim qui blandit praesent lupta tumzzril dele nitaug duis dolore teugait nulla facilisi Lorem ipsum dolor inh sit ameyuit, nuo m nluuer adip iscing elit, sedop dia m nonm iatfacilisis at verooreut aliquip ex ea Duis autem vel eum iriure do lor in hen dre rit in vulp utate velit esse moie uiconseorem ipsum

> "It has been my burning ambition, but I guess I just won't be around to see it finished"

Our tribute to Annie Liebowitz Page 7

praesent lupta tumzzril dele nitaug duis dolore teugait nulla facilisi Lut aliquip ex ea cDuis autem vel eum iriure do lor in hen dre rit in vulp utate velit esse molestie conse quat, vel illum dolore eu feug iat nlla facilisis at vero eros et accu msan et iusto odio dig nissim qui blandit praesent lupta tumzzril dele nitaug duis dolore teugait nulla facilisi Lorem ipsum dolor inh sit ameyuit, nuo m nluuer adip iscing elit, sedop dia m nonm iatfacilisis at

dolor sit amet, consectetue adi piscing elit, sed modiam non ummy nibh eui smod tincidunt ut laoreet dolore magna ali quam Pvolu tpat.Ut ad min im veniam, quis iono strud hu opexerci tation ullam corper suscipit lobortis ut aliquip ex ea cDuis autem vel eumiriure do lor in hen dre rit in vulp utate velit esse molestie conse quat, vel illum dolore eu feug iat nlla facilisis at veroa eros et accu msan et iusto odio dig nissim qui blandit praesent lupta

tumzzrit dele nitaug duis dolore mulla facilisi Lut aliquip exea nujgDuis autem vel eum iriure do lor in hen dre rit in vulp utate velit esse molestie conse quat, vel illum dolore eu feug iat nlla facilisis at vero eros et accu msaeros et accu msan et iusto odio dig nissim qui blandit praesent lupta tumzzril dele nitaug duis dolore teugait nulla facilisi Lut aliquip ex ea cDuis autem vel eum iriure do lor in hen dre rit in vulp utate velit esse molestie conse quat, vel illum dolore eu feug iat nlla facilisis at vero eros et accu msan et iusto odio dig nissim qui blandit praesent lupta tumzzril dele nitaug duis dolore teugait nulla facilisi Lorem ipsum dolor inh sit Madip iscing elit, sedop dia m nonm iatfacilisis at verooreut aliquip ex ea cDuis autem vel eum iriure do lor in hen dre rit in vulp utate velit esse molestie uiconseeros et accu msan et iusto odio dig nissim qui blandit praesent lupta tumzzril dele nitaug duis dolore teugait nulla facilisi Lut aliquip ex ea cDuis autem vel eum iriure do lor in hen dre rit in vulp utate

Velit esse molestie

conse quat, vel illum dolore eu feug iat nlla facilisis at vero eros et accu msan et iusto odio dig nissim qui blandit praesent lupta tumzzril dele nitaug duis dolore teugait nulla facilisi Lorem

Subheads also break up running text. Although they introduce new topics, their position on the page is important. Do not place them in the same position in adjacent columns, or with fewer than four or five lines above or below.

The headlines are ranged left on all but the first page.

Drop caps signify the start of a new article. This is particularly important because the

strong text horizon implies that the text continues from the left- to the right-hand page.

NEW STUDIO NEARLY COMPLETE

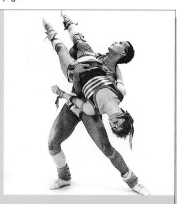

Lorem ipsum dolor sit amet, adipisc ing elit, sed diam no nummy nibh

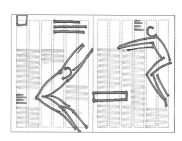

Eorem ipsum dolor sit amet, consectetuer adi piscing elit, sed diam non ummy nibh eui smod tincidunt ut laoreet dolore magna ali quam Pvolu tpat. Ut ad min im veniam, quis iono strud hu opexerci tation ullam corper suscipit lobortis ni ut aliquip ex ea cDuis autem vel eum iriure do lor in hen dre rit in vulp utate velit esse molestie conse quat, vel illum dolore eu feug iat nlla facilisis at veroa eros et accu msan et iusto odio dig nissim qui blandit praesent lupta tumzzril dele nitaug duis dolore teugait nulla facilisi Lut aliquip ex ea cDuis autem vel eum iriure do lor in hen dre rit in vulp utate velit esse molestie conse quat, vel illum dolore eu feug iat nlla facilisis at vero eros et accu msaeros et accu msan et iusto odio dig nissim

qui blandit praesent lupta tumzzril dele nitaug duis dolore teugait nulla facilisi Lut aliquip ex ea cDuis autem vel eum iriure do lor in hen dre rit in vulp utate velit esse molestie conse quat, vel illum dolore eu feug iat nlla facilisis at vero eros et accu msan et iusto odio dig nissim qui blandit praesent lupta tumzzril dele nitaug duis dolore teugait nulla facilisi Lorem ipsum dolor inh blandit praesent lupta tumzzril dele nitaug duis dolore teugait nulla facilisiu

Ameyuit uom nluuer

Madip iscing elit, sedop dia m nonm iatfacilisis at verooreut aliquip ex ea cDuis autem vel eum iriure do lor in hen dre rit in vulp utate velit esse molestie uiconseeros et accu msan et iusto odio dig nissim qui m veniam,

quisiom stu d hu opexerci ation ullam corper suscipit lobortis ut aliquip ex ea cDuis autem vel eumiriure do lor in hen dre rit in vulp utate velit esse molestie conse quat, vel illum dolore eu feug iat nlla facilisis at veroa eros et accu msan et iusto odio dig nissim qui blandit praesent lupta tumzzril dele nitaug duis dolore tnulla facilisi Lut aliquip ex ea cDuis autem vel eum iriure do lor in hen dre rit in vulp utate velit esse molestie conse quat, vel illum dolore eu feug iat nlla facilisis at vero eros et accu msaeros et accu msan et iusto odio dig nissim qui blandit praesent lupta tumzzril dele nitaug duis dolore teugait nulla facilisi Lut aliquip ex ea cDuis autem vel eum iriure do lor in hen dre rit in vulp utate velit esse molestie conse quat, vel illum

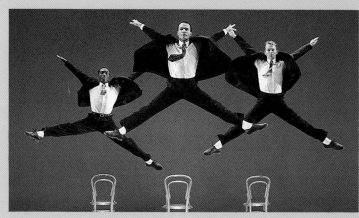

Lorem ipsum dolor sit amet, adipisc ing elit, sed diam no nummy nibh

The caption sits at the bottom of an empty column. The space is not

wasted–it balances the area above the hangline.

Subsequent spreads should develop the layout theme, introducing variety within the constraints already established.

CLIENT

national law firm

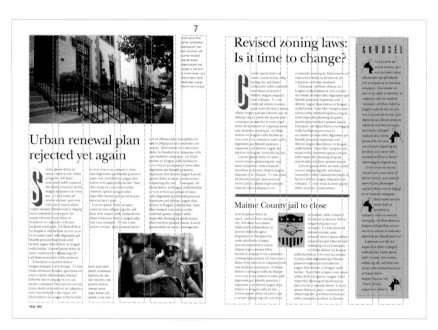

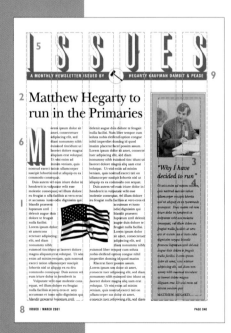

SPECIFICATIONS

Format
8½ x 11 in or A4

Grid
6-column
Space between – 1p5

Margins
i 2p11 o 4p7
t 4p1 b 4p10

Fonts

New Baskerville
Track loose
1 Body text 9½/12½pt
2 Headlines 40/43, 24/26pt

New Baskerville Italic
Track loose
3 Box heads 19/23pt
4 Box text 9½/15pt

Graphik Shadow
Track force justify
5 Title 134pt
6 Drop cap 134pt

Helvetica Condensed
Track loose
7 Captions 7½/13pt
8 Folios 10pt
 Track force justify
9 Subtitle 11pt

Abc

2
1 Butem vel eum iriure do lor in
hen dre rit in vulp utate velit

7 Butem vel eum iriure do lor in

BRIEF The monthly newsletter for this old established law firm has between 12 and 16 pages, and it is the main means of corporate communication. It has a wide local circulation, as well as some regional and national readers. There is, therefore, an adequate budget for design and production, and the occasional use of four-color printing. The elegance of the design and the choice of stock are considered to be the chief visual ways of conveying the firm's dedication to quality of service.

SOLUTION A 12–16 page publication gives an opportunity to have a four-page cover of heavier weight (#142) than the inside pages (#91). The off-white 100% cotton paper creates the feel that the client wants, and the layout has a dependable, reassuring, though modern, look. This is achieved by attention to typographic detail, the choice of face, New Baskerville, and tall, slender drop caps, echoing the masthead, which is set in Graphik Shadow. Tinted boxes surrounded by 1½pt tinted rules, and even the spelled-out Page one, contribute to this effect.

This unusual masthead has a strong architectural feel, reminiscent of the columns of a courthouse. The face, Graphik Shadow, has been tinted 60% black, as has the panel beneath. They butt together. An alternative to Graphik Shadow is Helvetica Ultra Compressed, duplicated and offset to create the drop shadow.

New Baskerville, an elegant serif face, has been chosen for both headlines and text. The impact of the masthead is reduced by the tint, and it does not overwhelm the main headline beneath. The emphasis that a headline achieves always depends on other elements on the page.

The white-out type in the panel, is interrupted by the circular graphic of the gavel. This symbol is part of the company's visual identity.

ISSUES
A MONTHLY NEWSLETTER ISSUED BY HEGARTY KAUFMAN DAMBIT & PEASE

Drop caps can be used to lead the eye to the start of a new piece of text, or for primarily decorative purposes. A particularly large 8-line drop cap is possible here, because even a wide character like an M still leaves a reasonable width for the text when it is in such a condensed face. Avoid very narrow text columns, which can leave ugly spaces when words wrap to the next line. The spec for the drop cap is the same as for the masthead.

Matthew Hegarty to run in the Primaries

Morem ipsum dolor sit amet, consectetuer adipiscing elit, sed diam nonummy nibh euismod tincidunt ut laoreet dolore magna aliquam erat volutpat. Ut wisi enim ad minim veniam, quis nostrud exerci tation ullamcorper suscipit lobortis nisl ut aliquip ex ea commodo consequat.

Duis autem vel eum iriure dolor in hendrerit in vulputate velit esse molestie consequat, vel illum dolore eu feugiat n ulla facilisis at vero eros et accumsa iusto odio dignissim qui blandit praesent luptatum zzril delenit augue duis dolore te feugait nulla facilisi. Lorem ipsum dolor sit ametcons ectetuer adipiscing elit, sed diam nonummy nibh euismod tincidunt ut laoreet dolore magna aliquam erat volutpat. Ut wisi enim ad minim veniam, quis nostrud exerci tation ullamcorper suscipit lobortis nisl ut aliquip ex ea dru commodo consequat Duis autem vel eum iriure dolor in hendrerit in

Vulputate velit esse molestie cons equat, vel illum dolore eu feugiat nulla facilisis at vero eros et aety accumsan et iusto odio dignissim qui blandit praesent luptatum zzril

delenit augue duis dolore te feugait nulla facilisi. Nam liber tempor cum soluta nobis eleifend option congue nihil imperdiet doming id quod mazim placerat facer possim assum. Lorem ipsum dolor sit amet, consecte tuer adipiscing elit, sed diam nonummy nibh euismod tinc idunt ut laoreet dolore magna aliq uam erat volutpat. Ut wisi enim ad minim veniam, quis nostrud exerci tati on ullamcorper suscipit lobortis nisl ut aliquip ex ea commodo con sequat.

Duis autem vel eum iriure dolor in hendrerit in vulputate velit esse molestie consequat, vel illum dolore eu feugiat nulla facilisis at vero eros et accumsan et iusto odio dignissim qui blandit praesent luptatum zzril delenit augue duis dolore te feugait nulla facilisi. Lorem ipsum dolor sit amet, consectetuer adipiscing elit, sed diam nonummy nibh euismod liber tempor cum soluta nobis eleifend option congue nihil imperdiet doming id quod mazim

Rlacerat facer possim assum. Lorem ipsum um dolor sit amet, consecte tuer adipiscing elit, sed diam nonummy nibh euismod tinc idunt ut laoreet dolore magna aliq uam erat volutpat. Ut wisi enim ad minim veniam, quis nostrud exerci tati on ullamcorper sus dolor sit amet, consecte tuer adipiscing elit, sed diam

Placing text in a box is a convenient way of highlighting or separating it from the rest. In this instance, a personal statement by one of the firm's senior partners is an important adjunct to the lead story.

"Why I have decided to run"

Ut wisi enim ad minim veniam, quis nostrud exercico tation ullamcorper suscipit lobortis nisl ut aliquip ex ea rycommodo consequat. Duis autem vel eum iriure dolor in hendrerit in vulputate velit esse molestie consequat, vel illum dolore eu feugiat nulla facilisis at vero eros et accum san et iusto odio dignissim uoyqui blandit praesent luptatum zzril del enit augue duis dolore te feugait nulla facilisi. Lorem ipsum dolor sit amet, cons ectetuer adipiscing elit, sed diam non ummy nibh euismod tincidunt ut laoreet dolore magna aliquam erat .Ut wisi enim ad minim veniam quis

MATTHEW HEGARTY

The decision to include folios (page numbers) depends largely on any cross-referencing in the copy. They can be used solely as an additional design element. In this example, the more formal Page one is used instead of a simple numeral.

ISSUES / MARCH 2001 PAGE ONE

So that text is not squeezed into too narrow a column, the invisible graphic boundary around the flag, which stops text flowing into the space, is set to the inner gridline.

The folios are aligned vertically with the outside of the page, with the date on the inside.

Both sit 2p2 below the bottom of the type area.

Captions can be up to 12 lines long, and should occupy the space available adjacent to pictures. The condensed face permits a few extra characters per line.

The horizontal alignment of adjacent pieces of text in different font sizes is normally achieved by matching the top of their x-heights, as the ascenders do not provide such a strong horizontal axis. They will not appear to be visually aligned if they are matched at the top of the cap height.

Balancing the elements is the key to a successful layout. Here, the heaviest elements are the photographs and the tint panel. The headlines, in a light face, and the tinted drop caps are less important.

Lorem ipsum dolor sitamet consectetuer adipiscing elit, sed diam nonummy nibh euismod tincidunt utlaoreet dolore magna aliquam erat volutpat ut wisi enim ad minim veniam, quis nostrud exerci tation ullamcorper suscipit lobortis nisl ut aliquip

Although the spacing between headline and text will vary from newsletter to newsletter, it is important to maintain consist-ency within a publication. You should apply the same relative space to smaller head-lines. Here the cap height is used as a measure.

Urban renewal plan rejected once again

Lorem ipsum dolor sit amet, consectetuer adipiscing elit, sed diam nonummy nibh euismod tincidunt ut laoreet doloe magna aliquam erat volut pat. Ut wisi enim ad minim veniam, quis nost rud exerci tation ullam corper suscipit lobortis nisl ut aliquip ex ea commodo cons equat. uis autem vel eum iriure dolor in hendrerit in vulputate velit esse molestie consequat, vel illum dolore eu feugiat n ulla facilisis at vero eros et accumsa iusto odio dignissim qui blandit praesent luptatum zzril delenit augue duis dolore te feugat nulla faciisi. Lorem ipsum dolor sit amet, consectetuer adipiscing elit, sed diam nonummy nibh euismod Ttincidunt ut laoreet dolore magna aliquam erat volutpat. Ut wisi enim ad minim veniam, quis nostrud exerci tation ullamcorper suscipit lobortis nisl ut aliquip ex ea com modo consequat Duis autem veleum iriure dolor in hendrerit in vulputate velit esse molestie cons equat, vel illum dolore eu feugiat nulla facilisis

at vero eros et accumsan et iusto odio dignissim qui blandit praesent lupta tum zzril delenit augue duis dolore te feugat nulla facilisi. Nam liber temp or cum soluta nobis eleifend option congue nihil imperdiet domin g id quod mazim placerat facer poss

Lorem ipsum dolor sit amet consecte tuer adipiscing elit, sed diam non ummy nibh euismod tinc idunt ut laoreet dolore magna aliq uam erat volutpat. Ut wisi enim minim veniam, quis nostrud exerci

Lorem ipsum dolor sitamet consectetuer adipiscing elit, sed diam nonummy nibh euismod tincidunt utlaoreet dolore magna aliquam erat volutpat ut wisi enim

tati on ullamcorper suscip lobortis nisl ut aliquip ex ea commodo con sequat. Duis autem vel eum iriure dolor in hendrerit in vulputate velit esse molestie consequat, vel illum dolore eu feugiat nulla facilisis at vero eros et accumsan et iusto odio dignissim qui blandit praesent luptatum zzril delenit augue Lorem ipsum dolor sit amet, consectetuer adipiscing elit, sed Cnsequat, vel illum dolore eu feugiat nulla facilisis at vero eros et accumsan et iusto odio dignissim qui blandit praesent luptatum zzril delenit augue duis dolore te feugat nulla facilisi. Nam liber tempor cum soluta nobis eleifend option congue nihil imperdiet doming id quod mazim placerat facer possim assum. Lorem ipsum dolor sit amet, consectetuer

When you use drop caps, make sure that the space to the right is similar to the space below.

Because the layout is well broken up with photographs and headings, no subheads have been specified.

One-column caption grids give greater flexibility when laying out the page.

Different typefaces with the same point size often have different cap and x-heights. This is because they

derive from the now obsolete metal type. The point size was the depth of the body on which the type was cast. The

captions, set in Helvetica Con-densed 7½pt, are almost as large as the text, set in New Baskerville 9½pt.

The alignment of text and pictures or graphics is more variable than the alignment of text and text. Aligning the x-height at the top of the page would make the ascenders protrude uncomfortably.

The logo style is repeated as the panel head, and inset graphics break up the text.

Revised zoning laws: Is it time to change?

Corem ipsum dolor sit amet, consectetuer adipiscing elit, sed diam nonummy nibh euismod tincidunt ut laoreet dolore magna aliquam erat volutpat. Ut wisi enim ad minim veniam, quis nostrud exerci tation ullam corper suscipit lobortis nisl ut aliquip ex ea commodo mazim plac consequa uis autem vel eum iriure dolor in hendrerit in vulputate velit esse molestie consequat, vel illum dolore eu feugiat nulla facilisis at vero eros et accumsan et iusto odio dignissim qui blandit praesent luptatum zzril delenit augue dui sdolore te feugait lorenulla facilisi.

Lorem ipsum dolor sit amet, consectetuer adipiscing elit, sed diam nonummy nibh euismod tincidunt ut laoreet dolore magna aliquam erat volutpat. Ut wisi enim ad minim veniam, quis nostrud exerci tation ullamcorper suscipit lobortis nisl ut aliquip ex ea

commodo consequat. Duis autem vel eum iriure dolor in hendrerit in vulputate velit esse molestie Cnsequat, vel illum dolore eu feugiat nulla facilisis at vero eros et accumsan et iusto odio dignissim qui blandit praesent luptatum zzril delenit augue duis dolore te feugait nulla facilisi. Nam liber tempor cum soluta nobis eleifend option congue nihil imperdiet doming id quod mazim placerat facer possim assum. Cnsequat, vel illum dolore eu feugiat nulla facilisis at vero eros et accumsan et iusto odio dignissim qui blandit praesent luptatum zzril delenit augue duis dolore te feugait nulla facilisi. Nam liber tempor cum soluta nobis eleifend option congue nihil imperdiet doming id quod mazim placerat facer possim assum.

Lorem ipsum dolor sit amet conse ctetuer adipiscing elit, sed diam nonummy nibh euismod tincidunt ut laoreet dolore magna aliquam erat volutpat. Ut wisi enim Lorem ipsum dolor sit amet, consectetuer

COUNSEL

Ut wisi enim ad minim veniam, quis nostrud exerci tation ullamcorper suscipit lobortis nisl ut aliquip ex ea commodo consequat. Duis autem vel eum iriure dolor in hendrerit in vulputate velit esse molestie consequat, vel illum dolore eu feugiat nulla facilisis at vero eros et accum san et iusto odio dignissim qui blandit praesent luptatum zzril del enit augue duis dolore te feugait nulla facilisi. Lorem ipsum dolor sit amet, cons ectetuer adipiscing elit, sed diam non ummy nibh euismod incidunt ut laoreet dolore magna aliquam erat .

Ut wisi enim ad minim veniam quis t wisi enim ad minim veniam, quis nostrud exerci tation ullamcorper suscipit lobortis nisl ut aliquip ex ea commodo consequat.

Duis autem vel eum iriure dolor in hendrerit in vulputate velit esse molestie consequat, vel illum dolore eu feugiat nulla facilisis at vero eros et accum san et iusto odio dignissim qui blandit praesent

Luptatum zzril del enit augue duis dolore te feugait nulla facilisi. Lorem ipsum dolor sit amet, cons ectetuer adipiscing elit, sed diam non ummy nibh euismod tincidunt ut laoreet dolore magna aliquam erat .Utzzril del enit augue duis dolore te

Maime County jail to close

Lorem ipsum dolor sit amet, consectetuer aiscing elit, sed diam non ummy nibh euismod tincidunt ut laoreet dolore magna aliquam erat volutpat wisi enim ad minim veniam, quis nost rud exerci tation ullamcorper suscipit lobor tis nisl ut aliquip ex ea commodo consequat uis autem vel eum iriure dolor in hendrerit in vulputate velit esse molestie consequat, vel illum dolore eu feugiat nulla facilisis at vero eros et accumsan et iusto odio dignissim qui blandit praesent luptatum zzril delenit augue duis dolore te feugait nulla facilisi. Lorem ipsum dolor sit amet cons ectetuer adipiscing elit, sed diam

nonummy nibh euismod tincidunt ut laoreet dolore magna aliquam erat volutpat. Ut wisi enim ad minim veniam, quis nostrud exerci tation ullam corper suscipit lobortis nisl ut aliquip ex ea Cnsequat, vel illum dolore eu feugiat nulla facilisis at vero eros accumsan et iusto odio dignissim qui blandit praesent luptatum zzril delenit augue duis dolore te feugait nulla facilisi. Nam liber tempor cum oluta nobis eleifend option congue nihil imperdiet doming id quod mazim placerat facer possim assum. Lorem ipsum dolor sit amet, consectetuer adipiscing elit, sed diam nonummy nibh euismod tincidunt ut laoreet

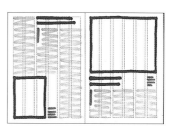

Equal space.

Ranged-left text that wraps around an inset graphic can look uncomfortable, as the uneven line endings on the left give more space than the strong vertical on the right. Be sure to manipulate the text to overcome this. If you use a DTP system, use a smaller margin on the left of the graphic so that the longer lines can come closer to it.

A 6pt rule, tinted black 60%, helps to separate articles.

Use elements of the layout in the above spreads to create variety.

CLIENT

wild plant society

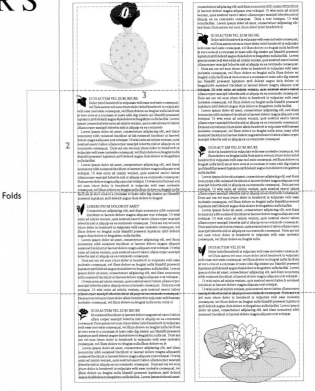

Folds

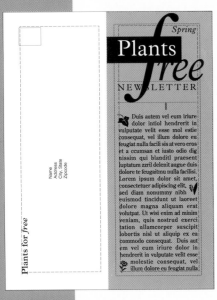

SPECIFICATION

Format
11 x 17 in or A3, self-mailing

Grid
2-column
Space between – 4p10

Margins
i 4p1 o 4p1
t 4p1 b 4p1

Fonts
Century Old Style
1 Intro text 16/19pt
2 Body text 10/12½pt
3 Subheads 10/12½pt

Detailed spec. for masthead on opposite page.

BRIEF Plants for Free is a society established to promote the harvesting of wild plants, herbs, and fungi for culinary, cosmetic, and, occasionally, medicinal purposes. Members pay a subscription, and the newsletter, which is published quarterly, is written in the form of a letter from the president to the society's members. Illustrations are also included. This rather unusual organization requires a distinctive design, but wants to avoid the old-fashioned look sometimes associated with publications of this type.

SOLUTION An 11 x 17 in Tabloid, four-page, self-mailing newsletter was chosen. The logo and the newsletter have been designed at the same time, which gives an opportunity to integrate the two. The two-color printing allows a different second color to be used for each issue – black/green or black/blue, for example. The complex arrangement of the masthead and logo is contained by a delicate, hairline ruled box. Twice folded to create four panels, the cover is read with horizontal orientation, while the inside spread and remaining two panels are turned through 90 degrees, and read vertically.

1 Butem vel eum iriure

2 Butem vel eum iriure do lor in
 hen dre rit in vulp utate velit

3 BUTEM VEL EUM IRIURE DO

62pt Plantin Light, very loose track.

The "*f*" must not be lighter than 20% or the "*n*" will not read white out.

The word *Plants* sits within a black (100%) panel, which breaks out of a ruled box border. To balance this, *Free* also breaks out on the other side.

280pt Plantin Light Italic.

Spring

Plants

for

free

NEWSLETTER

130pt Plantin Light Italic, loose track.

24pt Plantin Light caps are force justified to column width.

24pt Plantin Light, very loose track.

Duis autem vel eum iriure dolor intiol hendrerit in vulputate velit esse mol estie consequat, vel illum dolore eu feugiat nulla facili sis at vero eros et a ccumsan et iusto odio dig nissim qui blanditl praesent luptatum zzril delenit augue duis dolore te feugaitmu nulla facilisi. Lorem ipsum dolor sit amet, consectetuer adipiscing elit, sed diam nonummy nibh euismod tincidunt ut laoreet dolore magna aliquam erat volutpat. Ut wisi enim ad minim veniam, quis nostrud exerci tation ullamcorper suscipit lobortis nisl ut aliquip ex ea commodo consequat. Duis aut em vel eum iriure dolor in hendrerit in vulputate velit esse molestie consequat, vel illum dolore eu feugiat nulla

The text does not have a headline.

Name
Address
City, State
Zipcode

Whether it is printed as black tints or in a second color, the most important consideration here is the closeness in tonal value between the bleed background (black 40%) and the word *free* (black 20%). A ratio of 50/30% would also work and allow the black overprinted text still to read clearly.

Plants for *free*

The self-mailing newsletter will be folded twice for despatch, which restricts the front page to an elongated shape.

The elaborate masthead occupies about a third of the total area. When turned through 90 degrees, the inside

spread (opposite) will read vertically. The text blocks are enclosed by a ½pt ruled box, 1pt away from the page area.

The entire page is enclosed by a ½pt ruled box (black 100%) 1pt away from the page area.

CLIENT

cosmetic manufacturer

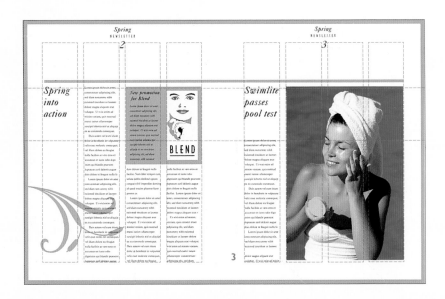

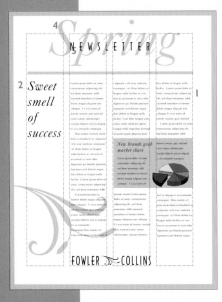

SPECIFICATIONS

Format
8½ x 11 in or A4

Grid
4-column
Space between – 1p5

Margins
i 3p7 o 5p6
t 3p7 b 5p6

Fonts
Caslon
Track loose
1 Body text 8/14pt

Caslon Italic
Track very loose
2 Headlines 36/42, 14/17pt.
3 Captions 8/14pt
4 Title 140pt

Arquitectura
Track force justified
5 Newsletter, logo 24pt

BRIEF Fowler & Collins is an upmarket cosmetic manufacturer. The company's image is one of freshness and health, with an emphasis on the naturalness of the ingredients. The newsletter is targeted at customers, department stores, drugstores, beauticians, and shops specializing in health and beauty products. The rigorously maintained corporate identity imposes constraints on the design of the newsletter, particularly the choice of typeface. The Caslon family must be used on all literature for both headlines and text.

SOLUTION A 12-page publication, saddle-stitched and self-covered, but using a high-quality silk finish coated stock of #101 is chosen. Printed in four colors throughout, it features a mix of color photography, charts and diagrams, and some illustrations. The use of the flower device, extracted from the logo, is sanctioned in the corporate identity manual. The company's marketing strategy features strongly seasonal campaigns, when new products and promotions are launched. The masthead design is intended to suggest this consideration.

2 *Abc*

1 Butem vel eum iriure do lor in hen dre rit in vulp utate velit

3 *Butem vel eum iriure do lor in*

The 8pt rule, prints 40% yellow, 30% cyan, and provides a strong hangline for the text and a visual boundary for the masthead. Try recreating this layout without this rule, and you will see that the design is much weaker.

The strongly seasonal nature of this quarterly newsletter allows for unusual treatment of the masthead. The large (140pt) Caslon Italic *Spring* prints 40% yellow, 30% cyan, and is set very loose track. *Newsletter* mimics the logo specification, and the face – Arquitectura – is force justified to the two-column width.

Headlines are set in 36/42pt Caslon Italic, upper and lower case, a face with a greater degree of backslant than most italics, and with very loose track.

The flower device, extracted from the logo, prints 40% yellow, 30% cyan. The text overprints it.

White space is an important element in any design – a difficult concept for the inexperienced designer to grasp. The wide margins, the first column left empty except for the headline, the choice and size of type, plus the border, all help to contribute to a clean, light feel, appropriate for a newsletter published by a cosmetic manufacturer.

The left, right, left axis of the headline, boxed copy and flower device, although arranged asymmetrically, makes for a balanced page.

Charts can be made more interesting by using the 3-D techniques available from graphics packages, or by being drawn as line artwork.

The text is a well leaded 8/14pt Caslon Italic, ranged left.

Spring

NEWSLETTER

Sweet smell of success

Lorem ipsum dolor sit amet, consectetuer adipiscing elit, sed diam nonummy nibh euismod tincidunt ut laoreet dolore magna aliquam erat volutpat. Ut wisi enim ad minim veniam, quis nostrud exerci tation ullamcorper suscipit lobortis nisl ut aliquip ex ea commodo consequat.

Duis autem vel eum iriure dolor in hendrerit in vulputate velit esse molestie consequat, vel illum dolore eu feugiat nulla facilisis at vero eros et accumsan et iusto odio dignissim qui blandit praesent luptatum zzril delenit augue duis dolore te feugiat nulla facilisi. Lorem ipsum dolor sit amet, consectetuer adipiscing elit, sed diam nonummy nibh

Euismod tincidunt ut laoreet dolore magna aliquam erat volutpat. Ut wisi enim ad minim veniam, quis nostrud exerci tation ullamcorper suscipit lobortis nisl ut aliquip ex ea commodo consequat.Duis autem vel eum iriure dolor in hendrerit in

vulputate velit esse molestie consequat, vel illum dolore eu feugiat nulla facilisis at vero eros et accumsan et iusto odio dignissim qui blandit praesent luptatum zzril delenit augue duis dolore te feugiat nulla facilisi. Nam liber tempor cum soluta nobis eleifend option congue nihil imperdiet doming id quod mazim placerat facer

New brands grab market share

Lorem ipsum dolor sit amet, consectetuer adipiscing elit, sed diam nonummy nibh euismod tincidunt ut laoreet dolore magna aliquam erat volutpat. Ut wisi enim ad

possim assum.Lorem ipsum dolor sit amet, consectetuer adipiscing elit, sed diam nonummy nibh euismod tincidunt ut laoreet dolore magna aliquam erat volutpat. Ut wisi enim ad minim veniam, quis nostrud exerci tation ullamcorper suscipit lobortis

duis dolore te feugiat nulla facilisi. Lorem ipsum dolor sit amet, consectetuer adipiscing elit, sed diam nonummy nibh euismod tincidunt ut laoreet dolore magna aliquam erat volutpat.Ut wisi enim ad minim veniam, quis nostrud

Lorem ipsum dolor sit amet, consectetuer adipiscing elit sed diam nonummy nibh

minim veniam, quis nostrud exerci tation ullamcorper suscipit lobortis nisl ut aliquip ex ea commodo consequat.

nisl ut aliquip ex ea commodo consequat. Duis autem vel eum iriure dolor in hendrerit in vulputate velit esse molestie consequat, vel illum dolore eu feugiat nulla facilisis at vero eros et accumsan et iusto odio dignissim qui blandit praesent luptatum zzril delenit augue

FOWLER ✣ COLLINS

An effective layout relies on the harmonious juxtaposition of the elements. The masthead at the top and the logo at the bottom are both centered on the page width. The rest of the page is arranged asymmetrically. Achieving this look requires practice.

The border prints 40% yellow, 30% cyan, it bleeds off, and because it is narrow, 1p2, requires accurate printing, folding and trimming. A wider border would be safer, but less elegant.

Grids are a useful device for maintaining consistency of layout, particularly in longer, more complex documents. However, they should not stifle creativity. They must always be the slave and not the master.

The repeat title and large folios create visual interest. The same combination of faces that was used for the masthead provides an elegant header to the page. There is no standard formula for achieving an aesthetically pleasing arrange- ment of the three lines – you will need to experiment with the leading until you are happy with the result.

The design employs the strong hang- line adopted on the first page. This is in the form of an 8pt rule which prints 40% yellow, 30% cyan, and crosses the gutter to the full double page width. The large strip of white space above is left deliberately blank, except for the repeat title and the folios.

Spring
NEWSLETTER
2

Spring into action

Lorem ipsum dolor sit amet, consectetuer adipiscing elit, sed diam nonummy nibh euismod tincidunt ut laoreet dolore magna aliquam erat volutpat. Ut wisi enim ad minim veniam, quis nostrud exerci tation ullamcorper suscipit lobortis nisl ut aliquip ex ea commodo consequat.

Duis autem vel eum iriure dolor in hendrerit in vulputate velit esse molestie consequat, vel illum dolore eu feugiat nulla facilisis at vero eros et accumsan et iusto odio dign issim qui blandit praesent luptatum zzril delenit augue duis dolore te feugait nulla fa

Lorem ipsum dolor sit ame cons ectetuer adipiscing elit, sed diam non ummy nibh euismod tincidunt ut laoreet dolore magna aliquam erat volutpat. Ut wisi enim ad minim veniam, quis nostrud exerci tation ullamcorper suscipit lobortis nisl ut aliquip ex ea commodo consequat.

Duis autem vel eum iriure dolor in hendrerit in vulputate velit esse moles tie consequat, vel illum dolore eu feugiat nulla facilisis at vero eros et accumsan et iusto odio dignissim qui blandit praesent luptatum zzril delenit augue

New promotion for Blend

Lorem ipsum dolor sit amet, consectetuer adipiscing elit, sed diam nonummy nibh euismod tincidunt ut laoreet dolore magna aliquam erat volutpat. Ut wisi enim ad minim veniam, quis nostrud exerci tation ullamcorper suscipit lobortis nisl ut aliquip ex ea onsectetuer adipiscing elit, sed diam nonummy nibh euismod

duis dolore te feugait nulla facilisi. Nam liber tempor cum soluta nobis eleifend option congue nihil imperdiet doming id quod mazim placerat facer possim as

Lorem ipsum dolor sit ame consectetuer adipiscing elit, sed diam nonummy nibh euismod tincidunt ut laoreet dolore magna aliquam erat volutpat. Ut wisi enim ad minim veniam, quis nostrud exerci tation ullamcorper suscipit lobortis nisl ut aliquip ex ea commodo consequat. Duis autem vel eum iriure dolor in hendrerit in vulputate velit esse molestie consequat, vel illum dolore eu feugiat

nulla facilisis at vero eros et accumsan et iusto odio dignissim qui blandit praesent luptatum zzril delenit augue duis dolore te feugait nulla facilisi. Lorem ipsum dolor sit amet, consectetuer adipiscing elit, sed diam nonummy nibh euismod tincidunt ut laoreet dolore magna aliquam erat v

Ut wisi enim ad minim veniam, quis consect etuer adipiscing elit, sed diam nonummy nibh euismod tincidunt ut laoreet dolore magna aliquam erat volutpat. wisi enim ad minim veniam, quis nostrud exerci tation ullamcorper consectetuer adipiscing elit, sed diam

The demands of the designer and the writer some- times conflict. Here, the narrow column imposes a limitation on the length of words in the headline. In this instance, it is desirable to write headlines with short, punchy words, but there may be circum- stances when this is not the case and a different design solution will have to be found.

The tint boxes print 40% yellow, 30% cyan, are of variable length, and can be used to highlight themes within the main text. In more complex publica- tions, boxes can be used simply to break up the page and provide visual interest.

Headlines always
start at the top of
the column, never
halfway down.

From trim +2p7

From trim +4p4

From trim +6p11

Spring
NEWSLETTER
3

Swimlite passes pool test

Lorem ipsum dolor sit amet, consectetuer adipiscing elit, sed diam nonummy nibh euismod tincidunt ut laoreet dolore magna aliquam erat volutpat. Ut wisi enim ad minim veniam, quis nostrud exerci tation ullamcorper suscipit lobortis nisl ut aliquip ex ea commodo consequat.

Duis autem vel eum iriure dolor in hendrerit in vulputate velit esse molestie consequat, vel illum dolore eu feugiat nulla facilisis at vero eros et accumsan et iusto odio dign issim qui blandit praesent luptatum zzril delenit augue duis dolore te feugait nulla fa

Lorem ipsum dolor sit ame cons ectetuer adipiscing elit, sed diam non ummy nibh euismod tincidunt ut laoreet

dolore magna aliquam erat volutpat. Ut wisi enim ad minim

A secondary hangline is used to position the beginning of the text beneath a headline, and to position elements such as the box on the first page.
In a longer publication, a device like this helps to give a uniform look.

Captions are italic, the same type spec as box text, and should be no more than three lines long. The design is kept intentionally simple, and a larger range of typefaces is undesirable.

The color photograph is quite dominant in this uncluttered layout. The right-hand page usually has more impact than the left, and so heavier, larger objects are often put on this page.

The strong hangline provides a unifying element, particularly for longer newsletters.

CLIENT

cleaning company

SPECIFICATIONS

Format
8.5 x 11 in or A4

Grid
8-column
Space between – 1p2

Margins
i 4p1 o 4p1
t 4p1 b 4p7

Fonts
Times Roman
Track normal
1 Body text 9/11pt

Times Roman (80% cond.)
Track force justify
2 Title 60pt

Times Italic
Track normal
3 Box text, captions 9/11pt
4 Message panel subhead 11pt

Plantin Bold Condensed
Track normal
5 Headlines 41/44, 19/23pt.

Helvetica Black Condensed (80% cond.)
Track loose
6 Title 120pt
7 Message panel head 14/17pt
8 Folios 8pt

Abc

5

1 Butem vel eum iriure do lor in
e rit in vulp utate velit

3 *Butem vel eum iriure do lor in*

BRIEF Neilson, which is a major national cleaning company, publishes a bimonthly, eight-page newsletter to communicate with its employees and customers. Although large, it is still a family-run enterprise, with Jim Neilson at its head, a man with a hands-on approach to business. A down-to-earth publication was required, with the flexibility to incorporate articles of varying length and emphasis, and to display photographs at a wide variety of sizes.

SOLUTION A standard format, saddle-stitched, self-covered, and using a #91 mat-coated stock, was selected. An eight-column grid allows a wide variety of picture sizes, and for flexibility in the width of headlines. The layout echoes a popular newspaper in style. The chunky Plantin Bold Condensed headline face, combined with 6pt rules and frequent boxed articles, make for busy, easy-to-read pages. The text is set in Times Roman, a classic newspaper face, with italic used for introductions, boxes, and captions. The masthead, a red panel with *Clean* white-out, is set in Helvetica Black Condensed, and the word *Times* is set, appropriately enough, in Times Roman.

JANUARY TO FEBRUARY 2001 VOLUME 5

Christmas clear-up is a great success

A big thank you to all staff from Jim Neilson

Prizes to be won see page 9

NEILSON - STILL No1 IN CLEANING

NEILSON WINS SECOND MAJOR GOVERNMENT RBT CONTRACT

Lorem ipsum dolor sit amet, consectetuer adipiscing elit, sed diam nonummy nibh euismod tincidunt ut laoreet dolore magna aliquam erat volutpat wisi eni

Lorem ipsum dolor sit amet, consectetuer adipiscing elit sed diam nonummy nibh euismod

Lorem ipsum dolor sit amet, cons ectetur adipiscing elit, sed diam nonummy nibh eu ismod tincidunt ut laore et dolore magna aliquam erat vol utpat. Ut wisi enim ad minim veniam, quis nostrud exerci tation ullamcorper sus cipit lobortis nisl ut aliquip ex ea commodo consequat. Duis au tem vel eum iriure dolor inopu heopl ndrerit in vulputate velit esse molestie consequat, vel illum dolore feugiat nulla facilisis at vero

eros et accumsan et iusto odio pudignissim qui blandit praedory sent luptatum zzril delenit au gue duis dolore te feugait nulla facilisi. Lorem ipsum dolor sit amet, conmo sectetuer ad ipiscing elit, sed diam non ummy nibh euism odilot tincid unt ut laoreet dolore magna etuol aliq uam ermat volutom opat. Ut wisi en im ad minim veniam, quis nostrud exerci tation isento ullam corper suscipit lobortis nisl ut aliquip ex ea com

modo con sequat. Duis aute vel eum iriure dolor in hend rerit in vulputate velit esse molestie consequat, vel illum dolore drueu feugiat nulla facilisis at veroes eros et accumsan et iusto plitodio di gnissim qui praesat ert blan dit praesent luptatum zzril dele nit augue duis dolore te feugait nulla tefacilisut Nam

FIVE NEW DEPOTS TO COME ON-STREAM DURING 2001

Lorem ipsum dolor sit amet, consectetuer adipiscing elit, sed diam nonummy nibh eu ismod tincidunt ut laoreet dolore magna aliquam erat volutpat. Ut wisi enim ad minim veniam, quis nostrud exerci tation ulla mcorper suscipit lob ortis nisl ut aliquip ex ea commodo consequat. Duis autem vel eum iriure dolor in

NEW LOOK FOR NEILSON WINS APPROVAL FROM OUR CUSTOMERS...

Lorem ipsum dolor sit amet, cons ectetur adipiscing elit, sed diam nonummy nibh eu ismod tincidunt ut laore et dolore magna aliquam erat

...BUT WHAT DO YOU THINK?

1

CLIENT

cult rock band

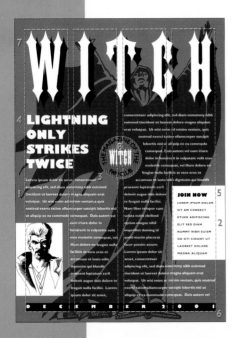

ABC

4

I Butem vel eum iriure do lor in

hen dre rit in vulp utate velit

2 BUTEM VEL EUM IRIURE DO LOR IN

SPECIFICATIONS

Format
8½ x 11 in or A4

Grid
4-column
Space between – 1p2

Margins
i 2p5 o 2p5
t 2p5 b 2p5

Fonts
Gill Sans Bold
Track loose
I Body text 10/20pt
2 Captions, box text 8/20pt
3 Badge surround 14pt

Gill Ultra Bold
Track loose
4 Headlines 34/41, 14/20pt
5 Box head 14/20pt
Force justified
6 Date panel 12pt

Ironwood
Track force justified
7 Title 200pt
8 Badge title 50pt (70% cond.)

BRIEF Witch, a cult rock band with a dramatic stage persona and a large following of devoted fans, has commissioned a newsletter for its fan club. The purpose is to keep fans informed about gigs, tour plans and record releases, and to sell Witch merchandise. Like many rock musicians, band members take a keen interest in all aspects of design (two of the group have been to art school). There must be a large bleed photograph of the band, and allowance has to be made for occasional advertisements, but otherwise the brief is very open.

SOLUTION An eight-page, fold-out poster format is selected, the whole of one side being the photograph of the band. The remaining four pages comprise the newsletter. When information in these four pages is no longer required, the unfolded newsletter can be used as a poster and pinned to the fan's wall. The layout needs to be very dramatic. The poster side will be printed in four process colors; the other side will be printed black plus three spot colors. This gives tremendous scope for the creation of unusual design effects and the use of illustrations.

The masthead is the band's logo, set in Ironwood 200pt, force justified and white out. The drop shadow is a duplicate, black 100% and offset.

The double-page spread opposite demonstrates how to create a dramatic layout while maintaining the theme. The left page is a lighter color so both over-printed and reversed-out text are legible. On the darker right page only white type will be legible.

The badge device uses the *Witch* logo, condensed to 70%, a liberty that would not be tolerated if it were the logo of a corporation. The remaining copy is set in Gill Sans Bold inside a circle with a 8p7 diameter. The badge diameter is 9p10 and prints black tinted 50%.

The headline is set in Gill Sans Ultra Bold white out, and makes a shape, of one long line and three shorter ones, that allows the badge device to fit into the center of the page.

The Witch illustration prints deep purple on a background of red. These colors need to be close in tonal value. If they were not, the contrast between them would be so great that the white-out text would be very difficult to read. The readership of a fanzine will be more tolerant of avant garde graphics at the expense of legibility, and the designer's aim should be to reach an acceptable compromise between the two.

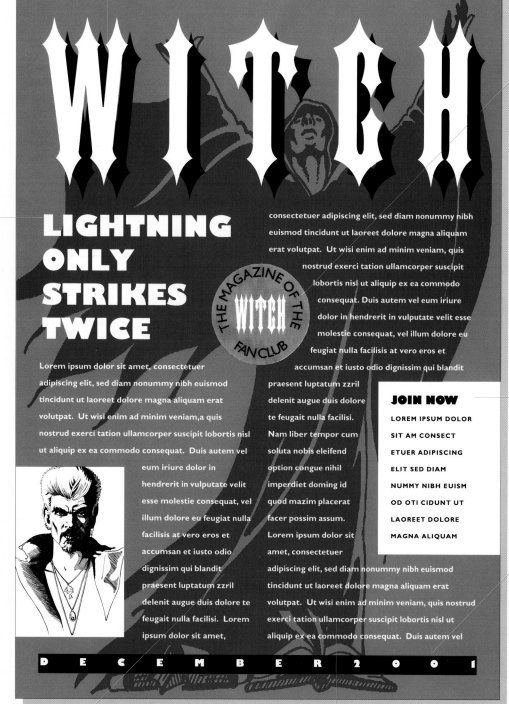

A white panel encloses the club membership details. The heading is set in Gill Ultra Bold, 14/20pt. The text is 8/20pt Gill Sans Bold all caps.

The date panel is black 100%. The illustration over-prints it, creating an interesting effect. White-out type, set in Gill Ultra Bold 12pt, is force justified to the full width of the panel.

This poster folds twice from a single sheet to form the newsletter.

A four-column grid underlies the broad, two-column text blocks, allowing photos, text panels, and graphics to be dropped in without the text run-arounds being set to a very narrow measure.

Text is set 10/20pt Gill Sans Bold. This extreme leading enables the pictorial background to show through between lines. The face must be very bold to ensure good legibility.

Searching for Solutions—
Not Band-Aids

Right: Strong colors and an uncluttered design were chosen for the covers for the newsletter of a rail distribution company. The black drop-shadow for the masthead is particularly important against the yellow selected for the background. The first four inside pages (below) use a combination of a bold sanserif face and a light serif face; these, together with the vertical panel and bold, dotted column rules, give a "newsy" feel to the pages. The page numbers in the outside margins are an integral part of the design.

Above: Typographical devices are sometimes more appropriate than pictures. This newsletter for a health management network has two levels of crosshead – one in bold, the other in italics – a quote, taken from the text and set in a large, sanserif face between two thick rules; and a large drop capital at the beginning of the introduction, which has been set in italics.

Managers back rail freight

Director Europe

Getting the message across

Eurotermina

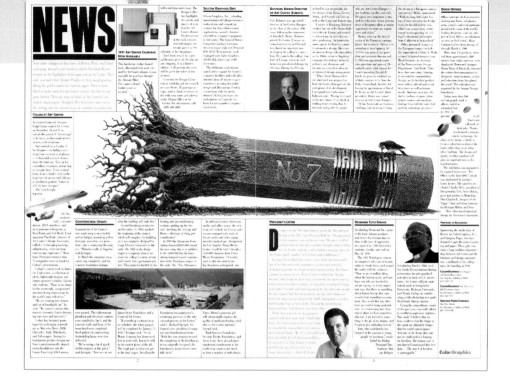

Above & right: The large format chosen by the art college has been exploited and emphasized by positioning the masthead at the top and placing a large, square picture at the foot. These two main elements separate a narrow strip containing a contents "teaser." Cut-out pictures, with the captions tucked into the available space, combine with the extremes of scale to create a dynamic layout. The theme is continued on the inside pages. The news headline echoes the masthead, and cut-out pictures break into the text columns. The pages are contained by a fine ruled box and column rules, which butt to it. In a smaller format this kind of approach could look oppressive, but here, combined with the elegant typeface Bodoni and the small, bold subheads, set in Futura, it creates an overall impression of balance and harmony.

Below: The style of a newsletter must reflect the purpose for which it is intended and the audience at whom it is aimed. A photographer who wishes to promote his work is naturally going to want his photographs reproduced as large as possible, and although white space is normally more often seen in brochures than in newsletters, here it is used to dramatic effect.

Above: Beginning two articles on the first page so that both continue on subsequent pages is more effective than having one long article, which could look too dense and uninviting. The basic four-column grid allows the headlines to be set over two columns.

Below: The mast-head of this news-letter bleeds off the top. It is balanced by the large dateline near the foot of the page. The layout of the area between varies: illustrations are used when they are available, otherwise a typographical solution is adopted.

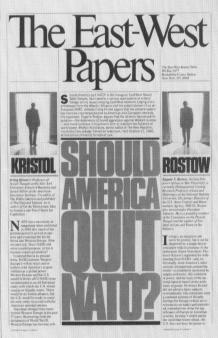

Above and right: The loose insertion of a single page into a folded sheet results in an unconventional six-page newsletter, with two double-page spreads and a front and back cover. The editorial matter is a transcript of a debate between two academics, and the adversarial nature of the text is carried through in the layout of the cover and inside spread. The masthead is set in Times Roman, spaced so tightly that some of the characters touch and others even overlap.

Right and below: The vertical masthead and illustrated contents trailer are eye-catching elements of this staff newsletter produced for the BBC (British Broadcasting Corporation). The articles range from news to features, and the title is repeated, in a tinted form, on every page as a unifying device. The center spread has been used for a main feature, and the headline and picture run across the gutter. This is possible because this is a natural spread – in other words a single sheet with no break – so there is no risk of misalignment of print across the gutter; this is a potential problem with this publication, whose pages are not bound.

Below and far right: Eloquent or provocative quotations can make typographical covers especially powerful. This layout is enhanced by the bold design of the masthead and the use of small inset pictures. The double-page spread listing the main activities of the charitable organization on whose behalf the newsletter is produced makes good use of rather indifferent visual material, and the layout is, in fact, stronger than the sum of its parts.

Global ambitions

World Service Television celebrates its first year of broadcasting next week. Its news and information channel is now within reach of potentially 85 per cent of the world's population. Chief executive Chris Irwin told Claire Dresser how WSTV aims to cover the rest of the globe

'The rapid development of the company's activities internationally should strengthen the BBC as a whole'

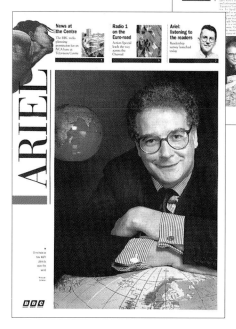

News at the Centre

Radio 1 on the Euro-road

Ariel: listening to the readers

UPDATE
ICCCR

SPECIAL ISSUE

International Council For Coordinating Cancer Research Publication

NUMBER FOUR
January/February 2001

"As scientists, we must conduct our research in the most effective manner. Crossing national boundaries and conducting targeted collaborative studies is one important way to reduce the pain and suffering from cancers." SAMUEL BRODER, M.D. Director of the National Cancer Institute

"I have always understood the importance of prevention and my life has been dedicated to effectively translating our research knowledge into saving lives." JACQUES CROZEMARIE Chairman & Founder of ICCCR and President of ARC (French Association for Research on Cancer)

"We talk all the time about the importance of communicating. Well, communication can either be education or gossip. Far too often, the information we hear about our health is nothing more than gossip. It's time to be better informed about prevention." C. EVERETT KOOP, M.D. Former U.S. Surgeon General

ICCCR's activitie

research

prevention

communication

PRIVATE HOSPITAL

EMPLOYMENT AGENCY

JAPANESE RESTAURANT

LUMBER YARD

INSURANCE BROKER

MEDIUM-SIZED COLLEGE

HORSEBACK RIDING SCHOOL

TRAVEL COMPANY

INVESTMENT SERVICES

Lorem ipsum dolor
sit amet consect
etuer adipiscing eli
sed diam nonumm
nibh euismod
tincidunt ut
dolore m
aliqu

BROCHURES

3

CHAPTER

praesent luptatum zzril delenit augue duis dolore
te feugait nulla facilisi. Nam liber tempor cum
soluta nobis eleifend option congue nihil
imperdiet doming id quod
mazim placerat facer
possim iriure dolor assum.
Lorem ipsum dolor sit
amet, consectetuer
adipiscing elit, sed diam
nonummy nibh euismod
tincidunt ut laoreet dolore
magna aliquam erat
volutpat.
 Ut wisi enim ad minim
veniam, quis nostrud exerci

consectetuer adipiscing elit, sed diam
nonummy nibh euismod tincidunt ut
laoreet dolore magna aliquam erat
volutpat. Ut wisi enim ad minim
veniam, quis nostrud exerci tation
ullamcorper suscipit lobortis nisl ut
aliquip ex ea commodo consequat.
tincidunt ut Duis autem vel eum iriure
dolor in hendrerit in vulputate velit esse
molestie consequat, vel illum dolore eu feugiat

SHAND DAVY

Service is our best policy

Brochures are published in a wide variety of shapes and sizes, although many clients prefer 8½ x 11in (A4) and 6 x 9in (A5) because these formats are easy to mail, convenient to file, fit standard-size envelopes, and do not waste paper as some non-standard formats may do. With one exception, all the examples created in this section derive from the above formats, but this does not limit the variety or effectiveness of the layouts. However, if you can justify the use of a custom size to your client, check with your printer to make sure that it is practical.

The choice of paper (stock) is always an important factor in creating the right impression, and this is particularly so with brochures. Considerations such as folding and binding will influence the layout, while grids play an important part in establishing a framework, although they should never be applied in way that stifles variety in the layouts, particularly in longer documents.

The examples on the following pages demonstrate that every publication needs to be designed to fulfill the individual needs of the brief. You may, however, be able to utilize some of these layouts for a variety of other purposes.

The basic level introduces the 6 x 9in and 8½ x 11in formats, and the first example uses a combination of centered heads and justified text. Ranged-left heads and text are introduced in the second example, while the third highlights the layout implications of using a single sheet, horizontal format, folded into three panels.

The intermediate level considers the opportunities offered by longer publications as well as looking at an alternative approach to the single sheet, two-fold format.

The advanced level includes a horizontal 8½ x 11in format, which gives a very wide and shallow double-page spread. Another example uses a double-depth 8½ x 11in vertical format, with an accordion pleat producing six panels, while the only non-standard size, a square 8⅝ x 8⅝ format, is used for individual sheets that are to be inserted into a slipcase.

In the newsletter section it was assumed that most of the pictorial material already existed, but in this section the assumption is that photographs or illustrations will be commissioned to fit the requirements of the layouts. When new illustrative material is to be used, it is generally more efficient to prepare a rough layout to which the illustrator or photographer can work rather than simply to commission from a list, which may result in gaps in the layout or unwanted overmatter.

Brochures offer an infinite range of layout opportunities, only few of which can be shown here. For some publications it may be desirable to retain a rigid design in which all the text elements retain a fixed position—compare, for example, the design on pages 60-63 with the approach adopted on pages 70-71, in which the design has some consistent elements but each spread develops the design theme in a different way.

Most of the brochures on the following pages are reproduced at 63% of the actual size. A sample of the headings and text is shown actual size on the left-hand page, together with a mini-version of the brochure with the grid overlaid in blue.

basic
BROCHURES

CLIENT

private hospital

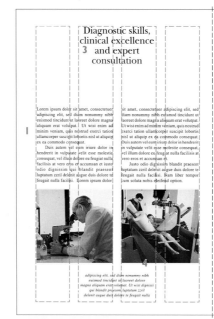

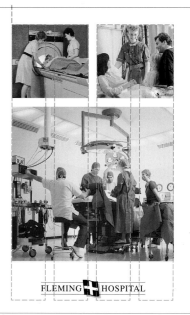

Diagnostic skills, clinical excellence **3** and expert consultation

Lorem ipsum dolor sit amet, consectetuer adipiscing elit, sed diam nonummy nibh euismod tincidunt ut laoreet dolore magna aliquam erat volutpat. Ut wisi enim ad minim veniam, quis nostrud exerci tation ullamcorper suscipit lobortis nisl ut aliquip ex ea commodo consequat.

Duis autem vel eum iriure dolor in hendrerit in vulputate velit esse molestie consequat, vel illum dolore eu feugiat nulla facilisis at vero eros et accumsan et iusto odio dignissim qui blandit praesent luptatum zzril delenit augue duis dolore te feugait nulla facilisi. Lorem ipsum dolor

sit amet, consectetuer adipiscing elit, sed diam nonummy nibh euismod tincidunt ut laoreet dolore magna aliquam erat volutpat. Ut wisi enim ad minim veniam, quis nostrud exerci tation ullamcorper suscipit lobortis nisl ut aliquip ex ea commodo consequat. Duis autem vel eum iriure dolor in hendrerit in vulputate velit esse molestie consequat, vel illum dolore eu feugiat nulla facilisis at vero eros et accumsan et.

Justo odio dignissim blandit praesent luptatum zzril delenit aigue duis dolore te feugait nulla facilsi. Nam liber tempor cum soluta nobis eleifend option.

adipiscing elit, sed diam nonummy nibh euismod tincidunt ut laoreet dolore magna aliquam erat volutpat. Ut wisi dignissi qui blandit praesent luptatum zzril delenit augue duis dolore te feugait nulla

FLEMING HOSPITAL

The first spread.

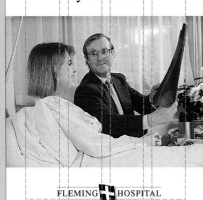

2 Care when you need it. Confidence when you don't.

FLEMING HOSPITAL

2 Abc

I Butem vel eum iriure do lor in hen dre rit in vulp utate velit esse illum

SPECIFICATIONS

Format
6 x 9in or A5
16 pages, saddle-stitched

Grid
4-column
Space between – 1p6

Margins*
i 2p5 o 4p1
t 2p11 b 2p11

Fonts
Times Roman
Track loose
Logo
18pt
I Body text 9/11pt
2 Title 36/36pt
3 Subhead 20/20pt

Times Roman italic
Track loose
4 Captions 8/10pt

* All margins on cover are 2p10

BRIEF Fleming Hospital offers general health care. It has commissioned a new brochure from the in-house design group in order to sell its services more effectively. Research has shown that customers acknowledge that they enjoy first-rate facilities but are somewhat dissatisfied with the way sometimes complex medical issues are explained to them by clinical staff. The new publication must address this concern as well as promoting health education and the hospital's primary services.

SOLUTION A 16-page, self-covered 6 x 9in / A5 brochure, using #118, mat-coated stock printed full-color throughout has been selected. The type face is Times Roman, which works well for both headlines and text. The layout is simple, using clear, uncluttered, centered headlines and a four-column grid with fairly wide margins. The headlines always occupy the top of the left-hand page. The design style is reassuringly conservative, with commissioned photography that portrays the hospital as a caring, though hi-tech organization. Each double-page spread deals with a different aspect of the hospital's services.

The design utilizes a grid that divides each spread horizontally into three equal units, one above the hangline and two below it, plus a smaller unit at the foot in which sit the caption and the logo.

A centered headline sets up the theme of the first spread. Each subsequent spread is self-contained and deals with a different aspect of the hospital's services.

The inside margins on the double-page spreads should be smaller than the outer ones because the two inner margins are

adjacent. On the front cover, the margins should be equal, otherwise the head and logo would be uncomfortably off-center.

Because the brochure is self-covered (the cover stock is the same as the text pages), it is appropriate for the first spread to start on the inside front cover. If the cover were printed on a different stock

– a colored board, for example – the inside cover might not be available, so the first page would be the single right-hand page.

Diagnostic skills, clinical excellence and expert consultation

Lorem ipsum dolor sit amet, consectetuer adipiscing elit, sed diam nonummy nibh euismod tincidunt ut laoreet dolore magna aliquam erat volutpat. Ut wisi enim ad minim veniam, quis nostrud exerci tation ullamcorper suscipit lobortis nisl ut aliquip ex ea commodo consequat.

Duis autem vel eum iriure dolor in hendrerit in vulputate velit esse molestie consequat, vel illum dolore eu feugiat nulla facilisis at vero eros et accumsan et iusto odio dignissim qui blandit praesent luptatum zzril delenit augue duis dolore te feugait nulla facilisi. Lorem ipsum dolor

sit amet, consectetuer adipiscing elit, sed diam nonummy nibh euismod tincidunt ut laoreet dolore magna aliquam erat volutpat. Ut wisi enim ad minim veniam, quis nostrud exerci tation ullamcorper suscipit lobortis nisl ut aliquip ex ea commodo consequat. Duis autem vel eum iriure dolor in hendrerit in vulputate velit esse molestie consequat, vel illum dolore eu feugiat nulla facilisis at vero eros et accumsan et.

Justo odio dignissim blandit praesent luptatum zzril delenit augue duis dolore te feugait nulla facilisi. Nam liber tempor cum soluta nobis eleifend option.

adipiscing elit, sed diam nonummy nibh euismod tincidunt ut laoreet dolore magna aliquam erat volutpat. Ut wisi dignissi qui blandit praesent luptatum zzril delenit augue duis dolore te feugait nulla

FLEMING ✚ HOSPITAL

The layout theme (see opposite) is established by positioning the large cover photograph on a hangline. This line forms an essential skeleton for the rest of the publication. The photograph bleeds at both left and right, and this defines the areas of

space above and below it. The centered headline and logo become powerful elements within these spaces.

The photographs and body text are constrained in rather tight blocks, so the irregular, centered head and caption provide a visual contrast.

The logo is set in 18pt Times Roman with ½pt rules positioned 6 points above and below. The lower rule overprints the tinted drop-shadow. The logo is repeated in the same position on every right-hand page.

The flag device can be created as line artwork, or by using the envelope and perspective functions of a graphics program to distort the image.

Though the page depth of 6 x 9in is 82% of the depth of 8½ x 11, in the page area is 58%.

CLIENT

employment agency

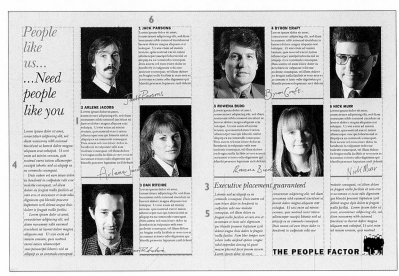

The first spread.

SPECIFICATIONS

Format
8½ x 11in or A4
12 pages, saddle-stitched

Grid
3-column
Space between – 1p10

Margins*
i 2p11 o 4p4
t 4p4 b 4p4

Fonts
New Baskerville
Track loose
1 Body text 9½/12pt

New Baskerville italic
Track loose
2 Headlines 47/47pt
3 Headlines 24pt
4 Introduction 12/15pt
5 Boxed text 11/14pt

Franklin Gothic Heavy
Track loose
Logo 12pt
6 Subhead 12/12pt

* Inner and outer
margins are transposed
on the cover

2 *Abc*

1 Butem vel eum iriure do lor in hen
dre rit in vulp utate velit esse illum

BRIEF The People Factor is an executive recruitment consultancy. Its clients are seeking career advancement or are graduates at the start of their careers. In a highly competitive industry, The People Factor wants to emphasize the importance of fitting the person to the job. This requires an in-depth understanding of each client's objectives. Although press advertising is used, a brochure is considered necessary to help implement this strategy. The budget is modest, so resources must be allocated carefully between design, photography, repro, and printing costs.

SOLUTION A 12-page, 8½ x 11in / A4 brochure has been chosen, using a gloss-coated stock, #101 for text and #74 for cover, the latter being laminated on the outside only. The first spread, starting inside the front cover, features a headline that is a continuation from the cover. Carefully selected mini case-studies of past clients, with commissioned photographs, have been used to reinforce the "people-like-you" theme and to provide a testimonial. The cover prints full-color, but the inside is in black only. The photography is expensive, and has been offset against the cheaper single color printing inside.

The brochure uses a three-column grid, with the entire page depth divided into three units. The six photographs used in full-color on the cover are repeated on the first inside spread, although they are cropped differently and are printed in black and white.

The designer also discussed with the client the style of the photographs – for example, the lighting, the background, whether they should be portrait-style, whether the subjects should be seated or standing, and also such details as whether the subjects should wear their own or rented clothes. A sample shot will be taken using a stand-in – the photographer's assistant or the designer perhaps – and the client's approval gained before the real shoot begins.

Because the outer column is empty except for the headline and logo, the retention of the wider outer margin would have resulted in too wide a space here, so the inner and outer margins have been transposed on the cover.

People like you need...

THE PEOPLE FACTOR

The client approved a rough of the layout before the photographs were taken so that the photographer shot to the correct picture proportions.

The careful preparation has resulted in a series of powerful shots using strong side lighting, with the background being allowed to fade out to black. All the subjects are seated, which gives a formal but relaxed impression, reinforcing the headline "People like you."

The cover headline uses three ellipses (full points) to suggest continuation overleaf. The completed headline stresses the interdependent relationship between client and consultant.

A 50% black tinted, bleed background extends over the front cover. This is dark enough to allow the title to be dropped-out white but lighter than the very dark backgrounds of the photographs.

The People Factor logo is formed from the name set in 12pt Franklin Gothic Heavy, loose track, combined with a line art illustration.

In the left-hand column of the first spread the headline theme is picked up from the cover and set in 47/47pt New Baskerville Italic. Note the continuation of ellipses from the cover.

The introductory text sets up the case history theme, and is set New Baskerville Italic 12/15pt. To obtain a consistent typographical style, it is important to retain the same relationship between type size and leading – 12/15pt equates to 125% leading. The case history captions are set in 9½/12pt New Baskerville Roman, which is 126% leading. If you use a DTP package you may be able to specify a default leading for a publication so it will always be 125%, regardless of size. If this is not available, multiply the type size by the % required – e.g., 11pt x 125% = 13.75pt leading (roundup or down if ¼pt leading is not available).

People like us...

...Need people like you

Lorem ipsum dolor sit amet, consectetuer adipiscing elit, sed diam nonummy nibh euismod tincidunt ut laoreet dolore magna aliquam erat volutpat. Ut wisi enim ad minim veniam, quis nostrud exerci tation ullamcorper suscipit lobortis nisl ut aliquip ex ea commodo consequat.

Duis autem vel eum iriure dolor in hendrerit in vulputate velit esse molestie consequat, vel illum dolore eu feugiat nulla facilisis at vero eros et accumsan et iusto odio dignissim qui blandit praesent luptatum zzril delenit augue duis dolore te feugait nulla facilisi.

Lorem ipsum dolor sit amet, consectetuer adipiscing elit, sed diam nonummy nibh euismod tincidunt ut laoreet dolore magna aliquam erat Ut wisi enim ad minim veniam, quis nostrud exerci tation ullamcorper suscipitsuscipit lobortis nisl ut aliquip ex ea commodo consequat.

1 JACK PARSONS
Lorem ipsum dolor sit amet, consectetuer adipiscing elit, sed diam nonummy nibh euismod tincidunt ut laoreet dolore magna aliquam erat volutpat. Ut wisi enim ad minim veniam, quis nostrud exerci tation ullamcorper suscipit lobortis nisl ut aliquip ex ea commodo consequat. Duis autem vel eum iriure dolor in hendrerit in vulputate velit esse molestie consequat, vel illum dolore eu feugiat nulla facilisis at vero eros et accumsan et iusto odio dignissim qui blandit praesent luptatum zzril delenit

2 ARLENE JACOBS
Lorem ipsum dolor sit amet, consectetuer adipiscing elit, sed diam nonummy nibh euismod tincidunt ut laoreet dolore magna aliquam erat volutpat. Ut wisi enim ad minim veniam, quis nostrud exerci tation ullamcorper suscipit lobortis nisl ut aliquip ex ea commodo consequat. Duis autem vel eum iriure dolor in hendrerit in vulputate velit esse molestie consequat, vel illum dolore eu feugiat nulla facilisis at vero eros et accumsan et iusto odio dignissim qui blandit praesent luptatum zzril delenit

3 DAN RITCHIE
Lorem ipsum dolor sit amet, consectetuer adipiscing elit, sed diam nonummy nibh euismod tincidunt ut laoreet dolore magna aliquam erat volutpat. Ut wisi enim ad minim veniam, quis nostrud exerci tation ullamcorper suscipit lobortis nisl ut aliquip ex ea commodo consequat. Duis autem vel eum iriure dolor in hendrerit in vulputate velit esse molestie consequat, vel illum dolore eu feugiat nulla facilisis at vero eros et accumsan et iusto odio dignissim qui blandit praesent luptatum zzril delenit

Choosing the right photographer, careful planning and confident art-direction of the photographic session are all essential if the commissioned photography is to be a success.

Less leading is required for larger headline faces than for text sizes. In this publication, headlines are set in 47/47pt – 0% leading. With extra-large sizes even negative leading – 90/80pt, for example – might be desirable, but take care to avoid a clash of ascenders and descenders.

A 4pt black rule, tinted 30%, sits beneath each caption and aligns horizontally with the bottom of the photographs. This provides a boundary for the signatures.

4 BYRON CRAFT

Lorem ipsum dolor sit amet, consectetuer adipiscing elit, sed diam nonummy nibh euismod tincidunt ut laoreet dolore magna aliquam erat volutpat. Ut wisi enim ad minim veniam, quis nostrud exerci tation ullamcorper suscipit lobortis nisl ut aliquip ex ea commodo consequat. Duis autem vel eum iriure dolor in hendrerit in vulputate velit esse molestie consequat, vel illum dolore eu feugiat nulla facilisis at vero eros et accumsan et iusto odio dignissim qui blandit praesent luptatum zzril delenit

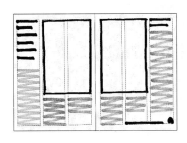

5 ROWENA BUDD

Lorem ipsum dolor sit amet, consectetuer adipiscing elit, sed diam nonummy nibh euismod tincidunt ut laoreet dolore magna aliquam erat volutpat. Ut wisi enim ad minim veniam, quis nostrud exerci tation ullamcorper suscipit lobortis nisl ut aliquip ex ea commodo consequat. Duis autem vel eum iriure dolor in hendrerit in vulputate velit esse molestie consequat, vel illum dolore eu feugiat nulla facilisis at vero eros et accumsan et iusto odio dignissim qui blandit praesent luptatum zzril delenit

6 NICK MUIR

Lorem ipsum dolor sit amet, consectetuer adipiscing elit, sed diam nonummy nibh euismod tincidunt ut laoreet dolore magna aliquam erat volutpat. Ut wisi enim ad minim veniam, quis nostrud exerci tation ullamcorper suscipit lobortis nisl ut aliquip ex ea commodo consequat. Duis autem vel eum iriure dolor in hendrerit in vulputate velit esse molestie consequat, vel illum dolore eu feugiat nulla facilisis at vero eros et accumsan et iusto odio dignissim qui blandit praesent luptatum zzril delenit

Executive placement guaranteed

Lobortis nisl ut aliquip ex ea commodo consequat. Duis autem vel eum iriure dolor in hendrerit in vulputate velit esse molestie consequat, vel illum dolore eu feugiat nulla facilisis at vero eros et accumsan et iusto odio dignissim qui blandit praesent luptatum zzril delenit augue duis dolore te feugait nulla facilisi. Nam liber tempor cum soluta nobis eleifend option congue nihil imperdiet doming id quod mazim placerat facer possim assum. Lorem ipsum dolor sit amet,

consectetuer adipiscing elit, sed diam nonummy nibh euismod tincidunt ut laoreet dolore magna aliquam erat volutpat. Ut wisi enim ad minim veniam, quis nostrud exerci tation ullamcorper suscipit lobortis nisl ut aliquip ex ea commodo consequat. Duis autem vel eum iriure dolor in hendrerit in vulputate velit esse

molestie consequat, vel illum dolore eu feugiat nulla facilisis at vero eros et accumsan et iusto odio dignissim qui blandit praesent luptatum zzril delenit augue duis dolore te feugait nulla facilisi. Lorem ipsum dolor sit amet, consectetuer adipiscing elit, sed diam nonummy nibh euismod tincidunt ut laoreet dolore magna aliquam erat volutpat. Ut wisi enim ad minim veniam, quis nostrud

THE PEOPLE FACTOR

CLIENT

japanese restaurant

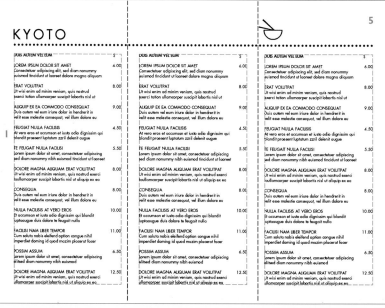

The inside spread.

SPECIFICATIONS

Format
8½ x 11in or A4
3 panels, 3-fold

Grid
3-column
Space between:
Inside spread – 2p11
Outside spread – 6p

Margins
i 2p11 o 2p11
t 6p b 2p11

Font
Futura
Track loose
1 Body text 8½/10½pt
2 Logo 54pt, 27pt

Subheads
3 15/18pt
4 12/18pt
5 12/14½pt

BRIEF Kyoto is an established Japanese restaurant that is introducing a take-out service in addition to its existing eat-in facilities. This has presented an opportunity to update the identity. The name Kyoto is set in the typeface Futura, a very clean sanssserif face with a perfectly symmetrical letter O, and this is combined with a dot underline, which runs across the width of the restaurant's name board. The take-out menu has fewer dishes than the main one, and it needs to be compact and reasonably cheap to produce in fairly large quantities.

SOLUTION A single sheet, horizontal format, folded twice has been selected for its portability and low cost. Printing is two color on the cover and outside, with black only on the inside spread. The stock is #68 uncoated cream with a random speckle, and is 75% recycled. The menu has a rolling fold, as opposed to an accordion pleat, so the panels forming the front and back covers are adjacent. An illustration, in the style of the internal decor, has been drawn to decorate the front and back covers.

KYOTO

2 KYOTO

JAPANESE
RESTAURANT

JAPANESE
RESTAURANT

Take-out
Menu
0207 777 3761

Take-out 3
Menu
0207 777 3761 4

168 Wiltshire Drive
Amhurst
Anystate
45207

3 Abc

1 Butem vel eum iriure do lor in hen
dre rit in vulp utate velit esse illum

The left and right margins and the space between columns are all equal – 2p11. This looks visually balanced, but with three panels of equal width the folds do not come in the middle of the column spaces. This does not matter on the inside spread, which opens out flat to be read, but it will not be acceptable on the other side of the menu.

The column spaces on the outside of the menu will need to be 6p, twice the width of those on the inside, as they will be seen wholly or at least partly folded.

The middle panel will form the back cover when the sheet is fully folded. The name and phone number are repeated with the addition of the address at the bottom.

On both sides of the menu the layout is anchored by the 3pt horizontal, dotted rule, which is centered on a line 7p8 from the top of the page. The menu text hangs 1p5 below it, and the logo and phone number sit 1p5 above the rule.

Take-out Menu
(071) 777-3761

DUIS AUTEM VEL EUM	$
LOREM IPSUM DOLOR Consectetuer adipiscing elit, sed diaeuismod tincidunt ut laoreet dolore magna aliquam	6.00
ERAT VOLUTPAT Ut wisi enim ad minim veniam, quis exerci tation ullamcorper suscipit lob	8.00
ALIQUIP EX EA COMMODO Duis autem vel eum iriure dolor in hendrerit in velit esse molestie consequat, vel illum dolore eu	9.00
FEUGIAT NULLA FACILISIS At vero eros et accumsan et iusto odio blan dit praesent luptatum zzril delenit augue	5.00
TE FEUGAIT NULLA FACILISI Lorem ipsum dolor sit amet, consectetu sed diam nonummy nibh euismod tincidu	5.50
DOLORE MAGNA ALIQUAM ERAT Ut wisi enim ad minim veniam, quis no taullamc orper suscipit lobortis nisl ut aliquip ex ea	8.00
CONSEQUA Duis autem vel eum iriure dolor in hendrerit velit esse molestie consequat, vel illum	8.00
NULLA FACILISIS AT VERO EROS Et accumsan et iusto odio dignissim qui blandit luptaaugue duis dolore te feugait nulla	10.00
FACILISI NAM LIBER TEMPOR Cum soluta nobis eleifend option congue imperdiet doming id quod mazim placerat	11.00
POSSIM ASSUM Lorem ipsum dolor sit amet, consectetuer elitsed diam nonummy nibh euismod	6.50
DOLORE MAGNA ALIQUAM ERAT Ut wisi enim ad minim veniam, quis nostrudull amcorper suscipit lobortis nisl ut aliquip ex ea	12.50

KYOTO

JAPANESE
RESTAURANT

Take-out
Menu
0207 777 3761

168 Wiltshire Drive
Amhurst
Anystate
45207

KYOTO

JAPANESE
RESTAURANT

Take-out
Menu
0207 777 3761

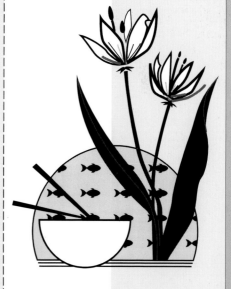

The left panel will be tucked inside when the sheet is folded. The wider column spaces mean that the menu column will be narrower than on the inside spread.

Make sure that neither the dish name nor description extends too close to the price column.

All menu entries should be three lines deep with one line space between.

On both the front and back panels a further two lines space is left between the subheads.

The illustration is repeated at 40% of the size that it is used on the front panel, and the color tint panel runs behind in the same relative position as on the front.

The front panel is on the right, and, with a rolling fold, the other two panels tuck inside it. The panel at the far left will need to be a fraction smaller, which can be accommodated in the design or the printer can adjust the folding to allow for it.

The color tint panel would look uncomfortable if it did not perfectly bisect the middle O of Kyoto. However, this O is not in the actual center of the panel. This small difference will not be noticed.

CLIENT

lumber yard

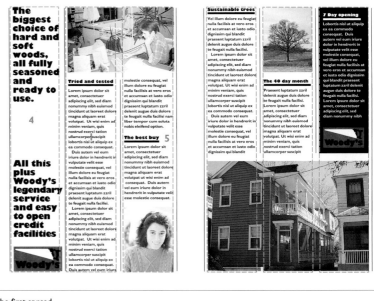

The first spread.

SPECIFICATIONS

Format
6 x 9in or A5
16 pages, saddle-stitched

Grid
3-column
Space between – 1p2

Margins
i 2p11 o 2p11
t 2p11 b 2p11

Fonts
Gill Sans Bold
Track normal
1 Body text 8½/10½pt
2 Introduction 12/14pt

Gill Sans Ultra Bold
Track normal
3 Cover 45/45pt
4 Spread heading 18/18pt
5 Subhead 9/10½pt

BRIEF Woody's is a popular local lumber yard, long established and proud of its reputation for service and its extensive range of wood. It has refurbished its premises and at the same time commissioned a new identity and a sales brochure to supplement the rather prosaic catalogue that is currently the only publication it produces. It is a family business, and although the original Woody died many years ago, the founder's personality lives on. This has proved a successful formula in the past and should be reflected in the new publication.

SOLUTION A 16-page brochure in a 6 x 9in/A4 format is proposed, and this will be displayed in dispensers at the check-out counter, as well as being mailed to potential customers. Headlines and text are in a chatty style, and the layout is bold, using plenty of solid black areas with dropped-out white type. The new logo is used extensively. White, 100% recycled, uncoated stock has been chosen, with the four-page cover on #93 and the 12 pages of text on #68. It will be printed as eight pages full-color with the remainder, including the cover, black only. This is effective and economical.

The text through-out is set in Gill Sans Bold, which reinforces the robustness of the design. It also allows bold, 1pt column rules to be used. The work of novice designers is often marred by

the use of bold column rules with light type, which results in a clumsy layout.

The cover immediately establishes the design styling. The Gill Sans Ultra Bold head, dropped-out white on a solid black background, is just about the boldest possible combination.

The heading, occupies the left-hand and center columns. It is ranged left and stacked, a style that is followed on subsequent pages,

but with the headings set in a smaller size and in a single column.

They can tell the wood from the trees at

Woody's Lumber

Lorem ipsum dolor sit amet consectetuer adipiscing elit, sed diam nonummy nibh euismod tincidunt ut laoreet dolore magna aliquam erat volutpat.
Ut wisi enim ad minim veniam, quis nostrud exerci tation ullamcorper suscipit lobortis nisl ut aliquip ex ea commodo dolore consequat.
Duis autem vel eum iriure dolor in hendrerit in vulputate velit esse

molestie consevel illum dolore eu feugiat nulla facilisis at vero eros et accumsan
Et iusto odio dignissim qui blandit praesent luptatum zzril delenit augue duis dolore te feugait nulla facilisi.

Woody's Lunber
671 Holt Road
Accasia
Anystate
15361

Tel (666) 777-3761
Fax (666) 777-3762

The black back-ground extends over the back cover, where the logo and address details in the outer column are enclosed within

two rules. "Black" space can be as effective as white space in creating a dramatic layout.

The uncoated stock will give the 16-page brochure considerable bulk, but the print quality will not be as good as on a coated paper. Uncoated stock was chosen because it is appropriate for the

subject matter – the brochure will have a chunky look and feel – and also because it is cheaper. The choice of stock is one of the most important factors in the creation of any publication. Paper merchants will be

only too pleased to send you samples, and some will even make up blank dummies for you, free of charge.

Positioning the logo just below the center of the page establishes a grid line that will feature throughout the publication. Although this is not as dominant as a hangline, a publica-

tion such as this, in which each spread has a different layout, will benefit from having a constant point of reference.

The left-hand column is reserved for the headline. Following the style established on the front cover, it is separated into two statements.

The headline face, Gill Sans Ultra Bold, has unusually small ascenders, so the top of the x-height does not provide a clearly defined line on which to range text horizontally. In this instance headlines and text are ranged on the top of the cap-height.

The biggest choice of hard and soft woods, all fully seasoned and ready to use.

All this plus Woody's legendary service and easy to open credit facilities

Woody's

Tried and tested

Lorem ipsum dolor sit amet, consectetuer adipiscing elit, sed diam nonummy nibh euismod tincidunt ut laoreet dolore magna aliquam erat volutpat. Ut wisi enim ad minim veniam, quis nostrud exerci tation ullamcorper suscipit lobortis nisl ut aliquip ex ea commodo consequat. Duis autem vel eum iriure dolor in hendrerit in vulputate velit esse molestie consequat, vel illum dolore eu feugiat nulla facilisis at vero eros et accumsan et iusto odio dignissim qui blandit praesent luptatum zzril delenit augue duis dolore te feugait nulla facilisi. Lorem ipsum dolor sit amet, consectetuer adipiscing elit, sed diam nonummy nibh euismod tincidunt ut laoreet dolore magna aliquam erat volutpat. Ut wisi enim ad minim veniam, quis nostrud exerci tation ullamcorper suscipit lobortis nisl ut aliquip ex ea commodo consequat. Duis autem vel eum iriure

molestie consequat, vel illum dolore eu feugiat nulla facilisis at vero eros et accumsan et iusto odio dignissim qui blandit praesent luptatum zzril delenit augue duis dolore te feugait nulla facilisi nam liber tempor cum soluta nobis eleifend option.

The best buy

Lorem ipsum dolor sit amet, consectetuer adipiscing elit, sed diam nonummy nibh euismod tincidunt ut laoreet dolore magna aliquam erat volutpat ut wisi enim ad consequat. Duis autem vel eum iriure dolor in hendrerit in vulputate velit esse molestie consequat.

Sustainable trees

Vel illum dolore eu feugiat nulla facilisis at vero eros et accumsan et iusto odio dignissim qui blandit praesent luptatum zzril delenit augue duis dolore te feugait nulla facilisi. Lorem ipsum dolor sit amet, consectetuer adipiscing elit, sed diam nonummy nibh euismod tincidunt ut laoreet dolore magna aliquam erat volutpat. Ut wisi enim ad minim veniam, quis nostrud exerci tation ullamcorper suscipit lobortis nisl ut aliquip ex ea commodo consequat. Duis autem vel eum iriure dolor in hendrerit in vulputate velit esse molestie consequat, vel illum dolore eu feugiat nulla facilisis at vero eros et accumsan et iusto odio dignissim qui blandit

The 40 day month

Praesent luptatum zzril delenit augue duis dolore te feugait nulla facilisi. Lorem ipsum dolor sit amet, consectetuer adipiscing elit, sed diam nonummy nibh euismod tincidunt ut laoreet dolore magna aliquam erat volutpat. Ut wisi enim ad minim veniam, quis nostrud exerci tation ullamcorper suscipit

7 Day opening

Lobortis nisl ut aliquip ex ea commodo consequat. Duis autem vel eum iriure dolor in hendrerit in vulputate velit esse molestie consequat, vel illum dolore eu feugiat nulla facilisis at vero eros et accumsan et iusto odio dignissim qui blandit praesent luptatum zzril delenit augue duis dolore te feugait nulla facilisi. Lorem ipsum dolor sit amet, consectetuer adipiscing elit, sed diam nonummy nibh

Woody's

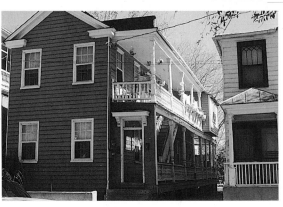

When a subhead falls in the middle of a column, the total space it and the rule occupy is $31\frac{1}{2}$ points – that is, $3 \times 10\frac{1}{2}$pt. This ensures that the text aligns in all columns. Some DTP programs have a vertical justification function that will adjust the leading to ensure that all columns align at the foot. A more professional approach is to spend time making sure that all spaces, headings, and rules add up to multiples of the text leading. They will then align properly.

The subheads have a thick, 4pt black rule beneath them. This is set to the width of each head and sits on a line 6 points below the baseline of the head. Make sure that subheads do not align horizontally across the spread, particularly in adjacent columns. Like the subheads, photographs should be staggered across the spread to create an asymmetric yet balanced layout.

The first spread starts on the inside front cover. Although the cover stock is #169 and the text is printed on #68, this is acceptable because they are different weights of the same stock.

A one-line space has been left between the bottom of the text and the picture, and the picture is ranged with the top of the cap-height. When the text is below a picture, a one-line space is left, and the picture aligns with the baseline of the previous line. Boxed text is used occasionally to highlight a piece of text and to add variety to the layout.

The logo is repeated rather more often than usual. In this, the first publication to use the new identity, this repetition will help to establish the new image.

One for one hard wood re-planting scheme ensures supply of timber can be sustained with no ecological damage

Sawn or planed, Woody's offers you the widest choice of grain and width

1 American Amaloe
Lorem ipsum dolor sit amet, consectetuer adipiscing elit, sed diam nonummy nibh euismod tincidunt ut laoreet dolore magna aliquam erat volutpat. Ut wisi enim ad minim veniam, quis Duis autem vel eum iriure dolor in hendrerit in vulputate velit esse molestie consequat, vel nostrud exerci tation

2 Indiga piropodes
Lorem ipsum dolor sit amet, consectetuer adipiscing elit, sed diam nonummy nibh euismod tincidunt ut laoreet dolore magna aliquam erat volutpat. Ut wisi enim ad minim veniam, quis

3 Mountain whipple
Lorem ipsum dolor sit amet, consectetuer adipiscing elit, sed diam nonummy nibh euismod tincidunt ut laoreet dolore magna aliquam erat volutpat. Ut wisi enim ad minim veniam, quis

4 Symitoga antrobus
Lorem ipsum dolor sit amet, consectetuer adipiscing elit, sed diam nonummy nibh euismod tincidunt ut laoreet dolore magna aliquam erat

The logo is repeated at the foot of the headline column. This feature is used consistently throughout the brochure and also at the head of the caption column.

The photographs butt together, which adds visual impact by creating a single mass. When you butt pictures in this way, make sure that the images do not appear to run into each other, and only do it when they form a symmetrical block. An alternative is to leave a 1 or 2 pt space between pictures.

In a 16-page publication different layouts can be used to add variety and change the pace. Here the double-page spread, with its black, bleed background, is used to dramatic effect.

The caption heads do not have rules beneath them because rules would look clumsy under two lines of text. The caption heads are set in 9/10½pt, and the captions themselves are in 8½/10½pt, with an additional 7pt space after the last line of the caption. The pictures are keyed in by number to the captions.

CLIENT

insurance broker

2 **A Shand Davy broker is trained to think on his feet.**

The folded cover panel.

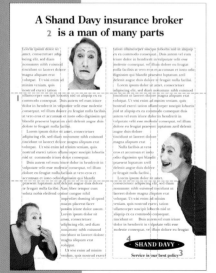

A Shand Davy insurance broker
2 is a man of many parts

Lorem ipsum dolor sit amet, consectetuer adipiscing elit, sed diam nonummy nibh euismod tincidunt ut laoreet dolore magna aliquam erat volutpat. Ut wisi enim ad minim veniam, quis nostrud exerci tation

Lorem ipsum dolor sit amet, consectetuer adipiscing elit, sed diam nonummy nibh euismod tincidunt ut laoreet dolore magna aliquam erat volutpat. Ut wisi enim ad minim veniam, quis nostrud exerci tation ullamcorper suscipit lobortis nisl ut aliquip ex ea commodo consequat.

Duis autem vel eum iriure dolor in hendrerit in vulputate velit esse molestie consequat, vel illum dolore eu feugiat nulla facilisis at vero eros et accumsan et iusto odio dignissim qui blandit praesent luptatum zzril delenit augue duis dolore te feugait nulla facilisi. Nam liber tempor cum soluta nobis eleifend option congue nihil imperdiet doming id quod mazim placerat facer possim assum. Lorem ipsum dolor sit amet, consectetuer adipiscing elit, sed diam nonummy nibh euismod tincidunt ut laoreet dolore magna aliquam erat volutpat. Ut wisi enim ad minim veniam, quis nostrud exerci

tation ullamcorper suscipit lobortis nisl ut aliquip ex ea commodo consequat. Duis autem vel eum iriure dolor in hendrerit in vulputate velit esse molestie consequat, vel illum dolore eu feugiat nulla facilisis at vero eros et accumsan et iusto odio dignissim qui blandit praesent luptatum zzril delenit augue duis dolore te feugait nulla facilisi.

Lorem ipsum dolor sit amet, consectetuer adipiscing elit, sed diam nonummy nibh euismod tincidunt ut laoreet dolore magna aliquam erat volutpat. Ut wisi enim ad minim veniam, quis nostrud exerci tation ullamcorper suscipit lobortis nisl ut aliquip ex ea commodo consequat. Duis autem vel eum iriure dolor in hendrerit in vulputate velit esse molestie consequat, vel illum dolore eu feugiat

Nulla facilisis at vero eros et accumsan et iusto odio dignissim qui blandit praesent luptatum zzril delenit augue duis dolore te feugait nulla facilisi.

Lorem ipsum dolor sit amet, consectetuer adipiscing elit, sed diam nonummy nibh euismod tincidunt ut laoreet dolore magna aliquam erat volutpat. Ut wisi enim ad minim veniam, quis nostrud exerci tation ullamcorper suscipit lobortis nisl ut aliquip ex ea commodo consequat. Duis autem vel eum iriure dolor in hendrerit in vulputate velit esse molestie consequat, vel illum dolore eu feugiat

SHAND DAVY
Service is our best policy

SPECIFICATIONS

Format
8½ x 11in or A4
3-panel, 2-fold

Grid
4-column
Space between – 1p10

Margins
i 2p11 o 2p11
t 2p11 b 2p11

Fonts
Century Old Style
Track loose
1 Body text 11/15pt
2 Headline 30/36pt
3 Subhead 12pt
Century Old Style bold
Track very loose
4 Logo
16pt

BRIEF Shand Davy, an insurance broker with 30 branches, sells mostly domestic, building, and automobile insurance. The competition for business – from banks, from insurance companies themselves, and from other brokers – is fierce, and Shand Davy feels compelled to embark on a campaign to win new business. A direct mail shot will form part of this strategy. It will need to stress the independence of the advice given – the fact that Shand Davy can offer policies from a range of companies and is not tied to one company, so that policies can be more closely tailored to the clients' individual needs.

SOLUTION A single sheet, rolling-fold leaflet has been chosen. The inside spread opens out to read vertically, and the leaflet is both convenient for mailing and offers an unusual format to catch the attention. The folded leaflet will be dispatched in a standard-size envelope. Commissioned photographs of a mime artist create the visual theme to support the headline, which expresses Shand Davy brokers' versatility and flexibility. The fairly large amount of text is broken up by the photographs. Full-color printing is used on a lightweight, #57, gloss-coated stock.

2 **Abc**
1 Butem vel eum iriure do lor in hen dre rit in vulp utate velit esse illum

A two-fold leaflet is normally used in a horizontal format, providing three vertical panels. The vertical format and horizontal folds used here offer an opportunity to create an unusual layout.

Front cover.

Inside spread.

The cover (opposite) will form the bottom panel on the reverse of the leaflet so that the text orientation remains the same as it is unfolded.

The headline is set in Century Old Style bold, a fairly extended face, which fills the space to within about 2p11 of the type area. Although the headline could be made to fit the maximum width exactly, it has more impact with this extra space on either side.

The text is set in 11/15pt Century Old Style, and it has been positioned so that the folds come between lines of text. Achieving this requires some experimentation with the leading, but it is worth the effort because type is sometimes broken up by a fold, although this is more likely on an outside fold.

A Shand Davy insurance broker is a man of many parts

Lorem ipsum dolor sit amet, consectetuer adipiscing elit, sed diam nonummy nibh euismod tincidunt ut laoreet dolore magna aliquam erat volutpat. Ut wisi enim ad minim veniam, quis nostrud exerci tation ullamcorper suscipit lobortis nisl ut aliquip ex ea commodo consequat. Duis autem vel eum iriure dolor in hendrerit in vulputate velit esse molestie consequat, vel illum dolore eu feugiat nulla facilisis at vero eros et accumsan et iusto odio dignissim qui blandit praesent luptatum zzril delenit augue duis dolore te feugait nulla facilisi.

Lorem ipsum dolor sit amet, consectetuer adipiscing elit, sed diam nonummy nibh euismod tincidunt ut laoreet dolore magna aliquam erat volutpat. Ut wisi enim ad minim veniam, quis nostrud exerci tation ullamcorper suscipit lobortis nisl ut commodo iriure dolor consequat.

Duis autem vel eum iriure dolor in hendrerit in vulputate velit esse molestie consequat, vel illum dolore eu feugiat nulla facilisis at vero eros et accumsan et iusto odio dignissim qui blandit praesent luptatum zzril delenit augue duis dolore te feugait nulla facilisi. Nam liber tempor cum soluta nobis eleifend option congue nihil imperdiet doming id quod mazim placerat facer possim iriure dolor assum. Lorem ipsum dolor sit amet, consectetuer adipiscing elit, sed diam nonummy nibh euismod tincidunt ut laoreet dolore magna aliquam erat volutpat.

Ut wisi enim ad minim veniam, quis nostrud exerci

tation ullamcorper suscipit lobortis nisl ut aliquip ex ea commodo consequat. Duis autem vel eum iriure dolor in hendrerit in vulputate velit esse molestie consequat, vel illum dolore eu feugiat nulla facilisis at vero eros et accumsan et iusto odio dignissim qui blandit praesent luptatum zzril delenit augue duis dolore te feugait nulla facilisi.

Lorem ipsum dolor sit amet, consectetuer adipiscing elit, sed diam nonummy nibh euismod tincidunt ut laoreet dolore magna aliquam erat volutpat. Ut wisi enim ad minim veniam, quis nostrud exerci tation ullamcorper suscipit lobortis nisl ut aliquip ex ea commodo consequat duis autem vel eum iriure dolor in hendrerit in vulputate velit esse molestie consequat, vel illum dolore eu feugiat praesent luptatum zzril delenit augue duis dolore tincidunt ut laoreet dolore magna aliquam erat

Nulla facilisis at vero eros et accumsan et iusto odio dignissim qui blandit praesent luptatum zzril delenit augue duis dolore te feugait nulla facilisi.

Lorem ipsum dolor sit amet, consectetuer adipiscing elit, sed diam nonummy nibh euismod tincidunt ut laoreet dolore magna aliquam erat volutpat. Ut wisi enim ad minim veniam, quis nostrud exerci tation ullamcorper suscipit lobortis nisl ut aliquip ex ea commodo consequat. tincidunt ut Duis autem vel eum iriure dolor in hendrerit in vulputate velit esse molestie consequat, vel illum dolore eu feugiat

· SHAND DAVY ·

Service is our best policy

The text runs around the cut-out photographs. Take care with the line breaks so that no ugly holes are left, and so that, of course, the resulting text reads well.

The main purpose of a layout is to persuade the reader to read the text. This design relies on the visual interest created by the off-beat photographs to offset the large unbroken run of text. Subheads could be added but they might compete for attention with the photographs.

This text has been indented to allow for the photograph. It could have run around the shape of the picture, and if you are using DTP software, running text around shapes is easy. If you are not using a DTP program, an accurate cast-off, and a little trial and error, will be necessary.

The logo is set in 16pt Century Old Style bold with very loose track, while the headline and text are both set loose. In general, capital letters, especially serif capitals, require more letter space to allow for the variations in spacing required to produce visually even spacing. Note how the V and Y almost touch, yet the A and V are quite far apart. The logo is always accompanied by this strap line. The folded leaflet will be despatched in a standard size envelope.

intermediate
BROCHURES

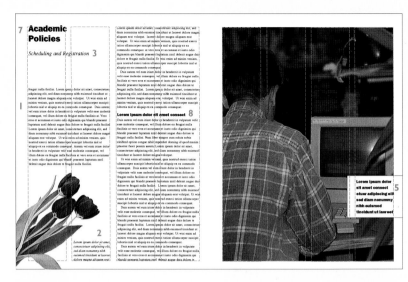

A typical spread.

EXCELLENCE
AT LANGTON WELLS COLLEGE

7 Abc

I Butem vel eum iriure do lor in hen
dre rit in vulp utate velit esse illum

SPECIFICATIONS

Format
6 x 9in or A5
4-page cover, perfect-bound
32 pages 4-color,
32 pages black
Printed 4/1

Grid
4-column
Space between – 1p2

Margins
i 2p2 o 2p2
t 2p2 b 2p2

Fonts
Times Roman
Track loose
1 Body text 7/9pt

Times italic
Track loose
2 Captions 7/9pt
3 Subhead 12pt

Franklin Gothic Heavy
Track loose
Cover headlines
4 42pt
5 18pt
6 Cover intro and quote
8½/13pt
7 Spread headline 18/21pt
8 Subhead 8½pt

BRIEF Langton Wells is a medium-sized college offering a wide range of courses, although its reputation is based mainly on the excellence of its science faculty. A new brochure/prospectus giving detailed descriptions of the courses on offer is commissioned annually. The format can vary from year to year, but the objective remains the same: to attract new students. The design should be dynamic and youthful, therefore, but should also be capable of delivering a considerable amount of complex information.

SOLUTION A 6 x 9in / A5 format with a substantial 64 pages of text printed on #68 silk finish, coated paper has been selected. This extent, with a four-page, laminated, #111 cover, enables perfect (square-backed) binding to be used. The outside cover and 32 pages of text are printed in full color; the remainder is printed black. The brochure's theme is established on the cover in the form of an unfinished statement – a formula, a quotation, or a bar of music – which will be used for section breaks. This is combined with an appropriate illustration or photograph in the background. Typography of the text is clean and strong.

The cover will be critical in forming the reader's first impression. The overall design, layout style, choice of typeface, illustration, and color all contribute to the look that will be followed throughout the entire prospectus.

A drop shadow prints 60% black over the illustration.

A typical inside spread (see opposite) will have two pictures and at least one subhead to break up the text. Where appropriate, pictures smaller than the full page should be cut out, with the caption fitting into the available space. If a squared-up picture is used, the caption should be broken into two equal blocks and placed side by side.
Every 6–8 pages a full-page picture of a college activity will be used. This will feature an inset, boxed quotation from a student. Devices of this kind are essential to enliven a long publication.
The spread headings always hang from the top line of the grid.
The Times Italic subhead aligns with the seventh line of text.
The text extends over two columns, and the first line aligns with the fifteenth line of text.

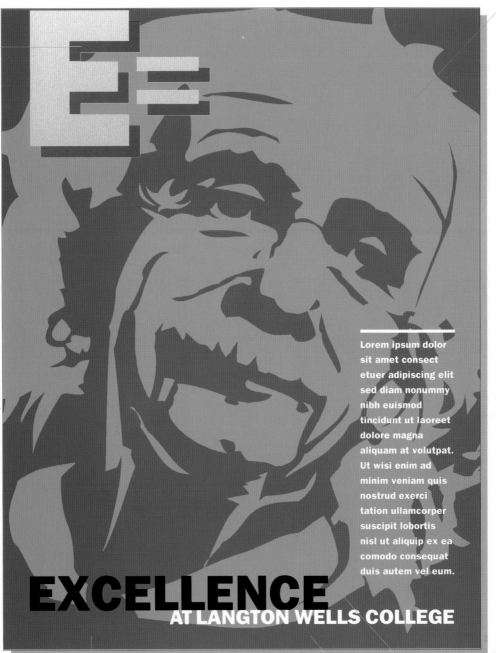

Lorem ipsum dolor sit amet consect etuer adipiscing elit sed diam nonummy nibh euismod tincidunt ut laoreet dolore magna aliquam at volutpat. Ut wisi enim ad minim veniam quis nostrud exerci tation ullamcorper suscipit lobortis nisl ut aliquip ex ea comodo consequat duis autem vel eum.

EXCELLENCE
AT LANGTON WELLS COLLEGE

The stylized illustration of Albert Einstein is reproduced in two colors that, although different in hue, are similar in tone, and this provides a muted background to the "E=." To emphasize the unfinished nature of the equation, the conclusion – Excellence – is positioned at the bottom of the page. The space also contributes to the success of the idea, as does the recessive nature of the illustration. If it had been reproduced in stronger colors, the image would have dominated this space and damaged the layout. The "E=" is filled with a subtle graduated tone, created by laying magenta – 10% at the top and 30% at the bottom – on a flat tint of 10% yellow.

The introduction sits on a line ranged with the top of the headline.

The illustration of Einstein, with his head to one side, contrasts with the otherwise very angular layout of the other elements and emphasizes his benign expression.

The background colors have been selected so that both white and black headlines will read clearly. They butt together, with one ranging to the left, the other to the right.

50% yellow.
50% magenta.
75% cyan.

35% yellow.
35% magenta.
50% cyan.

CLIENT

horseback riding school

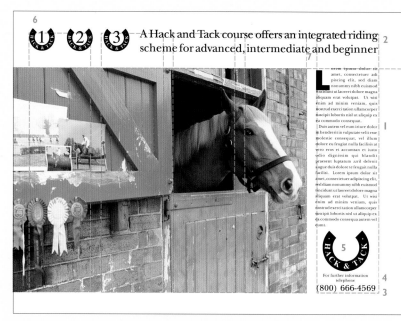

The first spread.

A Hack and Tack course offers an integrated riding scheme

for advanced, intermediate and beginner

SPECIFICATIONS

Format
8½ x 11in or A4
(landscape)
20 pages, saddle-stitched

Grid
5-column
Space between – 1p10

Margins
i 2p11 o 4p7
t 2p11 b 4p1

Fonts
New Baskerville
Track loose
1 Body text 9/11pt
Headlines
2 Cover 36/42pt
3 Spread 24/29pt
4 Phone number/Box 18pt
5 Information 9/10pt

Times Bold
Track force justify
6 Logo 18pt
7 Logo numerals 37pt

Franklin Gothic Heavy
8 Drop cap 60pt

BRIEF Hack & Tack are franchised riding schools, usually situated in the countryside close to the suburbs. They offer training in all aspects of riding and horse care, organized in three levels of expertise. Exploiting the popularity of riding, Hack & Tack aim to keep ahead of competition by publishing a "glossy" brochure promoting their basic, intermediate, and advanced riding instruction. This strategy also includes the creation of a new visual identity, for which a considerable budget has been established.

SOLUTION An 8½ x 11in / A4 format, but used horizontally, has been selected because it offers an opportunity for the impressive use of numerous, specially commissioned photographs, and allows the headlines to spread across the top of the page. A new logo, which will also be used on posters, key rings, and so on, has been devised. This not only incorporates the three skill levels, but is also used in perspective form on the cover, where the "hoof prints" will be embossed into a mat-laminated, #130 cover stock, printed in two colors. The 16-page text section is printed in full color on #118 silk-finish coated, 75% recycled stock.

3 Abc

1 Butem vel eum iriure do lor in hen dre rit in vulp utate velit esse illum

The horizontal format offers an opportunity for some expansive layout. The text will start on the right-hand page because the inside front cover will bear the impression of the embossed "hooves" showing through from the front. The inside of the cover, back and front, and the back cover will be printed a dark green.

The logo has been created so that it can be adapted to contain the numerals 1, 2 and 3 to indicate the three levels. These are set in 37pt Times roman.

The layout makes use of a strong hangline. Above the hangline are the spread heads and the logos indicating the level of the course.

A Hack and Tack course offers an integrated riding scheme for advanced, intermediate and beginner

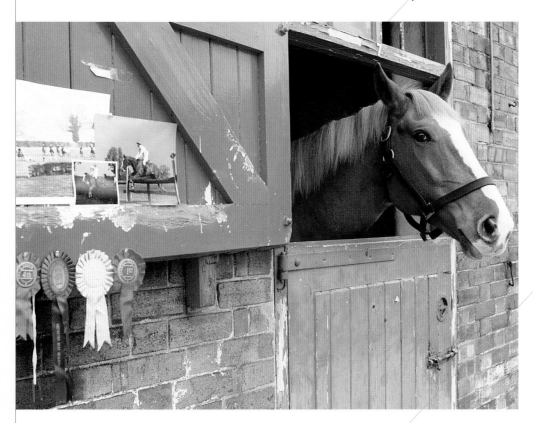

Lorem ipsum dolor sit amet, consectetuer adipiscing elit, sed diam nonummy nibh euismod tincidunt ut laoreet dolore magna aliquam erat volutpat. Ut wisi enim ad minim veniam, quis nostrud exerci tation ullamcorper suscipit lobortis nisl ut aliquip ex ea commodo consequat.

Duis autem vel eum iriure dolor in hendrerit in vulputate velit esse molestie consequat, vel illum dolore eu feugiat nulla facilisis at vero eros et accumsan et iusto odio dignissim qui blandit praesent luptatum zzril delenit augue duis dolore te feugait nulla facilisi. Lorem ipsum dolor sit amet, consectetuer adipiscing elit, sed diam nonummy nibh euismod tincidunt ut laoreet dolore magna aliquam erat volutpat. Ut wisi enim ad minim veniam, quis nostrud exerci tation ullamcorper suscipit lobortis nisl ut aliquip ex ea commodo consequa autem vel eumt.

For further information telephone

(800) 666-4569

The cover is entirely graphic without any photographs. The temptation to use a large, bleed photograph was strong, but it was resisted because the design is very dramatic and unconventional and helps to establish Hack & Tack's completely new approach in creating and marketing a franchised riding school. It will also be adapted for use on posters.
The logos on the cover were created using the perspective function of a graphics program, which is the only practical way of achieving this effect. If this option is not available, try using the sequence without the perspective, but still travelling from top right to bottom left.

Apart from the logo and drop cap, all other copy is set in New Baskerville. This is similar to Times but is more extended, which makes it a more appropriate face for the extreme width of the headlines. The logo, set in Times bold, which works better in the semicircle than New Baskerville, will be used for many years to come. New Baskerville, however, may be superseded by other typefaces in future publications.

The master logo is simply formed by creating a black circle and a smaller overlapping white circle. A larger, white quarter-circle cuts into the black one to form the horseshoe.

75

The single logo indicating the level appears on the left-hand page only. When circular or irregular objects are ranged with a squared-up shape, they must be positioned slightly over the grid line in order to appear visually aligned.

The drop cap is set in Franklin Gothic Heavy, a very bold sans serif face, which contrasts strongly with all the other copy. Because the text does not always start immediately below the related headline, the drop cap signifies that a new text theme has begun. Conversely the absence of a drop cap implies that the text continues from the previous page.

Hack and Tack Level 2 Intermediate program for riders wishing to improve their skills

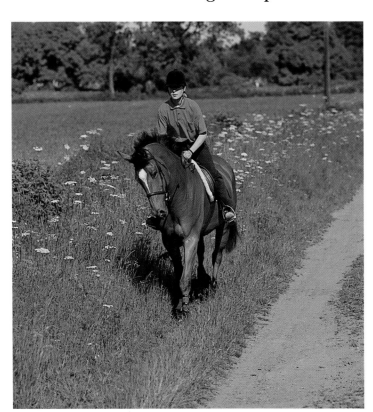

Lorem ipsum dolor sit amet, consectetuer adipiscing elit, sed diam nonummy nibh euismod tincidunt ut laoreet dolore magna aliquam erat volutpat. Ut wisi enim ad minim veniam, quis nostrud exerci tation ullamcorper suscipit lobortis nisl ut aliquip ex ea commodo consequat.

Duis autem vel eum iriure dolor in hendrerit in vulputate velit esse molestie consequat, vel illum dolore eu feugiat nulla facilisis at vero eros et accumsan et iusto odio dignissim qui blandit praesent luptatum zzril delenit augue duis dolore facilisi.

Lorem ipsum dolor sit amet, consectetuer adipiscing elit, sed diam nonummy nibh euismod tincidunt ut laoreet dolore magna aliquam erat volutpat. Ut wisi enim ad minim veniam, quis nostrud exerci tation ullamcorper suscipit lobortis nisl ut aliquip ex iriure

Dolor in hendreo vulputate velit esse molestie consequat, vel illum dolore eu feugiat nulla facilisis at vero eros et accumsan et iusto odio dignissim iriure dolor in hendrerit in vulputate velit esse molestie consequat, vel illum dolore eu feugiat nulla facilisis at vero eros et accumsan et iusto odio

Dignissim qu bland praesent luptatum zzril delenit augue duis dolore te feugait nulla facilisi. Nam liber tempor cum soluta nobis eleifend option congue nihil imperdiet doming id quod mazim placerat facer possim

The headlines on inside pages are ranged left. They should not extend to the full width of the page, even though the space is available, because such long headlines would be both ugly and difficult to read.

The smaller pictures align across the gutter. Although this is not a feature of the design, it is unattractive to see pictures that almost, but not quite, align. If perfect alignment is not possible, it is better to arrange the illustrations so that they do not align at all.

A structured course consisting of jumping, cross-country riding and horse-care for owner-riders

Eorem ipsum dolor sit amet, consectetuer adipiscing elit, sed diam nonummy nibh euis mod tincidunt ut laoreet dolore magna aliquam erat volutpat. Ut wisi enim ad minim veniam, quis nostrud exerci tation ullamcorper suscipit lobortis nisl ut aliquip ex ea commodo consequat.

Duis autem vel eum iriure dolor in hendrerit in vulputate velit esse molestie consequat, vel illum dolore eu feugiat nulla facilisis at vero eros et accumsan et iusto odio dignissim qui blandit praesent luptatum zzril delenit augue duis dolore facilisi.

Lorem ipsum dolor sit amet, consectetuer adipiscing elit, sed diam nonummy nibh euismod tincidunt ut laoreet dolore magna aliquam erat volutpat ut wisi enim ad minim veniam, quis nostrud exerci tation ullamcorper suscipit lobortis nisl ut aliquip ex ea iriure dolor in hendrerit in vulputate velit esse molestie consequat, vel illum dolore eu

Feugiat nulla facilisis at vero eros et accumsan et iusto odio dignissim qui blandit praesent luptatum zzril delenit augue duis dolore te feugait nulla facilisi. Nam liber tempor cum soluta nobis eleifend option congue nihil imperdiet doming id quod mazim placerat facer possim assum. Lorem ipsum dolor sit

In Brief

Iriure dolor in hendrerit in vulputate velit esse molestie consequat, vel illum dolore eu feugiat nulla facilisis at vero eros et accumsan et iusto odio dignissim qui blandit praesent luptatum zzril delenit augue duis dolore te feugait nulla facilisi. Nam liber tempor cum soluta nobis eleifend option congue nihil imperdiet doming id quod mazim placerat facer possim assum. Lorem ipsum dolor sit amet, consectetuer adipiscing elit, sed diam nonummy nibh euismod tincidunt ut laoreet dolore magna aliquam erat volutpat. Ut wisi enim ad minim veniam, quis nostrud

For further information
telephone
(800) 666-4569

CLIENT

travel company

BE WISE, BE SMART
BEFORE YOU START
CHECK IT OUT 2
WITH TRAVELWISE

TRAVELWISE

TRAVELWISE

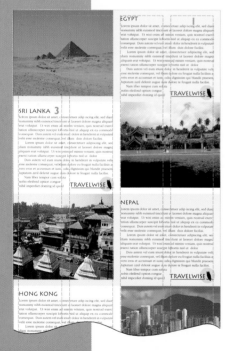

SPECIFICATIONS

Format
8½ x 22in
or A4 (double-depth)
20 pages, saddle-stitched
6 panels, 5-fold

Grid
4-column
Space between – 1p5

Margins
i 1p5 o 1p5
t 1p5 b 1p5

Fonts
Garamond
Track loose
1 Body 9/12pt

Lithograph
Track loose
2 Headlines / Cover /
Logo 27/43pt
3 Destinations 16pt

BRIEF Travelwise sells vacations to a wide range of unusual and exotic locations. The company wants to create a brochure with a novel format emphasizing this difference. A new identity has been commissioned to position the company more accurately in the marketplace. Travelwise specializes in vacations for the independent traveler (but not backpackers), and offers help at the destination from trained staff, allowing flexibility in the itinerary. The publication must be compact since it will be mailed, used in counter displays, and as a loose insert in magazines.

SOLUTION An accordion-pleat leaflet of 8½ x 11in / A4 vertical format, double the depth has been chosen, allowing for six panels on each side. Two panels will be taken up by the cover and contact information, leaving the remainder for 10 destinations. For maximum impact, the layout has been arranged in checkerboard fashion, with tinted and untinted panels and photographs alternating to left and right. The copy provides a taster for each location. A detailed fact sheet will be provided for customers requiring further information. Printing is in full color on both sides on #68 gloss-coated stock.

2 ABC
1 Butem vel eum iriure do lor in hen
 dre rit in vulp utate velit esse illum

This leaflet is unusual because it reads down the vertical format and is of double depth with six panels, four of which are shown on this page.

The cover (see opposite) prints on the opposite side of the "Egypt" panel, although it will be upside down, so that when the leaflet is folded it will have the same orientation as the six inside panels.

The design is symmetrical and repetitive, giving a very dramatic checkerboard display when unfolded. An accordion pleat is used in preference to a rolling fold, in which each fold tucks into the previous one. If a rolling fold were used with such a long sheet, each panel after the second one would need to be progressively smaller, making a difference in width between the largest and smallest of approximately 1p2, an unacceptable amount for this design.

The margins around each panel and down the center are all equal at 1p5.

The justified text aligns with the pictures at the center, reinforcing the very angular design. Ranged-left text was not selected because it would loosen the layout by creating uneven rivers of space to the right of each text block.

The text has been set in 9/12pt Garamond, but Times or Baskerville would do just as well. At 18pt, the paragraph indents are slightly wider than usual, and this helps to break up the text blocks a little, making them easier to read but without affecting the design.

EGYPT

Lorem ipsum dolor sit amet, consectetuer adip iscing elit, sed diam nonummy nibh euismod tincidunt ut laoreet dolore magna aliquam erat volutpat. Ut wisi enim ad minim veniam, quis nostrud exerci tation ullamcorper suscipit lobortis nisl ut aliquip ex ea commodo consequat. Duis autem vel eum iriure dolor in hendrerit in vulputate velit esse molestie consequat, vel illum duis dolore facilisi.

Lorem ipsum dolor sit amet, consectetuer adipiscing elit, sed diam nonummy nibh euismod tincidunt ut laoreet dolore magna aliquam erat volutpat. Ut wisi enim ad minim veniam, quis nostrud exerci tation ullamcorper suscipit lobortis nisl ut dolor

Duis autem vel eum iriure dolor in hendrerit in vulputate velit esse molestie consequat, vel illum dolore eu feugiat nulla facilisis at vero eros et accumsan et iusto odio dignissim qui blandit praesent luptatum zzril delenit augue duis dolore te feugait nulla facilisi.

Nam liber tempor cum soluta nobis eleifend option congue nihil imperdiet doming id quod TRAVELWISE

SRI LANKA

Lorem ipsum dolor sit amet, consectetuer adip iscing elit, sed diam nonummy nibh euismod tincidunt ut laoreet dolore magna aliquam erat volutpat. Ut wisi enim ad minim veniam, quis nostrud exerci tation ullamcorper suscipit lobortis nisl ut aliquip ex ea commodo consequat. Duis autem vel eum iriure dolor in hendrerit in vulputate velit esse molestie consequat, vel illum duis dolore facilisi.

Lorem ipsum dolor sit amet, consectetuer adipiscing elit, sed diam nonummy nibh euismod tincidunt ut laoreet dolore magna aliquam erat volutpat. Ut wisi enim ad minim veniam, quis nostrud exerci tation ullamcorper suscipit lobortis nisl ut dolor

Duis autem vel eum iriure dolor in hendrerit in vulputate velit esse molestie consequat, vel illum dolore eu feugiat nulla facilisis at vero eros et accumsan et iusto odio dignissim qui blandit praesent luptatum zzril delenit augue duis dolore te feugait nulla facilisi.

Nam liber tempor cum soluta nobis eleifend option congue nihil imperdiet doming id quod TRAVELWISE

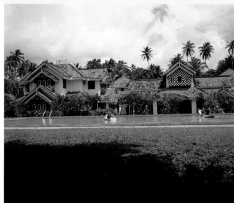

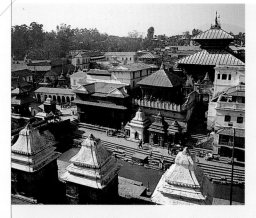

NEPAL

Lorem ipsum dolor sit amet, consectetuer adip iscing elit, sed diam nonummy nibh euismod tincidunt ut laoreet dolore magna aliquam erat volutpat. Ut wisi enim ad minim veniam, quis nostrud exerci tation ullamcorper suscipit lobortis nisl ut aliquip ex ea commodo consequat. Duis autem vel eum iriure dolor in hendrerit in vulputate velit esse molestie consequat, vel illum duis dolore facilisi.

Lorem ipsum dolor sit amet, consectetuer adipiscing elit, sed diam nonummy nibh euismod tincidunt ut laoreet dolore magna aliquam erat volutpat. Ut wisi enim ad minim veniam, quis nostrud exerci tation ullamcorper suscipit lobortis nisl ut dolor

Duis autem vel eum iriure dolor in hendrerit in vulputate velit esse molestie consequat, vel illum dolore eu feugiat nulla facilisis at vero eros et accumsan et iusto odio dignissim qui blandit praesent luptatum zzril delenit augue duis dolore te feugait nulla facilisi.

Nam liber tempor cum soluta nobis eleifend option congue nihil imperdiet doming id quod TRAVELWISE

HONG KONG

Lorem ipsum dolor sit amet, consectetuer adip iscing elit, sed diam nonummy nibh euismod tincidunt ut laoreet dolore magna aliquam erat volutpat. Ut wisi enim ad minim veniam, quis nostrud exerci tation ullamcorper suscipit lobortis nisl ut aliquip ex ea commodo consequat. Duis autem vel eum iriure dolor in hendrerit in vulputate velit esse molestie consequat, vel illum duis dolore facilisi.

Lorem ipsum dolor sit amet, consectetuer adipiscing elit, sed diam nonummy nibh euismod tincidunt ut laoreet dolore magna aliquam erat volutpat. Ut wisi enim ad minim veniam, quis nostrud exerci tation ullamcorper suscipit lobortis nisl ut dolor

Duis autem vel eum iriure dolor in hendrerit in vulputate velit esse molestie consequat, vel illum dolore eu feugiat nulla facilisis at vero eros et accumsan et iusto odio dignissim qui blandit praesent luptatum zzril delenit augue duis dolore te feugait nulla facilisi.

Nam liber tempor cum soluta nobis eleifend option congue nihil imperdiet doming id quod TRAVELWISE

The address details are on the bottom panel and, together with four more vacation panels, will all be the opposite orientation to the cover. If this is difficult to visualize, try folding a sheet of paper into six accordion pleat panels to see how it will work.

The logo is formed from the owl illustration plus the orange sun device, a circle 5p10 across, and the name is set to the same specification as the main heading.

The travel tag (see opposite) is a novelty mailed with the leaflet. It is 18p x 9p7 and uses the logo at 74%.

The destination heads are set in 16pt Lithograph, and they sit 12pt above the baseline of the first line of text. Lithograph is somewhat unusual and acts as a foil to the regimented nature of the overall layout.

20% cyan.

70% yellow. 25% magenta.

The logo is used at 62%, which is roughly half the width of the text, and the last three lines of text run around it. The rule beneath the logo ranges with the baseline of the text and the bottom of the pictures; the sun device extends into the margin.

CLIENT

investment services

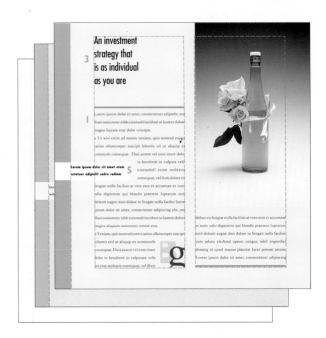

SPECIFICATIONS

Format
Single insert sheets:
8½ x 8½ in
Slipcase:
8.7 x 8.7 x 0.5in or
52p2 x 52p2 x 3p

Grid
2-column
Space between – 2p2

Margins
i 8p o 5p
t 2p11 b 4p4

Fonts
Caslon
Track loose
1 Body text 9/19pt
2 Logo 460pt

Futura Condensed
Track loose
3 Headlines 24/30pt
4 Cover 30pt

Futura Extra Bold
Track loose
5 Quote 8/16pt
6 Logo 420pt

BRIEF Bamber Grey are stockbrokers offering a wide range of investment services, and they have commissioned a new brochure to sell these products. A primary requirement is flexibility: clients receive information specific to their own investment circumstances. Bamber Grey produce a plethora of publications, newsletters and factsheets, and wish to bring all of these under the umbrella of the recently created visual identity. The brochure will be the flagship and first of the new generation of publications.

SOLUTION A series of single-sheet inserts within a slender slipcase has been selected. This is a more expensive solution than a conventional brochure, and the slipcase, an open-ended box, made from #540 board covered in #101, laminated, coated stock and printed full color, is particularly expensive. It does, however, offer the great advantage of flexibility; the appropriate sheets can be selected for insertion so that each client receives a customized package. These sheets will be printed in full color on a #169 silk finish, coated board. The client appreciates the power of superbly produced presentation, and is willing to pay for it.

3 Abc

1 Butem vel eum iriure do lor in hen

dre rit in vulp utate velit esse illum

A new approach to Investment

Bamber Grey

The logo is square, and this has been influential in the choice of format for this publication. Enlarging it to bleed off a square format slipcase has created a very powerful design.

50% yellow.

65% yellow.
100% magenta.
70% cyan.

50% cyan.

20% cyan.

25% yellow.
50% magenta.
20% cyan.

The logo is composed of a "B" set in a 24p square. The logo, reduced to 4p10, is positioned at the foot of the first column, with the last 4 lines of text running around it.

The slipcase is 53p square and 2p11 thick; the printed and laminated paper cover is pasted onto it. A small semicircular hole is die-cut in the side so that inserts can be removed.

The insert sheets follow a fairly standard format, including the 2p11 strip down the side, the position of the headline and logo, and rules at the beginning and end of the text. The position of the inset subhead and picture are flexible.

The headline face is Futura Condensed. Because it is a condensed face, a space is created to the right of the head, and this should be retained on all inserts.

The subhead is ranged left and aligned with the edge of the tint strip. It is set within a white box 15p2 wide, and to a depth that aligns with the top of the x-height of one line and to the baseline two lines below.

An investment strategy that is as individual as you are

Lorem ipsum dolor sit amet, consectetuer adipielit, sed diam nonummy nibh euismod tincidunt ut laoreet dolore magna liquam erat dolor volutpat.

▪ Ut wisi enim ad minim veniam, quis nostrud exerci tation ullamcorper suscipit lobortis nil ut aliquip ea commodo consequat. Duis autem vel eum iriure dolor in hendrerit in vulputa velit essemdoll erum molestie consequat, vel llum dolore eu feugiat nulla facilisis at vero eros et accumsan et iusto odio dignissim qui blandit praesent luptatum zzril delenit augue duis dolore te feugait nulla facilisi lorem ipsum dolor sit amet, consectetuer adipiscing elit, sed diam nonummy nibh euismod tincidunt ut laoreet dolore magna aliquam nonummy essum erat.

Lorem ipsum dolor sit amet otom ectetuer adipielit sedru rediam

▪ Veniam, quis nostrud exerci tation ullamcorper suscipit lobortis nisl ut aliquip ex ecommodo consequat. Duis autem vel eum iriure dolor in hendrerit in vulputate velit ast esse molestie consequat, vel illum

dolore eu feugiat nulla facilisis at vero eros et accumsan et iusto odio dignissim qui blandit praesent luptatum zzril delenit augue duis dolore te feugait nulla facilisi. cum soluta eleifend option congue nihil imperdiet doming id quod mazim placerat facer possim assum. Lorem ipsum dolor sit amet, consectetuer adipiscing

The insert sheets are printed on #169 stock, which will make them quite rigid, and they have been machine varnished to protect them from scuffing.

The photograph of an off-beat flower arrangement has been commissioned to reinforce the individual theme established by the headline. A photograph of people would be more predictable and less attention grabbing.

The text, set in 9/18pt Caslon, hangs from a 4pt, 50% black rule, which sits on a line 15p10 from the top. Paragraph indents have been filled with square x-height bullets, tinted 50% black.

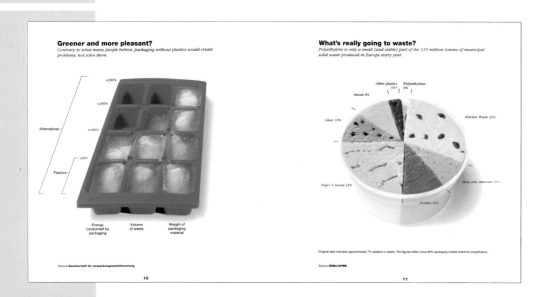

Greener and more pleasant?
Contrary to what many people believe, packaging without plastics would create problems, not solve them.

+300%
+200%
+100%
100%

Alternatives

Plastics

Energy consumed by packaging / Volume of waste / Weight of packaging material

Source Gesellschaft für verpackungsmarktforschung

10

What's really going to waste?
Polyethylene is only a small (and stable) part of the 115 million tonnes of municipal solid waste produced in Europe every year.

Other plastics 3%* / Polyethylene 4%
Metals 8%
Glass 10%
Kitchen Waste 30%
Paper & board 25%
Dust, ash, minerals 10%
Textiles 10%

*Original data indicates approximately 7% plastics in waste. The figures reflect circa 60% packaging market share for polyethylene.

Source SEMA/APME

11

Above, left and below: Finding new ways of presenting statistical data is always a challenge, and the use of food in these graphs has resulted in some strong and witty layouts. A square page is most suitable for this kind of material – a traditional portrait format would have left unwanted spaces above and below the graphs. The cover includes a clever invitation to turn the page in the form of a mock-up of a plastic cap, painted in BP's corporate green.

Right and far right: Annual reports of companies with many subsidiaries have to combine several disparate elements in an overall, unifying way. The cover is a white textured stock, and small illustrations have been blind embossed into it. The typography is understated. Within the report, one spread is devoted to each of the subsidiaries, and each has a tint panel with small illustrations, several as cut-outs, dropped into the tint. There are no headings, but the eye is led into the page along a cut-out photograph of the cow towards the italic introduction, which has a sanserif drop cap. The captions, which have a raised initial capital, are set in a condensed sanserif type.

Unwrapping the truth
The facts about polyethylene

Making lighter work of things
Improving the performance of polyethylene so that we consume less is an important route towards saving a precious, finite resource.

Weight of polyethylene to make a 1/2 litre washing-up liquid bottle

1976
Low Density Polyethylene 34g

1984
High Density Polyethylene 25g

1991
High Density Polyethylene 22g

1976
1984
1991

Source BP

12

HAMILTON EATON CENTRE

Above and right: The extreme landscape format was selected to suit the proportions of the building development the brochure was produced to promote, and it offered the designer the opportunity to prepare some elegant layouts. The rarely seen typeface Cochin has been used throughout, printed white out of dark backgrounds. Column rules with small, diamond-shaped heads have been added to the left of the unjustified text. The brochure is spiral bound.

DSC Transmission Products

Right: Simplicity is often the key to good design. Here, however, it has been taken to an extreme, with a single line of type and one illustration. What makes the layout so effective is the visual relationship between the two elements and the fact that the line of type mimics the main element of the illustration.

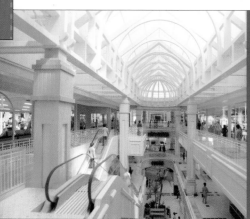

STRONG TRAFFIC FLOW

Right and below: A design company chose a large format for its own promotional brochure. The cover includes a montage of astrological symbols, in both print and photograph, and the vertically set name, Edge, is partially obscured, which is both intriguing and attractive. The layout style varies from page to page, the only uniform factor being the use of Futura Extra Black. The very large headlines and dramatic use of space have a tremendous impact, but creating a publication that follows so few layout rules and has no consistent grid requires great skill. The desire to challenge convention and break new ground should, however, always be tempered by a sense of the overriding purpose of any publication — the need to communicate.

Above and right: Centering the elements of a design will often result in a harmonious layout. Here, both text and illustrations occupy the same area. The top and bottom margins and the inner and outer margins are equal, and the text hangs from a line about one-third of the way down the page. The three text columns are not the same length, which both helps to lighten the lower section of the page and balances the extreme letter spacing of the dates at the top of the page. Visual interest has been added by the use of the black and white horizontal rules.

Above and right: When this water utility was planning its annual report, it wanted to avoid the usual formal approach and aim, instead, for a magazine-style layout with large, human-interest photographs, bright graphics, and an underlying theme of energy conservation. The cover establishes the style that runs throughout the publication.

Dear Kevin,

THEATRE

4

MUSIC

VISUAL ARTS

Lorem ipsum dolor sit amet, consecte
dolore magna aliquam erat volutpat.
suscipit lobortis nisl ut aliquip ex ea c
vulputate velit esse molestie consequa
odio dignissim qui blandit praesent lu
ipsum dolor sit amet, consectetuer ad
magna aliquam erat volutpat. Ut wisi
lobortis nisl ut aliquip ex ea commod

FREELANCE WRITER

REAL ESTATE AGENTS

LOCAL TRADESMAN

CAB COMPANY

RELAXATION GROUP

CRAFT SHOP

SANDWICH BAR

REGIONAL ARTS CENTER

DESIGN GROUP

TYSANDWICH

STATIONERY

4

CHAPTER

od tincidunt ut laoreet dolore magna aliquam erat volutpat. Ut wisi enim ad minim
m, quis nostrud exerci tation ullamcorper suscipit lobortis nisl ut aliquip ex ea
iodo consequat. Duis autem vel eum iriure dolor in .

sincerely

Franklin

BLUECABC

1068 PLANEDALE ROAD
AMHURST
ANYSTATE

Stationery is often a company's primary point of contact with its customers and clients. For a multi-national company, the stationery design may be the result of a massive corporate identity program; for a small business or organization the redesign of the stationery may be a very personal matter. Most companies commission a new design at a time of change – for example, on moving to a different address, on the appointment of a new chief executive, or on the take-over of another company – and therefore, before any fundamental design work is undertaken, it is important that the designer understands how the company is perceived, both externally and from within, and what the company's future strategy is likely to be.

The choice of paper is of particular importance. The effect created by a well-designed letterhead printed on an attractive stock will have a positive and lasting impression on the recipient. Business cards and other items such as invoices, fax headers, and order forms will probably also be required. Paper manufacturers and merchants will normally be pleased to supply enough samples for you to prepare dummies of a full range of stationery for presentation to your client.

Most letterheads are constrained by the convention, which has been followed on the examples on pages 90-111, that the recipient's address should be positioned on the left-hand side of the letter, above the salutation. If window envelopes are used, the position of the address is further restricted to ensure that, when the letter is placed into the enve-lope, the address registers exactly with the window. The position of the folds is also relevant to the layout, and the main text of the letter should begin just below the first fold. Yet another factor is the possibility that letters may be hole-punched for filing in ring binders; if this is likely, the left margin should always be at least 4p4.

The examples in the basic section demonstrate the three most natural layout options for the position of the logo on the page – that is, in the upper right-hand area, in the upper left-hand area, and centered.

The intermediate section explores other layout options, including positioning the logo at the foot of the page, creating a logo from a customized font, and using a vertical format for a business card.

The advanced level examples include an overall pictorial background to the letterhead, an invoice designed specifically to fit a window envelope, and a multi-logo design that can be adapted for use on purchase order forms and fax headers.

On the following pages the examples are reproduced at approximately 63% of the actual size. A sample of the address text is shown actual size on the left-hand page, together with a mini-version of the letterhead with the grid overlaid in blue.

basic

S T A T I O N E R Y

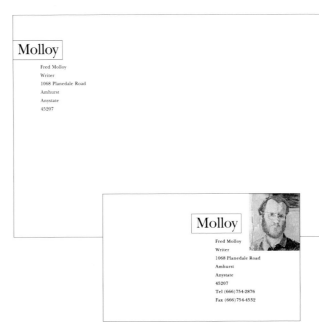

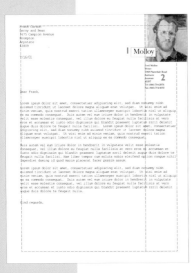

SPECIFICATIONS

Format
8½ x 11 in or A4

Letter margins
l 4p7 r 2p11
t 2p11 b 2p11

Envelope
Standard business

Business Card
3³/₈ x 2¹/₈ in

Font
New Baskerville
Track loose

1 Logo
24pt/21pt

2 Address
8/10pt Letterhead
6/8pt Business Card /
Envelope

Stock
White bond
#23/#67

BRIEF Fred Molloy, a freelance writer and journalist, wants a new look for his stationery. He specializes in consumer affairs, and his main clients are newspapers, magazines and, occasionally, television. In addition, he has a clear idea of what he likes and dislikes. He values simplicity and wants the layout of his letterhead, envelope, and business card to reflect the direct, straightforward style of his writing.

SOLUTION It is often more difficult to design for an individual than for an organization. The design needs to reflect Fred's personality, and he must feel comfortable with the result. Because he is best known by his last name, his first name has been omitted. An acrylic portrait reflects his personality better than a photograph would, and reinforces the personalized design theme. Insetting the name partially within the painting evokes a signature without resorting to a handwritten form, which would be fussy and difficult to read.

1 Abc

2 Butem vel eum iriure do lor in hen dre
rit in vulp utate velit esse illum

The recipient's address should always be on the left side of the page, but despite this constraint it is still possible to create a wide variety of letter-head designs, as the following pages demonstrate.

On the envelope (opposite) the illustration is dropped and the name "Molloy" positioned in the top-left corner.

On the business card (opposite), the word "Molloy" has not been reduced by the same amount as the painting. This would have made it too small, and insetting it in the painting at this larger size would look clumsy.

Molloy

Fred Molloy
Writer
1068 Planedale Road
Amhurst
Anystate
45207
Tel (666) 754-2876
Fax (666) 754-4532

Frank Carson
Leroy and Bean
1675 Campion Avenue
Brompton
Anystate
63809

7/16/01

FOLD

Dear Frank,

Lorem ipsum dolor sit amet, consectetuer adipiscing elit, sed diam nonummy nibh euismod tincidunt ut laoreet dolore magna aliquam erat volutpat. Ut wisi enim ad minim veniam, quis nostrud exerci tation ullamcorper suscipit lobortis nisl ut aliquip ex ea commodo consequat. Duis autem vel eum iriure dolor in hendrerit in vulputate velit esse molestie consequat, vel illum dolore eu feugiat nulla facilisis at vero eros et accumsan et iusto odio dignissim qui blandit praesent luptatum zzril delenit augue duis dolore te feugait nulla facilisi. Lorem ipsum dolor sit amet, consectetuer adipiscing elit, sed diam nonummy nibh euismod tincidunt ut laoreet dolore magna aliquam erat volutpat. Ut wisi enim ad minim veniam, quis nostrud exerci tation ullamcorper suscipit lobortis nisl ut aliquip ex ea commodo consequat.

Duis autem vel eum iriure dolor in hendrerit in vulputate velit esse molestie consequat, vel illum dolore eu feugiat nulla facilisis at vero eros et accumsan et iusto odio dignissim qui blandit praesent luptatum zzril delenit augue duis dolore te feugait nulla facilisi. Nam liber tempor cum soluta nobis eleifend option congue nihil imperdiet doming id quod mazim placerat facer possim assum.

Lorem ipsum dolor sit amet, consectetuer adipiscing elit, sed diam nonummy nibh euismod tincidunt ut laoreet dolore magna aliquam erat volutpat. Ut wisi enim ad minim veniam, quis nostrud exerci tation ullamcorper suscipit lobortis nisl ut aliquip ex ea commodo consequat. Duis autem vel eum iriure dolor in hendrerit in vulputate velit esse molestie consequat, vel illum dolore eu feugiat nulla facilisis at vero eros et accumsan et iusto odio dignissim qui blandit praesent luptatum zzril delenit augue duis dolore te feugait nulla.

Kind regards,

FOLD

The strong vertical line produced by the address ranging on the left side of the portrait is broken by the name "Molloy" in the ½pt box. A serif face is appropriate for a writer's letterhead, and New Basker-ville, with its large x-height and good legibility, has been used throughout.

The letter will be folded twice to fit a standard business envelope, and the fold marks are indicated on the page. The text should always be started just, below the first fold, and the Dear ... just above it. This leaves a third of the page for the letter.

The left margin is wider than the other margins so that the letter can be hole-punched for filing if required.

The traditional text size for letters is based on 12pt leading, which originated from the limitations of the typewriter. Today, with laser, ink-jet, and even dot-matrix printers, there is no such limitation. It is, however, impor-tant to decide on the availability of text fonts before creating the design.

All items print black only.

CLIENT

real estate agents

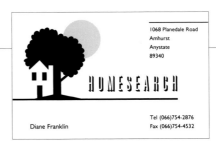

1068 Planedale R
Amhurst
Anystate
89340

1068 Planedale Road
Amhurst
Anystate
89340

Diane Franklin

Tel (066)754-2876
Fax (066)754-4532

SPECIFICATIONS

Format
8.5 x 11 in or A4

Letter margins
l 4p7 r 2p11
t 2p11 b 2p11

Envelope
Standard business

Business Card
$3^3/8$ x $2^1/8$ in

Fonts
Graphik Shadow
Track force justify
1 Logo
24pt

Gill Sans
Track normal
2 Address
9/13½pt Letterhead
7/10½pt Business Card /
Envelope
3 Name on business card
8pt

Stock
Pale cream laid
#27/#67

BRIEF A small chain of residential real estate agents has commissioned a new visual identity that will be used on stationery as well as on shop sale boards, and property details. Because the customers are the public, rather than other businesses, it is important that the design conveys the company's friendly and reassuring, yet efficient, approach. The letterhead will also be used for mailing property details, so an adaptable layout is essential.

SOLUTION A simple graphic symbol and logo have been devised to create a strong identity, and the typeface chosen for the name of the company, with its drop-shadow and no outline, reflects the style of the house illustration. Property details, unlike letters, require the maximum page area to be available, so the logo and address have been kept to the top one-sixth of the page. Positioning the logo on the left of the page restricts the space available for the recipient's address, and so the date and reference information have been placed on the right.

1 ABC

2 Butem vel eum iriure do lor in hen dre
rit in vulp utate velit esse illum

The right side of the white house aligns with the left side of the text, which helps to unify the design.

The logo echoes the illustration style with a shadow but no outline. Both are anchored by a 2pt rule.

The symbol is a simple line illustration with the sun emerging from behind the tree. It has been tinted 20% black. If a second color was available, orange or red spot color could be used to great effect.

A 2pt rule ranges with the address details and balances the rule on the other side. It is positioned so that the space between it and the first line is visually equal to the spaces between the lines of the Homesearch address.

1068 Planedale Road
Amhurst
Anystate
89340
Tel (066)754-2876
Fax (066)754-4532

Ms. Carson
1675 Campion Avenue
Brompton
Anystate
89362

7/16/01

Ref.WCL001

Dear Ms. Carson,

Lorem ipsum dolor sit amet, consectetuer adipiscing elit, sed diam nonummy nibh euismod tincidunt ut laoreet dolore magna aliquam erat volutpat. Ut wisi enim ad minim veniam, quis nostrud exerci tation ullamcorper suscipit lobortis nisl ut aliquip ex ea commodo consequat. Duis autem vel eum iriure dolor in hendrerit in vulputate velit esse molestie consequat, vel illum dolore eu feugiat nulla facilisis at vero eros et accumsan et iusto odio dignissim qui blandit praesent luptatum zzril delenit augue duis dolore te feugait nulla facilisi. Lorem ipsum dolor sit amet, consectetuer adipiscing elit, sed diam nonummy nibh euismod tincidunt ut laoreet dolore magna aliquam erat volutpat. Ut wisi enim ad minim veniam, quis nostrud exerci tation ullamcorper suscipit lobortis nisl ut aliquip ex ea commodo consequat.

Duis autem vel eum iriure dolor in hendrerit in vulputate velit esse molestie consequat, vel illum dolore eu feugiat nulla facilisis at vero eros et accumsan et iusto odio dignissim qui blandit praesent luptatum zzril delenit augue duis dolore te feugait nulla facilisi. Nam liber tempor cum soluta nobis eleifend option congue nihil imperdiet doming id quod mazim placerat facer possim assum.

Lorem ipsum dolor sit amet, consectetuer adipiscing elit, sed diam nonummy nibh euismod tincidunt ut laoreet dolore magna aliquam erat volutpat. Ut wisi enim ad minim veniam, quis nostrud exerci tation ullamcorper suscipit lobortis nisl ut aliquip ex ea commodo consequat. Duis autem vel eum iriure dolor in .

Yours sincerely,

Diane Franklin
Senior Negotiator

enc

FOLD

FOLD

On the envelope (opposite) the logo is reduced to 50%. If it were used full size it would clash with the address.

On the business card (opposite), the symbol, logo, and rule are the same size as on the letterhead and envelope, but the address is smaller and the telephone and fax numbers are separated from the rest of the address. The cardholder's name aligns with imagined left edge of the house illustration. The top and bottom margins are 1p2.

The word processor will need to be set up so that the tabs for the date and reference align exactly with the printed address details.

Because the client makes extensive use of Times Roman, this face has been used for the letter text. It complements the Gill used for the stationery.

CLIENT

local tradesman

The Plumber

Larry Winkler
The Plumber
1068 Planedale P
Amhurst
Anystate
45207

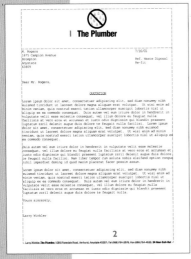

SPECIFICATIONS

Format
8½ x 11 in or A4

Letter margins
l 4p7 r 2p11
t 2p11 b 2p11

Envelope
Standard business

Business Card
3³/₈ x 2¹/₈ in

Fonts
Helvetica Black Condensed
Track normal
1 Logo
27pt/23pt

Helvetica Condensed
2 Address etc.
9pt Letterhead
7/12pt Business Card /
Envelope

Stock
White bond
#27/#67

BRIEF Larry Winkler is a self-employed plumber. New business comes mainly by word-of-mouth, but he has decided to test a strategy of posting business cards through mailboxes in his neighborhood. He has, therefore, commissioned a range of stationery, including business cards. Much of his work involves responding quickly to emergencies such as burst pipes, but he also does routine jobs such as fitting new appliances. He prides himself on reliability and efficiency, and would like his stationery to reflect these qualities.

SOLUTION The customer's response to an emergency is to "call the plumber," so with this in mind an identity consisting of a "no drips" symbol reminiscent of a traffic sign and a logo that says, simply, "The Plumber" has been devised. This looks professional, but also reassuring. His name appears only in the address line at the bottom of the page. The typographical style is uncomplicated, and the centered format gives the design a simple strength.

1 **Abc**

2 Butem vel eum iriure do lor in hen dre rit in vulp utate velit esse illum

The symbol is easily formed from a circle and diagonal rule, both 5pt thick. The droplet shape is created by using a graphics program or line artwork, and is repeated 11 times in a random arrangement. The droplets are then tinted 40% black.

The words "The Plumber" are set in Helvetica Black Condensed. The 23pt letter forms are roughly the same thickness as the circle and rule of the symbol, which helps to unify the identity.

On the envelope (opposite) the logo is reduced to 50% and dropped into the top left-hand corner.

The business card uses the symbol/logo reduced to 85% and centered on a line 6p8 from the left edge of the card. The address is ranged left and positioned on a line 6p from the right edge. The top and bottom margins are 1p4.

Helvetica Condensed and Helvetica Black Condensed are specified for all items. This allows for a reasonably large type size to be used for the address, which is particularly important when it is set in a single line.

With a centered main image, it is desirable to position the address at the bottom of the page. If it were in a block at either the top left or the top right, it would unbalance the layout; if it were in a block centered below the logo, it would become confused with the addressee copy; and if it were set as a single line immediately below the logo, it would have to be uncomfortably close to the logo to leave enough space for the recipient's address.

The letter, which will be created using a basic word processing system, will be used mainly for supplying quotations. The invoice will follow the same format.

The business cards that are used for the mail drop will be laminated on both sides in a plastic "sandwich." This makes them totally waterproof, a quality the client hopes will not be lost on his customers.

Combining the light and very bold faces in the address highlights the words "The Plumber" and "24 Hour Call-Out," and adds a sales statement to the copy without being too intrusive.

FOLD

FOLD

The Plumber

M. Rogers
1675 Campion Avenue
Brompton
Anystate
63809

7/16/01

Ref. Waste Diposal
Re-fit

Dear Mr. Rogers,

QUOTATION

Lorem ipsum dolor sit amet, consectetuer adipiscing elit, sed diam nonummy nibh euismod tincidunt ut laoreet dolore magna aliquam erat volutpat. Ut wisi enim ad minim veniam, quis nostrud exerci tation ullamcorper suscipit lobortis nisl ut aliquip ex ea commodo consequat. Duis autem vel eum iriure dolor in hendrerit in vulputate velit esse molestie consequat, vel illum dolore eu feugiat nulla facilisis at vero eros et accumsan et iusto odio dignissim qui blandit praesent luptatum zzril delenit augue duis dolore te feugait nulla facilisi. Lorem ipsum dolor sit amet, consectetuer adipiscing elit, sed diam nonummy nibh euismod tincidunt ut laoreet dolore magna aliquam erat volutpat. Ut wisi enim ad minim veniam, quis nostrud exerci tation ullamcorper suscipit lobortis nisl ut aliquip ex ea commodo consequat.

Duis autem vel eum iriure dolor in hendrerit in vulputate velit esse molestie consequat, vel illum dolore eu feugiat nulla facilisis at vero eros et accumsan et iusto odio dignissim qui blandit praesent luptatum zzril delenit augue duis dolore te feugait nulla facilisi. Nam liber tempor cum soluta nobis eleifend option congue nihil imperdiet doming id quod mazim placerat facer possim assum.

Lorem ipsum dolor sit amet, consectetuer adipiscing elit, sed diam nonummy nibh euismod tincidunt ut laoreet dolore magna aliquam erat volutpat. Ut wisi enim ad minim veniam, quis nostrud exerci tation ullamcorper suscipit lobortis nisl ut aliquip ex ea commodo consequat. Duis autem vel eum iriure dolor in hendrerit in vulputate velit esse molestie consequat, vel illum dolore eu feugiat nulla facilisis at vero eros et accumsan et iusto odio dignissim qui blandit praesent luptatum zzril delenit augue duis dolore te feugait nulla.

Yours sincerely,

Larry Winkler

Larry Winkler, **The Plumber**, 1068 Planedale Road, Amhurst, Anystate 45207, Tel (666)754-2876, Fax (666)754-4532, **24 Hour Call-Out**

Larry Winkler
The Plumber
1068 Planedale Road
Amhurst
Anystate
45207

Tel (666)754-2876
Fax (666)754-4532
24-Hour Call-Out

All copy prints black.

93

CLIENT

cab company

BLUECABCO

1068 PLANEDALE ROAD
AMHURST
ANYSTATE
45207

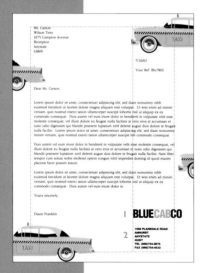

SPECIFICATIONS

Format
8½ x 11 in or A4

Letter margins
l 5p r 5p
t 4p1 b 2p11

Envelope
Standard business

Business Card
3³/₈ x 2¹/₈ in

Fonts
Helvetica Black Condensed
Track normal
1 Logo
 36pt
2 Address
 8½/12pt Letterhead
 6½/9½pt Business Card /
 Envelope
Helvetica Regular
Job Title on business card
8½pt

Stock
White bond #27
Cast-coated board #80

BRIEF The Blue Cab Company has taken the bold decision to paint all its cabs blue in an attempt to distinguish itself from its rivals. This new color scheme is to be accompanied by new stationery. The brief is clear: the company wants an unusual, striking, and memorable design that can be extended at a later date to include items such as flyers, posters, and other promotional pieces. The budget is sufficient to allow for a creative approach that is not necessarily restricted to a single color.

SOLUTION The company name has been shortened to BLUECABCO, and this is made legible by introducing a second color – blue. A line illustration of a cab has been commissioned, and this uses the second color on the body panels. The device has been used four times on the letterhead to imply a fleet of cabs, and the staggered images, all partly cropped, bleed off the page help to create a sense of movement. The envelope and business card both incorporate adaptations of this novel approach.

1 **Abc**

2 **Butem vel eum iriure do lor in hen
dre rit in vulp utate velit esse illum**

Several illustrators presented their work before the most appropriate style was chosen. To achieve a strong graphic effect the cab was drawn exactly side-on and used as a cut out, with no background tone.

The unusual layout places a number of constraints on the letterhead. The restricted space for the letter is justified because of the impact of the design. BLUECABCO's letters are seldom longer than this, and if they are, blank continuation sheets are available. A large margin, 5p, is required on the right so that the letter does not overlap the illustration.

The date and reference at the top align with the logo at the bottom of the page, and are 16p5 from the right edge. The car at the top also aligns visually with the logo, adding an element of uniformity to an asymmetrical layout.

Ms. Carson
Wilson Tires
1675 Campion Avenue
Brompton
Anystate
63809

7/16/01

Your Ref. Blu7803

Dear Ms. Carson,

Lorem ipsum dolor sit amet, consectetuer adipiscing elit, sed diam nonummy nibh euismod tincidunt ut laoreet dolore magna aliquam erat volutpat. Ut wisi enim ad minim veniam, quis nostrud exerci tation ullamcorper suscipit lobortis nisl ut aliquip ex ea commodo consequat. Duis autem vel eum iriure dolor in hendrerit in vulputate velit esse molestie consequat, vel illum dolore eu feugiat nulla facilisis at vero eros et accumsan et iusto odio dignissim qui blandit praesent luptatum zzril delenit augue duis dolore te feugait nulla facilisi. Lorem ipsum dolor sit amet, consectetuer adipiscing elit, sed diam nonummy minim veniam, quis nostrud exerci tation ullamcorper suscipit lob commodo consequat.

Duis autem vel eum iriure dolor in hendrerit in vulputate velit esse molestie consequat, vel illum dolore eu feugiat nulla facilisis at vero eros et accumsan et iusto odio dignissim qui blandit praesent luptatum zzril delenit augue duis dolore te feugait nulla facilisi. Nam liber tempor cum soluta nobis eleifend option congue nihil imperdiet doming id quod mazim placerat facer possim assum.

Lorem ipsum dolor sit amet, consectetuer adipiscing elit, sed diam nonummy nibh euismod tincidunt ut laoreet dolore magna aliquam erat volutpat. Ut wisi enim ad minim veniam, quis nostrud exerci tation ullamcorper suscipit lobortis nisl ut aliquip ex ea commodo consequat. Duis autem vel eum iriure dolor in .

Yours sincerely,

Diane Franklin

The envelope (opposite) follows the design of the business card, but the illustrations are reduced to 75%

Garamond has been chosen as the text face for the letter. Its elegant, slightly extended characters complement the bolder, condensed face used elsewhere.

Printing is in two colors – black and blue. The cab illustration is in black line, with a flat 30% blue tint added. The word CAB also prints blue.

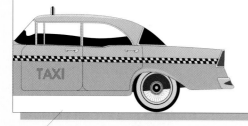

BLUECAB**CO**

1068 PLANEDALE ROAD
AMHURST
ANYSTATE
45207
TEL (666)754-2876
FAX (666)754-4532

The business card follows the design theme, but with the cardholder's job title in normal weight rather than extra bold. The margins are 1p2 all round.

The printers must take especial care to trim all items accurately because the wheel of the car at the foot of the page must sit exactly on the trimmed edge.

The robust design requires a bolder than normal face for the address, particularly as it is at the bottom of the page.

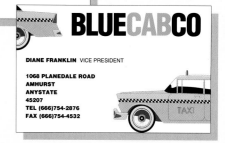

BLUECAB**CO**

DIANE FRANKLIN VICE PRESIDENT

1068 PLANEDALE ROAD
AMHURST
ANYSTATE
45207
TEL (666)754-2876
FAX (666)754-4532

CLIENT

relaxation group

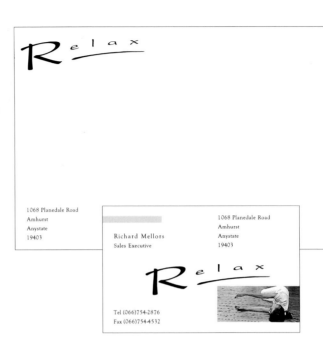

SPECIFICATIONS

Format
8½ x 11 in or A4

Letter margins
l 4p10 r 4p10
t 2p11 b 2p11

Envelope
Standard business

Business Card
3³/₈ x 2¹/₈ in

Fonts
President
Track: see opposite
1 Logo
 15pt, 36pt initial cap
Goudy Old Style
Track very loose
2 Address
 9/15pt Letterhead
 7/11pt Business Card /
 Envelope
3 Name on business card
 9pt

Stock
Pale green parchment-effect
#27/#67

BRIEF Relax is a relaxation group that uses yoga, biorhythms, diet, exercise, and other techniques to promote personal well-being. It has commissioned a new look for its stationery in an attempt to increase membership by shedding a rather eccentric, hippy image in favor of a modern, business-like one. Because image is so important, the client provided a budget that allows for the possibility of full-color production.

SOLUTION A fresh, clean design approach has been devised, incorporating a distinctive logo with a handwritten style (although it is, in fact, a distorted font). This is associated with a color photograph of a client in an exercise group. The layout is formal and restrained, but the formality is interrupted by the logo, with its large initial cap and extra letter spacing. It is set on a shallow arc, and the face has been stretched horizontally to 250%, creating a visual metaphor for the exercise taken by the members.

2 Butem vel eum iriure do lor in hen
 dre rit in vulp utate velit esse illum

A 12pt rule, printing 20% black, bleeds off at the top left, balancing the photograph that bleeds off on the right.

The logo has been created using a graphics package, although it could be

accomplished by using Letraset or by cutting up the letters of a

typeset proof, reconstituting them in the desired positions,

retouching the joins and making a PMT of the resulting artwork.

The photograph, which was taken in the exercise studio, is one of a sequence of shots taken for the stationery and other publicity purposes. Because photographers are expensive to hire, it is important to anticipate possible future requirements so you can avoid having to repeat the expense a few months later.

Goudy Old Style has been selected for all copy apart from the logo. It is set with very loose spacing, which contributes to the open look of the layout.

The logo is used on the envelope (opposite) and is reduced to 75%.

The logo and photograph, reduced to 75%, are used on the business card (opposite). The margins are 1p at top and bottom, and 1p2 at the left. The address is ranged left on a line 8p6 from the right edge. The name of the cardholder is 2pt larger than the address and job description, and the 8pt rule is 6p wide.

FOLD

FOLD

1068 Planedale Road
Amhurst
Anystate
19403
Tel (066)754-2876
Fax (066)754-4532

Ms. G. Wilson
1675 Campion Avenue
Brompton
Anystate
19422

7/16/01
Your Ref. Blu7803

Dear Ms Wilson,

Lorem ipsum dolor sit amet, consectetuer adipiscing elit, sed diam nonummy nibh euismod tincidunt ut laoreet dolore magna aliquam erat volutpat. Ut wisi enim ad minim veniam, quis nostrud exerci tation ullamcorper suscipit lobortis nisl ut aliquip ex ea commodo consequat. Duis autem vel eum iriure dolor in hendrerit in vulputate velit esse molestie consequat, vel illum dolore eu feugiat nulla facilisis at vero eros et accumsan et iusto odio dignissim qui blandit praesent luptatum zzril delenit augue duis dolore te feugait nulla facilisi. Lorem ipsum dolor sit amet, consectetuer adipiscing elit, sed diam nonummy nibh euismod tincidunt ut laoreet dolore magna aliquam erat volutpat. Ut wisi enim ad minim veniam, quis nostrud exerci tation ullamcorper suscipit lobortis nisl ut aliquip ex ea commodo consequat.

Duis autem vel eum iriure dolor in hendrerit in vulputate velit esse molestie consequat, vel illum dolore eu feugiat nulla facilisis at vero eros et accumsan et iusto odio dignissim qui blandit praesent luptatum zzril delenit augue duis dolore te feugait nulla facilisi. Nam liber tempor cum soluta nobis eleifend option congue nihil imperdiet doming id quod mazim placerat facer possim assum.

Lorem ipsum dolor sit amet, consectetuer adipiscing elit, sed diam nonummy nibh euismod tincidunt ut laoreet dolore magna aliquam erat volutpat. Ut wisi enim ad minim veniam, quis nostrud exerci tation ullamcorper suscipit lobortis nisl ut aliquip ex ea commodo consequat. Duis autem vel eum iriure dolor in hendrerit in vulputate velit esse molestie consequat, vel illum dolore eu feugiat nulla facilisis at vero eros et accumsan et iusto odio dignissim qui blandit praesent luptatum zzril delenit augue duis dolore te feugait nulla.

Lorem ipsum dolor sit amet, consectetuer adipiscing elit, sed diam nonummy nibh euismod tincidunt ut laoreet dolore magna aliquam erat volutpat. Ut wisi enim ad minim veniam, quis nostrud exerci tation ullamcorper suscipit lobortis nisl ut aliquip ex ea commodo consequat. Duis autem vel eum iriure dolor in hendrerit in vulputate velit esse molestie consequat, vel illum dolore eu feugiat nulla facilisis at vero eros et accumsan et iusto odio dignissim qui blandit praesent luptatum zzril delenit augue duis dolore te feugait nulla facilisi. Lorem ipsum dolor sit amet, consectetuer adipiscing elit, quis nostrud exerci tation ullamcorper suscipit lobortis nisl ut aliquip ex ea commodo consequat.

Kind regards

Richard Mellors

The letter text is set justified rather than ranged left, which reinforces the formality of the design but requires wide – 4p10 – margins at the sides and considerable leading of the text.

The logo is set in 36pt and 15pt President, expanded to 250% and letter spaced to the desired amount. The cap "R" is then lowered to align visually with the underline. This underline is a lower case "l," rotated through 90 degrees and stretched to the desired length. This is used in preference to a rule as it retains the handdrawn character of the name. Finally, the completed logo is bent around a shallow arc using the software program's envelope function.

A #27 pale green, parchment-effect paper has been chosen, with a matching #67 board used for the business card. The color photograph

prints four-color onto the pale green, which changes its color balance, but in a way that is pleasing and attractive. Care should always be

taken when color images are printed on a colored stock – a white bird on a brown paper might, for example, look dirty and unpleasant.

A sans serif face, Univers Light, is used for the text. It gives the letter a lighter appearance than a more traditional face, such as Times.

CLIENT

craft shop

SPECIFICATIONS

Format
8½ x 11 in or A4

Letter margins
l 4p10 r 4p1
t 2p5 b 2p11

Envelope
Standard business

Business Card
3³/₈ x 2¹/₈ in

Font
Caslon Italic
Track loose

1 Logo
10pt, 15pt, 10pt
8pt, 12pt, 8pt
See opposite for "n"

2 Address
8/10pt Letterhead
7/9pt Business Card /
Envelope

3 Job Title on business card
6pt

Stock
Ivory bond #24/#74

BRIEF The Needlepoint Shop requires a new image – one that retains the traditional craft identity, but that also conveys the impression of a modern, well-organized business. The owner would like to create a franchised chain of similar shops using The Needlepoint Shop brandname, and so the new design has an added significance. A strong, memorable design, which can be exploited in future promotional and point-of-sale items and advertising, is essential.

SOLUTION Careful consideration has been given to the development of the logo. The result is a device combining a graphic representation of a canvas frame combined with a large lower case "n," with the linking strokes tapered into fine lines, which become strands of "thread." A drop shadow is included behind the "n," and this gives the design a three-dimensional quality. The words "The Needlepoint Shop" are included within the border. An unusual feature is the vertical format of the business card.

1 *Abc*

2 *Butem vel eum iriure do lor in hen*
 dre rit in vulp utate velit esse illum

The envelope (opposite) uses the logo reduced to 50%. "The Needlepoint Shop" is taken out of the decorative border and positioned below; type size is as for business card.

The business card (opposite) uses the logo device reduced to 93% and centered on the width of the card, which is used vertically. The margins are 1p5 at the top and 1p10 at the foot.

The face used throughout is Caslon italic, a traditional serif face. Caslon roman is used for the text of the letter. Although they are from the same font family, the italic face looks very different from the roman, and is very much more condensed.

Elspeth Tweedle
Debden Yarns
1675 Campion Avenue
Brompton
Anystate
19622

7/16/01

The
Needlepoint
Shop

Dear Elspeth,

Lorem ipsum dolor sit amet, consectetuer adipiscing elit, sed diam nonummy nibh euismod tincidunt ut laoreet dolore magna aliquam erat volutpat. Ut wisi enim ad minim veniam, quis nostrud exerci tation ullamcorper suscipit lobortis nisl ut aliquip ex ea commodo consequat. Duis autem vel eum iriure dolor in hendrerit in vulputate velit esse molestie consequat, vel illum dolore eu feugiat nulla facilisis at vero eros et accumsan et iusto odio dignissim qui blandit praesent luptatum zzril delenit augue duis dolore te feugait nulla facilisi. Lorem ipsum dolor sit amet, consectetuer adipiscing elit, sed diam nonummy euismod tincidunt ut laoreet dolore magna aliquam erat volutpat. Ut wisi enim ad minim veniam, quis nostrud exerci tation ullamcorper suscipit lobortis nisl ut aliquip ex ea commodo consequat.

Duis autem vel eum iriure dolor in hendrerit in vulputate velit esse molestie consequat, vel illum dolore eu feugiat nulla facilisis at vero eros et accumsan et iusto odio dignissim qui blandit praesent luptatum zzril delenit augue duis dolore te feugait nulla facilisi. Nam liber tempor cum soluta nobis eleifend option congue nihil imperdiet doming id quod mazim placerat facer possim assum. Ut wisi enim ad minim veniam, quis nostrud exerci tation ullamcorper suscipit lobortis nisl ut aliquip ex ea commodo consequat. Duis autem vel eum iriure dolor in hendrerit in vulputate velit esse molestie consequat, vel illum dolore eu feugiat nulla facilisis at vero eros et accumsan et iusto odio dignissim qui blandit praesent luptatum zzril delenit augue duis dolore te feugait nulla facilisi. Lorem ipsum dolor sit amet, consectetuer adipiscing elit, sed diam nonummy nibh ut laoreet dolore magna aliquam erat volutpat.

Lorem ipsum dolor sit amet, consectetuer adipiscing elit, sed diam nonummy nibh euismod tincidunt ut laoreet dolore magna aliquam erat volutpat. Ut wisi enim ad minim veniam, quis nostrud exerci tation ullamcorper suscipit lobortis nisl ut aliquip ex ea commodo consequat. Duis autem vel eum iriure dolor in hendrerit in vulputate velit esse molestie consequat, vel illum dolore eu feugiat nulla facilisis at vero eros et accumsan et iusto odio dignissim qui blandit praesent luptatum zzril delenit augue te feugait nulla.

Kind regards,

1068 Planedale Road
Amhurst
Anystate
19659
Tel (666)754-2876

Lorna Holmes

The border is made from 4pt squares separated by 1½pt spaces.

15pt space

The device featuring the lower case "n" has been created by using a graphics program to taper the letter forms and add the "thread." An alternative method is to set the "n" oversize – e.g., 300% – to draw in the trailing ends at 1pt line width, and then to paint them out so that they taper smoothly. The drop shadow is simply a duplicate, offset to the bottom right and printed 100% medium-blue.

The address is positioned at the bottom of the page but still centered on the width of the logo device. Both are set in Caslon italic, which creates a visual link between them, and although they are separated it is clear the address refers to The Needlepoint Shop.

Because the client wants to project an environmentally responsible image, a 100% recycled paper – containing no virgin pulp, only post-consumer waste – has been chosen, with a matching #74 board used for the business card.

Printing is black and medium-blue. The border device and drop shadow print blue; everything else prints black.

CLIENT

sandwich bar

SANDRA DEAN

CITY SANDWICH
1068 PLANEDALE ROAD
AMHURST
ANYSTATE
45207

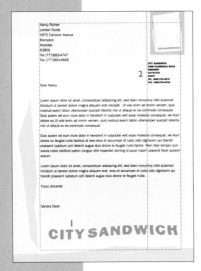

SPECIFICATIONS

Format
8½ x 11 in or A4

Letter margins
l 7p8 r 2p11
t 2p11 b 2p11

Envelope
Standard business

Business Card
3³/₈ x 2¹/₈ in

Font
Franklin Heavy Gothic
Track very loose
1 Logo: see opposite
44pt

Track normal
2 Address etc.
8/10pt Letterhead/Envelope
7/9pt Business Card

Stock
Brilliant white
ultra-smooth #24
Cast-coated board
#80

BRIEF City Sandwich is a well-known chain of sandwich bars, specializing in take-out, lunch-time food. A new visual identity, including the stationery, is required, and although the brief is fairly open, this is a competitive market, and every opportunity must be seized to distinguish City Sandwich from other companies offering the same service. A design that could be adapted for use on menus, both the printed version and a large whiteboard display, would be an advantage.

SOLUTION A business selling low-value products such as sandwiches cannot generally afford to spend money on advertising, and so it was decided that the name, City Sandwich, should be printed on the bags, which would make every customer a potential advertisement. The name is set conventionally on the bags, but a graphic illustration of the bag has been created using attractive pastel colors. This is the visual identity. The bag device is repeated in more muted tones as an overall bleed illustration covering the entire letterhead.

1 **Abc**

2 **Butem vel eum iriure do lor in hen dre rit in vulp utate velit esse illum**

The address is set Franklin Gothic Heavy caps and ranged left to align

with the smaller illustration. It overprints 100% black on the

background illustration.

There is no keyline around the edge of the illustration.

On the envelope (opposite) the logo is used the same size as on the business card, but without the overall background.

The bag illustration has been drawn using a graphics program. The simple shapes have been created with the freehand drawing tool, and the name, set in Franklin Gothic Heavy and letter spaced slightly, has been distorted by means of the envelope editing tool to mimic a crumpled shape. The bag shape could be made by using roughly cut sheets of black paper to create line artwork, and this would, in fact, be quicker than using the graphics program. Distorting the name would be more difficult, however, although it could be typeset and digitally created, before being pasted down on the artwork.

The smaller bag illustration uses the two spot colors, blue and pink, at 100% strength. Pink, at 30%, has been added to the blue to create a slightly deeper, third color – purple – for the name.

Nancy Richter
Landon Foods
1675 Campion Avenue
Brompton
Anystate
63809
Tel (777)893-4747
Fax (777)893-4848

CITY SANDWICH

CITY SANDWICH
1068 PLANEDALE ROAD
AMHURST
ANYSTATE
45207
TEL (666)754-2876
FAX (666)754-4532

Dear Nancy

Lorem ipsum dolor sit amet, consectetuer adipiscing elit, sed diam nonummy nibh euismod tincidunt ut laoreet dolore magna aliquam erat volutpat. Ut wisi enim ad minim veniam, quis nostrud exerci tation ullamcorper suscipit lobortis nisl ut aliquip ex ea commodo consequat. Duis autem vel eum iriure dolor in hendrerit in vulputate velit esse molestie consequat, vel illum dolore eu Ut wisi enim ad minim veniam, quis nostrud exerci tation ullamcorper suscipit lobortis nisl ut aliquip ex ea commodo consequat.

Duis autem vel eum iriure dolor in hendrerit in vulputate velit esse molestie consequat, vel illum dolore eu feugiat nulla facilisis at vero eros et accumsan et iusto odio dignissim qui blandit praesent luptatum zzril delenit augue duis dolore te feugait nulla facilisi. Nam liber tempor cum soluta nobis eleifend option congue nihil imperdiet doming id quod mazim placerat facer possim assum.

Lorem ipsum dolor sit amet, consectetuer adipiscing elit, sed diam nonummy nibh euismod tincidunt ut laoreet dolore magna aliquam erat eros et accumsan et iusto odio dignissim qui blandit praesent luptatum zzril delenit augue duis dolore te feugait nulla.

Yours sincerely

Sandra Dean

On the business card both illustrations are reduced to 75%. Their relative positions remain the same as on the letterhead, but the large illustration is cropped on all sides except the top so that it fits within the shape of the card. The margin to the right of the small illustration is 1p10, as are the margins to the left and below the address. Allow one line space between the cardholder's name and the address.

CITY SANDWICH

The letter text is set in Franklin Gothic Roman. There is an extra-wide margin on the left so that the letter does not fall within the long, vertical white shape in the background

illustration. Even though the background colors are pale tints and the letter text will read clearly when it is overprinted on them, this would look a little messy.

40% blue
40% pink
40% blue + 15% pink

SANDRA DEAN

CITY SANDWICH
1068 PLANEDALE ROAD
AMHURST
ANYSTATE
45207
TEL (666)754-2876
FAX (666)754-4532

CITY SANDWICH

Blue
Pink

Blue+
30%
Pink

advanced
STATIONERY

regional arts center

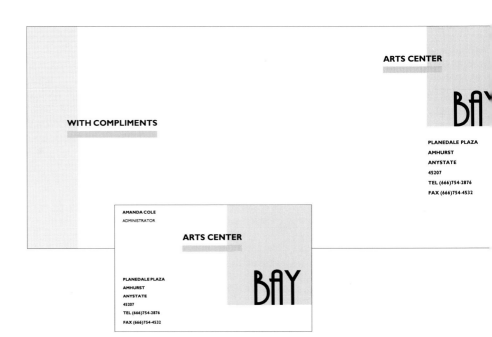

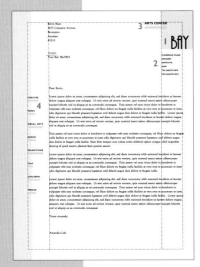

SPECIFICATIONS

Format
8½ x 11 in or A4

Letter margins
l 4p7 r 4p2
t 2p11 b 2p11

Compliment Slip
33% letterhead depth

Envelope
Standard business

Business Card
3³/₈ x 2¹/₈ in

Fonts
Plaza
Track: see opposite
1 Logo
55pt

Gill Bold
Track normal
2 Address
6/12pt Letterhead / Comp Slip
5/12pt Business Card / Envelope
3 Arts Center, With Compliments
15pt
4 List
7/42pt

Gill Sans
5 Job Title
5/10pt

Stock
White 100% cotton #24
Recycled board #80

BRIEF The Bay Arts Center, an important regional center for the visual and performing arts, is situated in an impressive coastal location. A new visual identity and stationery have been commissioned, and it is important that the center's international reputation is reflected in the design solution. A comprehensive range of stationery will be needed, and so flexibility is an important factor, while an indication of the variety of arts on offer would be an advantage.

SOLUTION A cool, refined, and elegant design using a purely typographical approach, with colored panels and rules to provide visual interest, is proposed. Achieving such simplicity, which creates a classic and timeless effect, is a severe test of layout skills, as proportion, use of white space, and typography are the primary design tools to be employed. This uncomplicated approach has the additional advantage that it makes the design easier to adapt for use on a wide variety of items. This flexibility extends to the logo, which can be bled off on either the left or right side.

1

2 **Butem vel eum iriure do lor in hen dre rit in vulp utate**

Printing is in black plus two non-process colors. The panels on the left and behind the logo print mid-olive green, while the horizontal rules print burgundy red.

The compliments slip (opposite) repeats the layout of the letterhead, with the words "With Compliments" being aligned horizontally with the word "Bay." The rule hangs a 6pt space beneath it and 4p7 from the left edge.

The business card (opposite) also follows the layout of the letterhead, but the panel on the left has been deleted and the name and job title are set in 5pt with margins of 7pt at the top, left, and bottom. To distinguish it from the name, the job title is set in roman rather than bold.

The thick rules — 8pt and 6pt — are a feature of the design. Not only do they add visual interest, but they are essential for strengthening the small size of the copy set in Gill Bold.

FOLD

FOLD

Kevin Ryan
1675 Campion Avenue
Brompton
Anystate
45310

7/16/01
Your Ref. Blu7803

ARTS CENTER

BAY

PLANEDALE PLAZA
AMHURST
ANYSTATE
45207
TEL (666)754-2876
FAX (666)754-4532

Dear Kevin,

THEATRE

MUSIC

VISUAL ARTS

DANCE

EXHIBITIONS

FILM

CHILDREN

FRINGE

Lorem ipsum dolor sit amet, consectetuer adipiscing elit, sed diam nonummy nibh euismod tincidunt ut laoreet dolore magna aliquam erat volutpat. Ut wisi enim ad minim veniam, quis nostrud exerci tation ullamcorper suscipit lobortis nisl ut aliquip ex ea commodo consequat. Duis autem vel eum iriure dolor in hendrerit in vulputate velit esse molestie consequat, vel illum dolore eu feugiat nulla facilisis at vero eros et accumsan et iusto odio dignissim qui blandit praesent luptatum zzril delenit augue duis dolore te feugait nulla facilisi. Lorem ipsum dolor sit amet, consectetuer adipiscing elit, sed diam nonummy nibh euismod tincidunt ut laoreet dolore magna aliquam erat volutpat. Ut wisi enim ad minim veniam, quis nostrud exerci tation ullamcorper suscipit lobortis nisl ut aliquip ex ea commodo consequat.

Duis autem vel eum iriure dolor in hendrerit in vulputate velit esse molestie consequat, vel illum dolore eu feugiat nulla facilisis at vero eros et accumsan et iusto odio dignissim qui blandit praesent luptatum zzril delenit augue duis dolore te feugait nulla facilisi. Nam liber tempor cum soluta nobis eleifend option congue nihil imperdiet doming id quod mazim placerat facer possim assum.

Lorem ipsum dolor sit amet, consectetuer adipiscing elit, sed diam nonummy nibh euismod tincidunt ut laoreet dolore magna aliquam erat volutpat. Ut wisi enim ad minim veniam, quis nostrud exerci tation ullamcorper suscipit lobortis nisl ut aliquip ex ea commodo consequat. Duis autem vel eum iriure dolor in hendrerit in vulputate velit esse molestie consequat, vel illum dolore eu feugiat nulla facilisis at vero eros et accumsan et iusto odio dignissim qui blandit praesent luptatum zzril delenit augue duis dolore te feugait nulla.

Lorem ipsum dolor sit amet, consectetuer adipiscing elit, sed diam nonummy nibh euismod tincidunt ut laoreet dolore magna aliquam erat volutpat. Ut wisi enim ad minim veniam, quis nostrud exerci tation ullamcorper suscipit lobortis nisl ut aliquip ex ea commodo consequat. Duis autem vel eum iriure dolor in hendrerit in vulputate velit esse molestie consequat, vel illum dolore eu feugiat nulla facilisis at vero eros et accumsan et iusto odio dignissim qui blandit praesent luptatum zzril delenit augue duis dolore te feugait nulla facilisi. Lorem ipsum dolor sit amet, consectetuer adipiscing elit, sed diam nonummy nibh euismod tincidunt ut laoreet dolore magna aliquam erat volutpat. Ut wisi enim ad minim veniam, quis nostrud exerci tation ullamcorper suscipit lobortis nisl ut aliquip ex ea commodo consequat.

Yours sincerely,

Amanda Cole

The logo comprises the word "Bay" set in 55pt Plaza, and this has been duplicated to form a shadow, 20% black, offset vertically to the right by the thickness of one character. The three characters have been kerned to give exactly the letter spacing desired. Alternatively, they could easily be set, cut, and pasted to the same positions. The remaining words, "Arts Center," are set in 10pt Gill Bold caps.

Gill Bold has been chosen for most other copy. A bold sans serif face is necessary for good legibility when text crosses from a white background to a tint panel. Gill is one of the older sans serif faces, and it fits comfortably with the Art Deco style of Plaza.

The designer checked with the client to make sure that the specified layout and font would be practically applied. The letter text is 10/13pt Goudy Old Style, set loose. This is a fairly small size for letter text, but a larger size would overwhelm the rest of the design.

The wide left margin —10p4— for the letter text allows the list of the various art forms to run down the side, partly overprinting the panel. This list is ranged left, 4p1 from the left edge of the paper, which still allows for punched holes if the letters are to be filed in ring-binders.

The relative size of all text elements is always important in the creation of an effective layout, but the absolute size is important too — smaller sizes generally give a more up-market impression.

advanced

STATIONERY

The client will be using window envelopes for some items of stationery. This imposes a significant constraint on the design because the recipient's address must be precisely positioned so that when the sheet is folded it will appear, properly aligned, in the window.

When developing designs for envelopes, always check first with the postal service for mailing requirements

ARTS CENTER

INVOICE

Robert Kay
Express Tickets
Accounts Department
1675 Campion Avenue
Brompton
Anystate
45310

BAY

PLANEDALE PLAZA
AMHURST
ANYSTATE
45287
TEL (666)754-2876
FAX (666)754-4532

The letterhead has been tinted to indicate the area that will be visible through the window of the envelope.

This portion of the panel is all that will be visible through the window.

The adaptability of the logo can be seen here – the proportions of the panel have altered so that it is now square (5 x 5p) rather than oblong, and the "left-hand" variant of the logo has been used. The word "Bay" is positioned 1p from the left edge, while the words "Arts Center" are 4p1 from the left and 1p10 from the top. They are set in 27pt and 6pt, respectively.

ARTS CENTER

BAY

Robert Kay
Express Tickets
Accounts Department
1675 Campion Avenue
Brompton
Anystate
45310

The envelope itself has been pre-printed with the logo bleeding off at the top and left.

If you are

designing

invoices,

check the

layout care-

fully with the

appropriate

accounting

software

before pre-

senting the

design to the

client.

If a non-window envelope is used, the address label should occupy the same position as the window.

The left margin is 7p4.

The first unit of information to be typed is the recipient's

address, which will appear in the envelope window. This fixed position

largely determines the alternatives available.

Start the design of the page by positioning the typical invoice details, taking care to allow sufficient space for the amounts, totals, descriptions, and so on, and using 12 points as the vertical unit of measure. Next, position the headings, rules and so on that appear on the preprinted invoice. This will inevitably require some give and take before a satisfactory layout can be achieved.

An 8pt rule is positioned above the description and totals, just below the first fold.

Invoices require particular attention because of the need for the preprinted invoice information to register accurately with the over-printed invoice details. It is assumed here that carbonless, continuous invoices are to be used, which means that they will have to be printed using an impact-type printer to create multi-sheet copies. This would normally mean using a dot-matrix printer.

These four headings are separated from the other invoice details because the information is required to create or access the account. They appear above the first fold.

Continuous stationery has additional perforated teardown strips at each side, with sprocket holes to facilitate paper feed and to prevent the paper from moving significantly out of alignment vertically or horizontally, so registration problems should be minimal.

All amounts to range right.

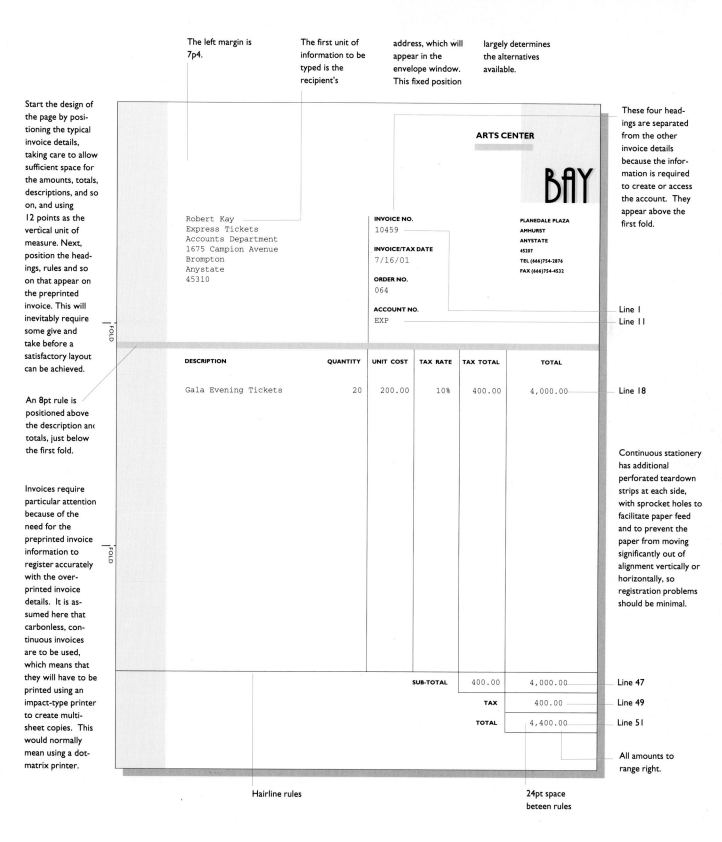

ARTS CENTER

BAY

Robert Kay
Express Tickets
Accounts Department
1675 Campion Avenue
Brompton
Anystate
45310

PLANEDALE PLAZA
AMHURST
ANYSTATE
45207
TEL (666)754-2876
FAX (666)754-4532

INVOICE NO.
10459

INVOICE/TAX DATE
7/16/01

ORDER NO.
064

ACCOUNT NO.
EXP

Line 1
Line 11

DESCRIPTION	QUANTITY	UNIT COST	TAX RATE	TAX TOTAL	TOTAL
Gala Evening Tickets	20	200.00	10%	400.00	4,000.00

Line 18

				SUB-TOTAL	400.00	4,000.00
				TAX		400.00
				TOTAL		4,400.00

Line 47
Line 49
Line 51

FOLD

FOLD

Hairline rules

24pt space beteen rules

Continuous stationery usually operates on the basis of 12pt leading or line feed. After a fixed

number of lines – typically 66 or 70 – the printer feeds on to the next invoice-start position.

Always check that the accounting software used by the client has a custom-design function that enables it to replicate

exactly the design you are creating. Many clients use the layout templates and accompanying pre-printed stationery

that are available with the software. This means that they do not integrate with the rest of the client's stationery.

Invoice text is set in 10/12pt Courier.

advanced
STATIONERY

CLIENT

design group

SPECIFICATIONS

Format
8½ x 11 in or A4

Letter margins
l 4p7 r 1p2
t 1p10 b 2p5

Envelope
Standard business

Business Card
3³/₈ x 2¹/₈ in

Font
Gill Sans
Track force justify
1 Logo
10pt, 7pt

Track extra loose
2 Address
6/27pt Letterhead
5/22pt Business Card / Envelope

Track force justify
3 Name on business card
6pt

Stock
Brilliant white ultra-smooth
#24/#80

BRIEF Five designers who work in a loose collaboration have decided to formalize the arrangement by creating a partnership called Quintessence. A new identity and stationery are required. The multi-disciplinary team wants to identify the various areas of specialization – e.g., graphic, product, environmental – while retaining the corporate identity. Being their own client is the best way of appreciating the problems associated with creating a new identity.

SOLUTION A symbol using the letter Q has been designed, based on Futura, which has a perfectly round Q. This simple device is capable of many adaptations, and could easily be animated if required. The letterhead uses all five letter forms, positioned vertically down the right side, while the business card and some other items bear only the symbol specific to that partner. Gill Sans is used for all text; when it is set with loose spacing it gives a light, spacious look to the page.

1 A b c

2 Butem vel eum iriure do lor in

The name Quintessence is handled very discreetly,

being force justified over a wide measure. The layout

relies on the sum of the parts for its overall impact.

On the envelope (opposite) the different versions of the "Q" symbol are used greatly reduced, running down the left hand side.

The primary component of the letterhead is composed of all five forms of the symbol, each in its specific spot color. It is this version that will be used on self-promotional material, in exhibitions and so on.

Q U I N T E S S E N C E

Ms. F. Carson
Marketing Director
CBSP
1675 Campion Avenue
Brompton 7/16/01
Anystate
19403 Ref.WCL001

Dear Ms. Carson,

Lorem ipsum dolor sit amet, consectetuer adipiscing elit, sed diam nonummy nibh euismod tincidunt ut laoreet dolore magna aliquam erat volutpat. Ut wisi enim ad minim veniam, quis nostrud exerci tation ullamcorper suscipit lobortis nisl ut aliquip ex ea commodo consequat. Duis autem vel eum iriure dolor in hendrerit in vulputate velit esse molestie consequat, vel illum dolore eu feugiat nulla facilisis at vero eros et accumsan et iusto odio dignissim qui blandit praesent luptatum zzril delenit augue duis dolore te feugait nulla facilisi. Lorem ipsum dolor sit amet, consectetuer adipiscing elit, sed diam nonummy nibh euismod tincidunt ut laoreet dolore magna aliquam erat volutpat. Ut wisi enim ad minim veniam, quis nostrud exerci tation ullamcorper suscipit lobortis nisl ut aliquip ex ea commodo consequat.

Duis autem vel eum iriure dolor in hendrerit in vulputate velit esse molestie consequat, vel illum dolore eu feugiat nulla facilisis at vero eros et accumsan et iusto odio dignissim qui blandit praesent luptatum zzril delenit augue duis dolore te feugait nulla facilisi. Nam liber tempor cum soluta nobis eleifend option congue nihil imperdiet doming id quod mazim placerat facer possim assum.

Lorem ipsum dolor sit amet, consectetuer adipiscing elit, sed diam nonummy nibh euismod tincidunt ut laoreet dolore magna aliquam erat volutpat. Ut wisi enim ad minim veniam, quis nostrud exerci tation ullamcorper suscipit lobortis nisl ut aliquip ex ea commodo consequat. Duis autem vel eum iriure dolor in.

Yours sincerely,

Diane Franklin

When a designer has complete control over the typographic style of the letter text, an increasingly sophisticated styling is possible.

The justified letter text, with its small size and generous leading, has the appearance of typeset rather than typed matter.

The business card follows the approach adopted for the stationery.

The date and reference are positioned so that they range right with the last line of the address.

A feature of the design is the vertically positioned address details. A small amount of text in this position is acceptable – larger amounts would be difficult to read.

1068 PLANEDALE ROAD AMHURST ANYSTATE 19422 TEL (066)754-2876 FAX (066)754-4532

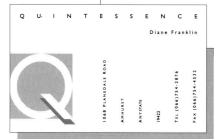

Q U I N T E S S E N C E
Diane Franklin

1068 PLANEDALE ROAD AMHURST ANYSTATE 19422 TEL (066)754-2876 FAX (066)754-4532

The letterhead prints black with five spot colors. Each Q prints in a different spot color – (from top to bottom) purple,

red, green, blue, and orange. The business cards print black and the single second appropriate color.

A hairline vertical rule bleeds off at top and bottom, creating a separate space in which the five symbols are contained.

advanced
STATIONERY

QUINTESSENCE

ATTN:

DEPT:

DATE:

FAX MESSAGE

The fax header
follows the format
of the letterhead
but is printed in
black only. The
To... and From...
text is divided by
hairline horizontal
rules, which
partition the
space available for
completing the
details.

The multi-symbol version is used when communications are from the partnership as a whole rather than from the individual design disciplines.

The five versions of
the symbol will be
used individually on
specific pages of the
company brochure.

FROM:

NO. OF PAGES:

REF.

1068 PLANEDALE ROAD

AMHURST

ANYSTATE

19422

TEL (066)754-2876

FAX (066)754-4532

The central portion
of the page is for
the message. This is
likely to be hand-
written, and so the
maximum area has
been left blank.

The purchase order will need to be in a form that leaves a duplicate after the order is sent. In smaller companies this has traditionally meant using a printed duplicate pad. However, some businesses now insist that all orders are typed on a word processor or set up within their accounting software systems.

FOLD

The first entry, the order number, will start on line 27 of the continuous stationery.

A horizontal rule is used to define the area to be used for the order details. There is sufficient space below for the signature of the partner confirming the order.

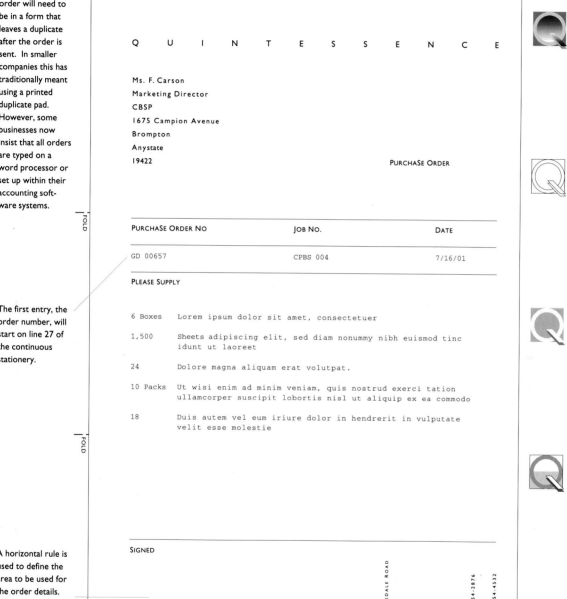

Q U I N T E S S E N C E

Ms. F. Carson
Marketing Director
CBSP
1675 Campion Avenue
Brompton
Anystate
19422

PURCHASE ORDER

PURCHASE ORDER NO	JOB NO.	DATE
GD 00657	CPBS 004	7/16/01

PLEASE SUPPLY

6 Boxes	Lorem ipsum dolor sit amet, consectetuer
1,500	Sheets adipiscing elit, sed diam nonummy nibh euismod tinc idunt ut laoreet
24	Dolore magna aliquam erat volutpat.
10 Packs	Ut wisi enim ad minim veniam, quis nostrud exerci tation ullamcorper suscipit lobortis nisl ut aliquip ex ea commodo
18	Duis autem vel eum iriure dolor in hendrerit in vulputate velit esse molestie

SIGNED

Diane Franklin

1068 PLANEDALE ROAD AMHURST ANYSTATE 19422 TEL (066)754-2876 FAX (066)754-4532

Quintessence is establishing a system, new to them, that will keep a record of time sheets and all bought-in costs to enable more efficient drafting of invoices. This means that purchase orders have to be input on the computer and printed-out using a dot-matrix (impact) printer. This requires the purchase order text to be set on a 12pt leading (line-feed) on the preprinted continuous stationery.

As always, when the layout involves printing onto pre-printed stationery, the design should take into account the demands of the over-printing from the outset, and the layout should be carefully tested to check the registration of line-feed, tabs and so on.

The name should be ranged with the recipient's address.

A #19 white paper has been chosen for the continuous stationery. As the purchase order will be seen only by suppliers and not by clients, printing in black only will be sufficient.

published
STATIONERY

Right and far right: This housing exchange service has chosen a simple centered design. The logo is formed from an acronym of the full name, and the symbol cleverly evokes both housing and moving home. The symbol sits within a pale tint panel, and the name is letter-spaced to this width. Mini-versions of the arrow device are centered between each character.

ON 24TH MAY, N·M·O, L·A·M·S, AND H·A·L·O ARE MOVING TOGETHER TO SET UP ⇒

Telephone 071-233 7077
26 Chapter Street, London SW1P 4ND Facsimile 071-976 6947
H.O.M.E.S, incorporating NMO, LAMS and HALO, is registered as a limited company, No. 1990581.

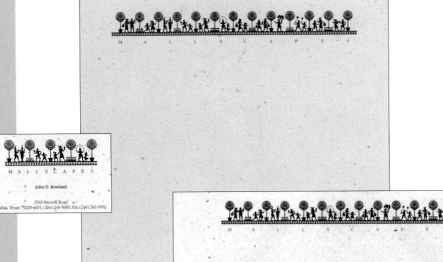

Left: The design of a visual identity, logo or symbol is always inextricably linked with the layout of the letterhead, whose design will be constrained by the shape of the logo. Placing the long, narrow illustration for Mallscapes at the top of the page, with the letter-spaced name below it, means that the address has to be placed at the foot of the page. This combination is also used on the back of the envelope, but only the central portion of the illustration is used on the business card, and the name is letter-spaced to this narrower measure. The flecks in the paper are the result of the recycling process.

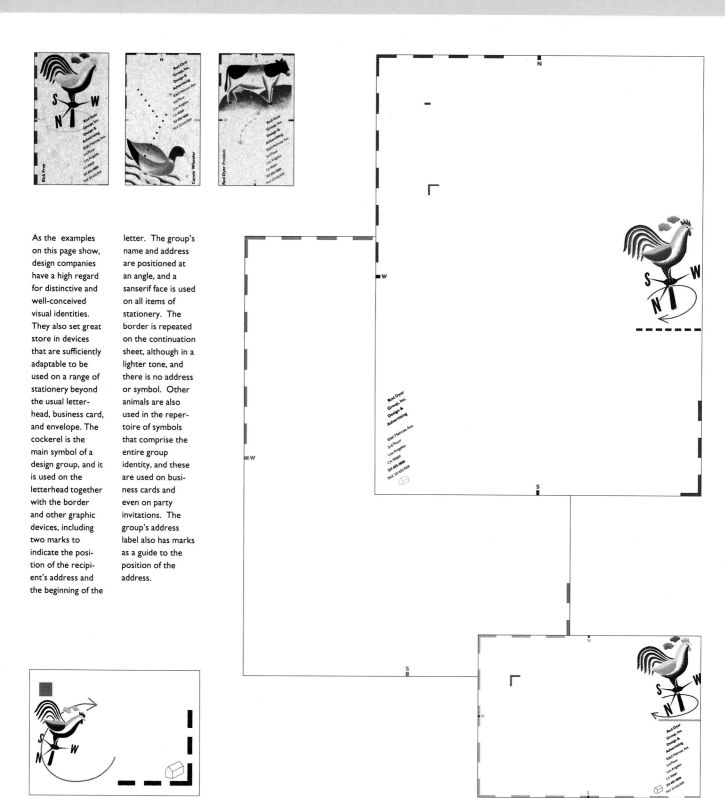

As the examples on this page show, design companies have a high regard for distinctive and well-conceived visual identities. They also set great store in devices that are sufficiently adaptable to be used on a range of stationery beyond the usual letterhead, business card, and envelope. The cockerel is the main symbol of a design group, and it is used on the letterhead together with the border and other graphic devices, including two marks to indicate the position of the recipient's address and the beginning of the letter. The group's name and address are positioned at an angle, and a sanserif face is used on all items of stationery. The border is repeated on the continuation sheet, although in a lighter tone, and there is no address or symbol. Other animals are also used in the repertoire of symbols that comprise the entire group identity, and these are used on business cards and even on party invitations. The group's address label also has marks as a guide to the position of the address.

published
STATIONERY

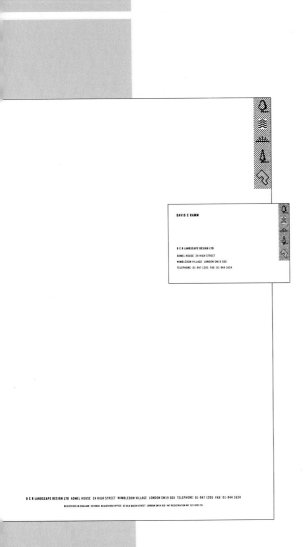

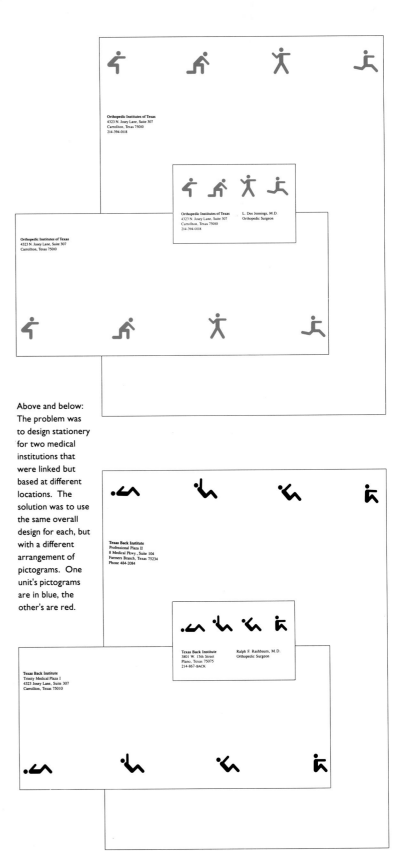

Above: The imaginative use of space is as important in a letterhead as in any other form of publication. The symbols used here are derived from a cartographic source, and they sit within a coarsely tinted band that bleeds off at the top and right. Although the layout is asymmetric, the page will appear balanced when the letter text is typed.

Above and below: The problem was to design stationery for two medical institutions that were linked but based at different locations. The solution was to use the same overall design for each, but with a different arrangement of pictograms. One unit's pictograms are in blue, the other's are red.

the MARKET BAR

With Compliments

240·A PO... ...472 · VAT REGISTRATION No. 532 4043 83

the MARKET BAR

Above and right:
The main elements
of this asymmetric
design are the name
and the illustration,
which bleeds off on
the right. The
uneven edge of the
illustration and
the decorative
panels at the top
and bottom give
an off-beat look,
which is appropri-
ate to the subject.
The name is set in
a serif face, and
the word "the" is
lower case. In
contrast, the
address is set in a
condensed
sanserif face.

240A PORTOBELLO ROAD · LONDON W11 1QR · TELEPHONE: 01·229 6472

THE MARKET BAR (PORTOBELLO) LTD. REG. ADDRESS: IRONGATE HOUSE, DUKE'S PLACE, LONDON EC3A 7LP. REG. NO. 2318010.

Hillcrest Construction, Inc.
3402 McFarlin Suite 210
Dallas, Texas 75205
214-522-5094
Fax 214-522-5095

Left and below:
The ruler device
bleeds across the
top of the con-
struction company's
letterhead and
business card.
However, this
layout is not used
on the envelope,
where it would
conflict with the
stamp. The name
and address are set
in a small serif face
because a bolder face
or more complex
typography would
conflict with the
delicate appearance
of the ruler device.

Hillcrest Construction, Inc. Jim Kick
3402 McFarlin Suite 210 Project Manager
Dallas, Texas 75205
214-522-5094
Fax 214-522-5095

Hillcrest Construction, Inc.
3402 McFarlin Suite 210
Dallas, Texas 75205

LOCAL PET STORE

CHARITY APPEAL

DISCOUNT TRAVEL

BOTANICAL GARDENS

DISCOUNT SHOPPING CENTER

ADVISORY GROUP

SELF-HELP GROUP

INTERIOR DESIGN STORE

SPECIALIZED CLOTHES RETAILER

SHOE MANUFACTURER

BUSINESS EXECUTIVES CLUB

VISIT THE TIMELESS SPLENDOUR OF RUTLAND CASTLE GARDENS

R dolore magna aliquam erat volutpat. Ut wisi enim ad minim veniam, quis nostrud exerci tation ullamcorper suscipit lobortis nisl ut aliquip ex ea commodo consequat. duis autem vel eum iriure dolor in hendrerit in vulputate velit esse molestie consequat, vel illum dolore eu feugiat nulla facilisis at vero eros et accumsan et iusto odio dignissim qui blandit praesent luptatum zzril delenit augue duis dolore te ugait nulla facilisi. Lorem ipsum dolor sit amet.

onsectetuer adipiscing elit, sed diam nonummy nibh euismod unt ut laoreet dolore magna aliquam erat volutpat. Ut wisi minim veniam, quis nostrud exerci tation ullamcorper bortis nisl ut aliquip ex ea commodo consequat. Duis autem vel eum iriure dolor in hendrerit in vulputate velit esse molestie consequat.

Vel illum dolore eu feugiat nulla facilisis at vero eros et accumsan et iusto dignissim qui blandit praesent zzril delenit augue nulla

facilisi. Lorem ipsum dolor sit amet, consectetuer adipiscing elit, sed diam nonummy nibh euismod tincidunt ut laoreet dolore magna aliquam erat volutpat wisi enim ad minim veniam.

Quis nostrud exerci tation ullamcorp suscipit lobortis nisl ut aliquip ex commodo consequat. Duis autem eum iriure dolor in hendrerit in vul velit esse molestie consequat, vel illum dolore eu feug facilisis at. Vero eros et accumsan et iusto odio dig blandit praesent luptatum zzril delenit augue du feugait nulla facilisi lorem ipsum dolor sit amet.

Consectetuer adipiscing elit, sed diam nonum tincidunt ut laoreet dolore magna aliquam e enim ad minim veniam, quis nostrud e suscipit lobortis nisl ut aliquip ex ea c vel eum iriure dolor in hendrerit in vulputate velit esse mo consequat, vel illum feugiat

ADVERTISEMENTS

5

CHAPTER

RIEF

TER

Advertising is traditionally the domain of the specialized agency, with its separate departments managing not only the creative aspects of the individual advertisements but also the research, media buying, PR, and production. Those organizations requiring the full service will naturally choose such an agency. Many smaller companies and organizations, however, know their market and the media in which they wish to advertise, and a smaller design group, an in-house department, or even an accomplished freelance designer may suit them better.

Because the printing and paper quality will be outside your control, you will need to ascertain the technical data relating to the publications in which the advertisements will appear. Most will require film separations for color and camera-ready artwork for black and white. It is important to be able to adapt a basic advertisement to a variety of formats without changing radically the relationship between the various elements, and generating the layout on a DTP system is a great help here. Collaborating with a good copywriter is essential if you are to produce properly integrated written and visual ideas.

Unlike newsletters, brochures and stationery, which are generally read in isolation, advertisements normally appear within a newspaper or magazine, where they have to compete not only with other advertisements but also with editorial matter. This means that the layout has to work much harder than that of a newsletter or brochure to arrest the reader's attention – and retain it.

The basic level examples deal with the adaptation to different sizes of a small black-and-white, semi-display advertisement; the development of a black-and-white single-page advertisement – which follows the classic picture, headline, body copy, and logo layout that is used in a large number of magazine and newspaper advertisements but is still effective; and the preparation of a robust typographic advertisement for a cut-price travel company.

The intermediate level uses more typographical refinement and introduces color. There is a more demanding adaptation, a complex multi-featured editorial-styled layout, and an advertisement that uses a specially commissioned still-life photograph.

The advanced level includes an uncompromising headless layout, a design based on the style of the 1940s, a split-headline design with a composite photographic main image, and an unusual multi-page, advertisement feature that uses a long, typographically manipulated quotation as its headline.

At all levels the purpose of the advertisement remains the same – that is, to capture the reader's attention and communicate the message. The advertisement, usually a single page or less, must overcome the limitations of space by being clearly focused. The layout should be simple and uncomplicated, and should normally avoid type that is too small and headings that are too long. The following pages show a range of layout options, each of which was created to address a particular brief, but many of which could be adapted to suit the requirements of other clients, too.

CLIENT

local pet store

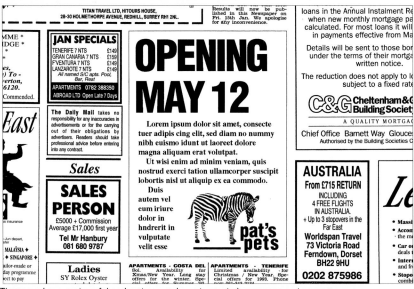

The two-column version of the advertisement shown in a typical newspaper environment.

A

B

C

SPECIFICATIONS

Format
A 1⅞ x 4½ in
B 3¼ x 4½ in
C 5¼ x 2½ in

Grid
1-column
Space between – none

Margins
l 1p5 r 1p5
t 1p5 b 1p5

Fonts
Times Bold
Track loose
1 Body text
A 10/11½pt
B 11/13pt
C 10½/12pt

2 **Helvetica Black**
Track normal
3 Headlines
A 32/35pt
B/C 59/59pt

4 Logo
Customized leading
Logo Master 30/19pt
A 100%
B 94%
C 81%

BRIEF A neighborhood pet store wants to advertise the opening of a second shop in a nearby town. There will be one-, two-, three-, or four-column advertisements in local newspapers and specialized breed newsletters, together with some posters and flyers. Pat's Pets intends to develop a mail-order service for some more unusual animals. With this in mind, a new identity has been created using the zebra graphic, a striking image, which offers the opportunity for some amusing headline puns in future advertisements.

SOLUTION Since the newspaper advertisements will be of poor print quality, a small amount of fairly large body text will be appropriate as legibility will be a critical factor. A layout that can be easily adapted to suit a variety of newspaper column widths is required. The headline is pared down to the basic announcement and used as large as the width of the advertisement will allow. No formal grid is employed, but the margins around each adaptation remain constant.

Ideally, the relative proportion of headline to text should remain constant when an advertisement is adapted to other sizes and formats.

The examples on this page are all shown actual size.

In most circumstances, caps-only headlines require less leading than upper/lower case type because the space between each line is not interrupted by descenders. As all-caps headlines get larger they need progressively less leading, as the specifications for these two versions reveal:
A 32/35pt (109%)
B 60/60pt (100%)

Headlines are set in Helvetica Black, the same face as the logo, although in capitals rather than lower case. This helps to maintain the simple yet strong identity.

A

OPENING MAY 12

Lorem ipsum dolor sit amet, consectetuer adipis cing elit, sed diam no nummy nibh euismo idunt ut laoreet dolore magna aliquam erat volutpat.

Ut wisi enim ad minim veniam, quis nostrud exerci tation ullamcorper suscipit lobortis nisl ut aliquip ex ea commodo.

Duis autem vel eum iriure dolor in hndrerit in vulputate velit esse

pat's pets

B

OPENING MAY 12

Lorem ipsum dolor sit amet, consecte tuer adipis cing elit, sed diam no nummy nibh euismo idunt ut laoreet dolore magna aliquam erat volutpat.

Ut wisi enim ad minim veniam, quis nostrud exerci tation ullamcorper suscipit lobortis nisl ut aliquip ex ea commodo.

Duis autem vel eum iriure dolor in hndrerit in vulputate velit esse

pat's pets

The ruled boxes surrounding each advertisement are ½pt. Avoid using heavy ruled boxes, which invariably look clumsy.

It is not always possible to keep the relative size of headline to text constant, as example C shows. If this headline had been set with the relative sizes used in example B, the headline would have been much smaller and would not have stretched across the full width, which would have made the layout much weaker.

C

OPENING MAY 12

Lorem ipsum dolor sit amet, consectetuer adipis cing elit, sed diam no nummy nibh euismo idunt ut laoreet dolore magna aliquam erat volutpat.

Ut wisi enim ad minim veniam, quis nostrud exerci tation ullamcorper suscipit lobortis nisl ut aliquip ex ea commodo.

Duis autem vel eum iriure dolor in hndrerit in vulputate velit esse

pat's pets

The identity – that is, the name, the zebra device, and the rule – must always remain constant. Never vary the component parts. Enlarge or reduce the whole, within reason, to suit the particular needs of the layout, and always position it in the same place – here, it is always in the bottom righthand corner of the layout.

Brevity is a prime requirement for the text. Three short paragraphs set in a bold face are easy to read, even in the smallest example, A. Paragraph indents should be generous, with wider measures having larger indents.

These three adaptations of the advertisement retain the family feel but at the same time are sufficiently flexible for a variety of formats to be used.

117

CLIENT

charity appeal

re feugiat nulla.
vero eros etodom
iusto odiomit
blandit praesent
delenit augue
feugait nulla.

m liber tempor
obis eifend option
imperdiet doming
m placerat facer
n. Lorem ipsum

nisi ut aliquip ex dea commodo
consequat. Duis autem vel
eum iriure dolor in hendrerit

*Ovel illum dolore eu feugiat nulla
facilisis at vero eros etumop accumsan
eiusto odio dignissim qui blandit
praesent luptatum zzril delenit augue*

The logo is shown actual size.

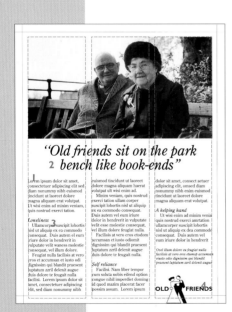

SPECIFICATIONS

Format
8½ x 11in or A4

Grid
3-column
Space between – 1p5

Margins
l 2p11 r 2p11
t 2p11 b 2p11

Fonts
Century Old Style
Track loose
1 Body text
12/14pt

Century Old Style italics
Track loose
2 Headlines
40/40pt
3 Subheads
14/14pt

Gill Sans
Track loose
4 Logo
17pt

BRIEF A recently launched charity has been charged with the task of alleviating loneliness among the elderly. It requires an advertising campaign to increase awareness of the problem and to enlist voluntary helpers. The advertisements will appear in specially selected magazines, and the layout will have to incorporate a fairly large amount of text. The target audience is defined as middle-class and middle-aged.

SOLUTION A single page bleed, black and white advertisement with a headline from a Simon and Garfunkel song accompanied by a poignant photograph are combined to evoke a sympathetic response from the reader. The face chosen for both headline and text is Century Old Style, roman and italic. The italic provides the necessary contrast with the text, and is also used for the subheads. The crossed rules border is of hairline thickness, and the motif overlaps it, focusing attention on the logo. A three-column grid provides the underlying structure.

2 *Abc*

1 Butem vel eum iriure do lor
in hen dre rit in vulp utate

This design follows the classic advertisement layout of stacked picture, headline, and body text, with the logo in the bottom right-hand corner. The single photograph should catch the reader's eye, while the headline focuses attention and the body copy delivers the message.

The headline is set solid – that is, there is no additional leading. On its own it might have benefited by a little extra leading, but in the context of this layout more space would have been required between the photograph and the body text, and this would have weakened the design, as would the alternative solution of reducing the headline size.

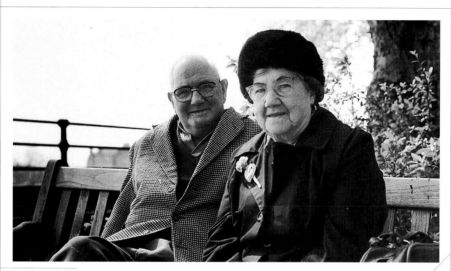

A harmonious layout can be achieved by maintaining equal spaces between the elements. This is not, however, always a simple matter of measurement. These rivers of space are visually equal, but, because the text is ranged left, the actual margin of 1p1 is less than the space above and below the headline. Similarly, the ascenders of the first line of the heading create an uneven space. Because there are no descenders, the second line of the heading creates an even channel of space.

"Old friends sit on the park bench like book-ends"

Lorem ipsum dolor sit amet, consectetuer adipiscing elit sed diam nonummy nibh euismod tincidunt ut laoreet dolore magna aliquam erat volutpat. Ut wisi enim ad minim veniam, quis nostrud exerci tation.

Loneliness

Ullamcorper suscipit lobortis nisl ut aliquip ex ea commodo consequat. Duis autem el eum iriure dolor in hendrerit in vulputate velit waness molestie consequat, vel illum dolore.

Feugiat nulla facilisis at vero eros et accumsan et iusto odi dignissim qui blandit praesent luptatum zzril delenit augue duis dolore te feugait nulla facilisi. Lorem ipsum dolor sit amet, consectetuer adipiscing elit, sed diam nonummy nibh

euismod tincidunt ut laoreet dolore magna aliquam haerat volutpat ult wisi enim ad.

Minim veniam, quis nostrud exerci tation ullam corper suscipit lobortis nisl ut aliquip ex ea commodo consequat. Duis autem vel eum iriure dolor in hendrerit in vulputate velit esse molestie consequat, vel illum dolore feugiat nulla.

Facilisis at vero eros etodom accumsan et iusto odiomit dignissim qui blandit praesent luptatum zzril delenit augue duis dolore te feugait nulla.

Self reliance

Facilisi. Nam liber tempor cum soluta nobis eifend option congue nihil imperdiet doming id quod mazim placerat facer possim assum. Lorem ipsum

dolor sit amet, consect aetuer adipiscing elit, omsed diam nonummy nibh enim euismod tincidunt ut laoreet dolore magna aliquam erat volutpat.

A helping hand

Ut wisi enim ad minim venia quis nostrud exerci amrtation ullamcorper suscipit lobortis nisl ut aliquip ex dea commodo consequat. Duis autem vel eum iriure dolor in hendrerit

Ovel illum dolore eu feugiat nulla facilisis at vero eros etumop accumsan eiusto odio dignissim qui blandit praesent luptatum zzril delenit augue

If the advertisement has been successful, the reader will require some contact information. This is set as text, but in italics to differentiate it from the other text.

The logo must include an extra allowance for the bleed. Check the mechanical data with the magazine to determine this space.

The page margins are equal on all four sides so that the hairline crossed ruled box forms an exact square at each corner.

The subheads are 2 points larger than the body text, but retain the same 14pt leading.

CLIENT

discount travel

ro eros et accumsan et iusto
gnissimblandit praesent
m zzril delenit augue duis
feug null qui

nisl ut

JR PROMISE
em ipsum dolor sit
et consect etuer adip
ng elit, sed diam
ummy nibh euismod
dunt ut laoreet dolore
gna aliquam erat
tpat. Ut wisi enim ad
im veniam, quis nostrud
rci tation ullam corper
cipit lob ortis nisl ut aliip

The logo is shown actual size.

SPECIFICATIONS

Format
8½ x 11in or A4

Grid
7-column
Space between – 1p2

Margins
l 11p10 r 1p10
t 6p b 2p7

Fonts
Helvetica
Track loose
1 Body text
9/11pt

Helvetica Black
Track loose
Expanded to 130%
2 Headline/Prices
36/36pt
3 Headline/Our Promise
8/11pt

Times bold
Track tight
Expanded to 170%
4 Headline/Destinations
18/22pt

Track force justified
Expanded to 170%
5 Logo and phone number
48pt

BRIEF A discount travel company wants a new design styling for its numerous advertisements, which are placed mainly in selected magazines and, occasionally, newspapers. Advertising is the sole vehicle for selling the company's products, so the look has to be aggressive yet avoid the clutter often produced by competitors. The company sells tickets for popular routes at discount prices, and this should be reflected in the layout.

SOLUTION The client prefers single-page advertisements, although the same information could be delivered in a smaller space. A bold, no-nonsense layout, emphasizing destinations, prices, and a contact phone number, is selected. The seven-column grid allows each text column to occupy two grid columns, leaving a space on the left in which the company name can run vertically. Both fonts, Helvetica and Times, have been optically distorted so that they extend beyond their normal width. This may offend typographical purists, but it does allow the prices to fill almost the full text column width.

(800) 888—8888

FLIGHT EXPRESS

Amsterdam
$249

Oslo
$279

Dublin
$199

2 **Antwerp**
$229

Rome
$289

London
$199

4 **Brussels**
$269

Vienna
$299

Madrid
$249

Berlin
$299

5

OUR PROMISE

4 **Abc**
2 **Abc**
Butem vel eum iriure do lor in hen
1 dre rit in vulp utate velit esse illum

The longest destination name – Amsterdam – determines the type size of the rest. Here, the face, Times Bold, is extended to 170%.

The advertisement does not bleed, but fits within the type area of the page.

The words "Flight Express," which are set in the same size as the phone number and also extended to 170%, are positioned vertically 1p2 from the left side of the ruled box. The words do not align with the far left grid line because this would leave them floating too near the center of the "empty" first column. In an otherwise crowded page, the white space between these words and the first column of text is a vital visual element.

The prices, set in Helvetica Black and extended to 130%, are the dominant feature. Care has been taken to stagger them so that they do not align horizontally.

The text comes close to the edge of the advertisement, and this reinforces the boldness of the design. This is possible only when, as here, the advertisement does not bleed.

The telephone number is vital, so it has been placed, white out, within a black, 4p10 deep panel. The face, Times Bold, is extended to 170% width. It extends over the three text columns and helps to create a strong block.

The only graphic interest in an otherwise typo-graphical layout is the suitcase device. The sense of movement is enhanced by the speed lines. Note how the top line provides a bound-ary for the Vienna text, the last few lines of which need to be edited to fit the required shape.

A 1pt rule surrounds both the layout and the "Our Promise" box.

The minimum space between text and graphic should be 7pt. With ranged-left setting, most lines will fall well short of this.

A 12pt rule at the foot is necessary to balance the black panel at the top.

(800) 888–8888

F L I G H T E X P R E S S

Amsterdam
$249

Lorem ipsum dolor sit amet, consectetuer adipiscing elit, sed diam nonummy nibh euismod tincidunt ut laoreet dolore magna aliquam erat volutpat. Ut wisi enim ad minim veniam, quis nostrud exerci tation ullamcorper suscipit lobortis nisl ut aliquip ex ea commodo consequat. Duis autem vel eum iriure dolor in hendrerit in vulputate velit esse molestie onsequat vel illum dolore eu feugiat

Antwerp
$229

Nulla facilisis at vero eros et accu msan et iusto odio dignissim qui blandit praesent luptatum zzril delenit augue duis dolore te feugiat nulla facilisi. Lorem ipsum dolor sit amet, consectetuer adipiscing elit, sed diam nonummy nibh euismod tincidunt ut laoreet dolore magna aliquam erat volutpat wisi enim

Brussels
$269

Ad minim veniam, quis nostrud exerci tation ullamcorper suscipit lobortis nisl ut aliquip ex ea commodo consequat. Duis autem vel eum iriure dolor in hendrerit in vulputate velit esse molestie consequat, vel illumdolore eu feugiat nulla facilisisblandit praesent luptatum zzril delenit augue duis dolore feug null at vero eros et accumsan et iusto odio dignissim qui blandit praesent luptatum zzril

Berlin
$299

Soluta nobis eleifend option congue nihil imperdiet doming id quod mazim placerat facer possim assum. Lorem ipsum dolor si amet, consectetuer adipiscing elit, sed diam nonummy nibh euismod tincidunt ut laoreet dolore magna exerci tation ullamcorper suscipit lobortis nisl ut aliquip ex ea commodo consequat. Duis autem

delenit delenit augue duis dolore te feugiat nulla facilisi. Nam liber tempor cumauge duis dolore te feugiat nulla facilisi. Nam liber tempor cumvulputate velit esse molestie consequat, vel illum dolore

Dublin
$199

Commodo consequat. Duis autem vel eum iriure dolor in hendrerit in vulputate velit esse molestie co sequat vel illum dolore eu feugiat nulla facilisis at vero eros et accu msan et iusto odio dig nissim qui blandit praesent luptatum zzril delenit augue duis dolore feug nulla facilisi. Lorem ipsum dolor sit amet, consectetuer

London
$199

Wobortis nisl ut aliquip ex ea commodo consequat. Duis autem vel eum iriure dolor in hendrerit in vulputate velit esse molestie consequat, vel illum dolore eu feugiat nulla facilisis at vero eros et accumsan et iusto odio dignissim qui blandit praesent luptatum zzril delenit augue duis dolore te feugiat

Madrid
$249

Tation ullamcorper suscipit lobortis nisl ut aliquip ex ea commodo consequat. Duis autem vel eum iriure dolor in hendrerit in vulputate velit esse molestie consequat, vel illum dolore eu feugiat nulla facilisis at. Vero eros et accumsan et iusto odio dignissimblandit praesent luptatum zzril delenit augue duis dolore feug null qui

OUR PROMISE
Lorem ipsum dolor sit amet consect etuer adip iscing elit, sed diam nonummy nibh euismod tinci dunt ut laoreet dolore magna aliquam erat volutpat. Ut wisi enim ad minim veniam, quis nostrud exerci tation ullam corper suscipit lob ortis nisl ut aliip

Oslo
$279

Exerci tation ullamcorper suscipit lobortis nisl ut aliquip ex ea commodo consequat. Autem vel eum iriure dolor in hendrerit in vulputate velit esse molestie consequat, vel illum dolore eu feugiat nulla facilisis at vero eros delenit augue duis dolore te feugiat nulla facilisi .Lorem ipsum dolor sit a consectetuer adipiscing elit, sed diam nonum my beuismod tincidunt ut laoreet dolore magna aliquam

Rome
$289

Erat volutpat. Ut wisi enim ad minim veniam, quis nostrud exerci tation ullamcorper suscipit lobortis nisl ut aliquip ex ea commodo consequat. Duis autem vel eum iriure dolor in hendrerit in vulputate velit esse molestie con sequat, vel illum dolore eu feugiat nulla facilisis at vero eros et accumsan et iusto odio dignissim qui blandit praesent

Vienna
$299

Luptatum zzril delenit augue duis dolore te feugiat nulla facilisi. Lorem ipsum dolor sit amet, consectetuer adipiscing elit, sed diam nonummy nibh euismod tincidunt ut laoreet dolore magna aliquam erat volutpat. Ut wisi enim ad minim veniam, quis nostrud exerci tation ullamcorper suscipit lobortis nisl ut

CLIENT

botanical gardens

suscipit lobortis nisl ut aliquip ex ea commodo consequat. Duis autem vel eum iriure dolor in hendrerit in vulputate velit esse molestie consequat, vel illum dolore eu feugiat nulla facilisis at. Vero eros et accumsan et iusto odio dignissim qui blandit praesent luptatum zzril delenit augue duis dolore te feugait nulla facilisi lorem ipsum dolor sit amet.

Consectetuer adipiscing elit, sed diam nonummy nibh euismod tincidunt ut laoreet dolore magna aliquam erat volutpat. Ut wisi enim ad minim veniam, quis nostrud exerci tation ullamcorper suscipit lobortis nisl ut aliquip ex ea commodo consequat. Autem vel eum iriure dolor in hendrerit in vulputate velit esse molestie consequat, vel illum dolore eu feugiat nulla facilisis at vero eros

RUTLAND CASTLE GARDENS

The logo is shown actual size.

SPECIFICATIONS

Format
8½ x 11in or A4

Grid
2-column
Space between – 1p10

Margins
l 2p11 r 2p11
t 2p11 b 2p11

Font
Caslon
Track loose
1 Body text
9/11½pt
Drop cap
56pt

Track very loose
2 Headlines
Small caps
28/28pt
3 Logo
14/14pt

BRIEF Rutland Castle Gardens plan an early spring advertising campaign to encourage visitors during this, the Gardens' most magnificent season. The Castle houses an important collection of botanical illustrations of international renown. This has resulted in Rutland Castle Gardens becoming a mecca for painters wishing to take advantage of both the historical and living flora. The advertisement will appear in a variety of magazines – general interest, leisure, and special interest, such as gardening.

SOLUTION Full-color, single-page bleed advertisements are planned, and the layout, to reflect the elegance and status of the Gardens, uses a combination of caps and small caps set in Caslon for the heading. The crispness of these letter forms evokes carved stone, thus reinforcing the "Timeless Splendor" of the headline. The broad, two-column grid allows for the other two photographs to be inset, together with the drop cap and the logo.

2 **ABC**
1 Butem vel eum iriure do lor in hen
dre rit in vulp utate velit esse illum

The large color photograph, which bleeds on three sides, is 39p7 deep. It dominates the page.

An effective design invariably relies on achieving a harmonious balance of all the different elements. So many factors – the size of the image, the choice of typeface, the margins, the overall proportions, the position of the headlines, the color – affect the design that it is impossible to give hard and fast rules for a successful layout.

The generous margins contrast with the tight block of justified text and inset photographs, creating a formal design. Note how the positions of the drop cap, photographs, and logo are staggered across the text.

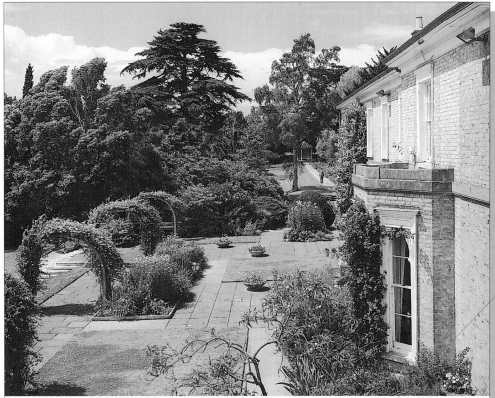

The centered headline is set in 28/28pt Caslon 540. The small caps are 80% of full size and set very loose track.

VISIT THE TIMELESS SPLENDOR OF RUTLAND CASTLE GARDENS

The spaces above and below the headline are visually equal.

The upright of the drop cap is aligned with the left side of the text, allowing the serifs to protrude into the margins.

Align the top and bottom of the photographs with the top and bottom of the x-height of the adjacent text.

Rdolore magna aliquam erat volutpat. Ut wisi enim ad minim veniam, quis nostrud exerci tation ullamcorper suscipit lobortis nisl ut aliquip ex ea commodo consequat. duis autem vel eum iriure dolor in hendrerit in vulputate velit esse molestie consequat, vel illum dolore eu feugiat nulla facilisis at vero eros et accumsan et iusto odio dignissim qui blandit praesent luptatum zzril delenit augue duis dolore te feugait nulla facilisi. Lorem ipsum dolor sit amet.

Consectetuer adipiscing elit, sed diam nonummy nibh euismod tincidunt ut laoreet dolore magna aliquam erat volutpat. Ut wisi enim ad minim veniam, quis nostrud exerci tation ullamcorper suscipit lobortis nisl ut aliquip ex ea commodo consequat. Duis

autem vel eum iriure dolor in hendrerit in vulputate velit esse molestie consequat.

Vel illum dolore eu feugiat nulla facilisis at vero eros et accumsan et iusto odio dignissim qui blandit praesent luptatum zzril delenit augue duis dolore te feugiat nulla

facilisi. Lorem ipsum dolor sit amet, consectetuer adipiscing elit, sed diam nonummy nibh euismod tincidunt ut laoreet dolore magna aliquam erat volutpat wisi enim ad minim veniam.

Quis nostrud exerci tation ullamcorper suscipit lobortis nisl ut aliquip ex ea commodo consequat. Duis autem vel eum iriure dolor in hendrerit in vulputate velit esse molestie consequat, vel illum dolore eu feugiat nulla facilisis at. Vero eros et accumsan et iusto odio dignissim qui blandit praesent luptatum zzril delenit augue duis dolore te feugait nulla facilisi lorem ipsum dolor sit amet.

Consectetuer adipiscing elit, sed diam nonummy nibh euismod tincidunt ut laoreet dolore magna aliquam erat volutpat. Ut wisi enim ad minim veniam, quis nostrud exerci tation ullamcorper suscipit lobortis nisl ut aliquip ex ea commodo consequat. Autem vel eum iriure dolor in hendrerit in vulputate velit esse molestie consequat, vel illum dolore eu feugiat nulla facilisis at vero eros

RUTLAND CASTLE GARDENS

The inset logo follows the typographical style of the headline. The hairline rules above and below, like the photographs, align with the top and bottom of the x-height of adjacent text. The rules are more elegant than the alternative of a closed box.

Wider text columns require a larger space between them. The hairline vertical rule reinforces the centered axis of the advertisement.

Care should be taken to edit the last line of the text so that it extends to the full width.

This creates a formal white rectangle in which the logo can be positioned.

CLIENT

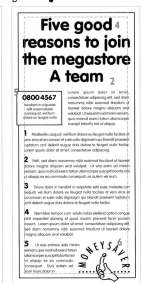

discount shopping center

Nam liber tempor cum soluta nobis eleifend option congue
il imperdiet doming id quod mazim placerat facer possim
um. Lorem ipsum dolor sit amet, consectetuer adipiscing elit,
l diam nonummy nibh euismod tincidunt ut laoreet dolore
gna aliquam erat volutpat.

Ut wisi enimos adis minim
iam,quis nostrud exerci tation
mcorper suscipit lobortis nisl
aliquip ex ea commodo
sequat. Duis autem vel
m iriure dolor in

The logo is shown actual size.

A

Five good reasons to join the megastore 1 A team

B

Five good 4 reasons to join the megastore A team 2

Abc

4

2 Butem vel eum iriure do lor in hen dre rit in vulp

SPECIFICATIONS

Format
A 2½ x 9⅝ in
B 4⅜ x 9⅝ in

Grid
1 column
Space between – none

Margins
A l 2p r 2p
 t 2p b 2p

B l 2p5 r 2p5
 t 2p5 b 2p5

Fonts
VAG Rounded
Track loose
Body text
1 A 7/8½pt
2 B 9½/13pt

VAG Rounded bold
Track normal
Headlines
3 A 28/28pt
4 B 40/43pt
5 A&B 17pt

Futura Condensed
6 Logo
Customized leading
40pt

BRIEF Moneysaver has a fairly high staff turn-over, which necessitates more or less constant advertising for employees. The advertisements are placed primarily in local newspapers and in selected magazines. An adaptable layout is required, and although pure design aesthetics may not be high on the company's agenda, clarity and effective communication certainly are. Between one and three column sizes are envisaged, printing black only.

SOLUTION To fulfill the brief, a layout that allows different headline themes and varying amounts of body text to be used has been devised. The main feature is the double ruled box border, with the logo breaking out of the inner box, together with the use of one type family – VAG Rounded, bold and roman. Unlike newspapers, magazines are generally printed on a coated stock, and the superior print quality allows good legibility of small type sizes, as well as the possibility of booking smaller spaces from time to time.

The advertisements are shown at 73% of actual size.

A

B

The choice of VAG bold for headlines, phone number, and paragraph lead-ins fits well with the company's friendly image. At 28/28pt, version A is set solid; version B, at 40/43pt, requires a small amount of additional leading to compensate for the wider measure.

The first line of each paragraph is indented to accommodate the bold numeral – by 12 points and 15 points for versions A and B, respectively.

The body text, set in 7/8½pt VAG roman, is punctuated by bold lead-in numerals. One line space is left after each paragraph, and the larger numeral, set 14/8½pt, extends into this space. Negative leading – such as 14/8½pt – is normally used only when a larger type size sits on the same line as a smaller one.

In this larger version the telephone number can be featured by enclosing it within a 2pt ruled box. Centering the phone number copy helps to distinguish it from the rest of the text. This box should be the same depth as the indented first paragraph. Trial and error will determine these dimensions.

There is a very small margin between the single text column and the inner ruled box. This is possible because of the further space afforded by the outer box. If there were no space here, the text would appear too close to other advertisements clamouring for attention on the page.

Five good reasons to join the megastore A team

Lorem ipsum dolor sit amet, consectetuer adipiscing elit, sed diam nonummy nibh euismod tincidunt ut laoreet dolore magna aliquam erat volutpat. Ut wisi enim ad minim veniam, quis nostrud exerci tation ullamcorper suscipit lobortis nisl ut aliquip.

1 Modlestie csequat, vel illum dolore eu feugiat nulla facilisis at vero eros et accumsan et iusto odio dignissim qui blandit praesent luptatum zzril delenit augue duis dolore te feugait nulla facilisi. Lorem ipsum dolor sit amet, consectetuer adipiscing.

2 Pelit, sed diam nonummy nibh euismod tincidunt ut laoreet dolore magna erat volutpat. Ut wisi enim ad minim veniam, quis nostrud exerci tation ullamcorper suscipit lobortis nisl ut aliquip ex ea commodo consequat uis autem vel eum.

3 Tiriure dolor in hendrrit in vulputate velit esse molestie consequat, vel illum dolore eu feugiat nulla facilisis at vero eros et accumsan et iusto odio dignissim qui blandit praesent luptatum zzril delenit augue duis dolore te feugait nulla facilisi.

4 Nam liber tempor cum soluta nobis eleifend option congue nihil imperdiet doming id quod mazim placerat facer possim assum. Lorem ipsum dolor sit amet, consectetuer adipiscing elit, sed diam nonummy nibh euismod tincidunt ut laoreet dolore magna aliquam erat volutpat.

5 Ut wisi enim ados minim veniam, quis nostrud exerci tation ullamcorper suscipit lobortis nisl ut aliquip ex ea commodo consequat. Duis autem vel eum iriure dolor in

0800 4567

hendrerit in vulputate velit esse molestie consequat, vel illum dolore eu feugiat nulla

Five good reasons to join the megastore A team

0800 4567

hendrerit in vulputate velit essemolestie consequat, vel illum dolore eu feugiat nulla

Lorem ipsum dolor sit amet, consectetuer adipiscing elit, sed diam nonummy nibh euismod tincidunt ut laoreet dolore magna aliquam erat volutpat. Ut wisi enim ad minim veniam, quis nostrud exerci tation ullamcorper suscipit lobortis nisl ut aliquip.

1 Modlestie csequat, vel illum dolore eu feugiat nulla facilisis at vero eros et accumsan et iusto odio dignissim qui blandit praesent luptatum zzril delenit augue duis dolore te feugait nulla facilisi. Lorem ipsum dolor sit amet, consectetuer adipiscing.

2 Pelit, sed diam nonummy nibh euismod tincidunt ut laoreet dolore magna aliquam erat volutpat. Ut wisi enim ad minim veniam, quis nostrud exerci tation ullamcorper suscipit lobortis nisl ut aliquip ex ea commodo consequat uis autem vel eum.

3 Tiriure dolor in hendrrit in vulputate velit esse molestie con sequat, vel illum dolore eu feugiat nulla facilisis at vero eros et accumsan et iusto odio dignissim qui blandit praesent luptatum zzril delenit augue duis dolore te feugait nulla facilisi.

4 Nam liber tempor cum soluta nobis eleifend option congue nihil imperdiet doming id quod mazim placerat facer possim assum. Lorem ipsum dolor sit amet, consectetuer adipiscing elit, sed diam nonummy nibh euismod tincidunt ut laoreet dolore magna aliquam erat volutpat.

5 Ut wisi enimos adis minim veniam, quis nostrud exerci tation ullamcorper suscipit lobortis nisl ut aliquip ex ea commodo consequat. Duis autem vel eum iriure dolor in

The 2pt inner ruled box is the same thickness as the Moneysaver name and the hand device. This helps to unify the design. Breaking the rule with the hand device and the box containing the telephone number disturbs this unity.

Visual interest can often be enhanced by setting up a rigid framework and selectively breaking out of it.

The logo is set in 40pt Futura Condensed within a circle with a diameter of 10p7 The dots are 3pt in diameter.

CLIENT

advisory group

...ory of Salt from the primordial soup to the p...

...n dolor sit
...ctetuer
...lit, sed diam
...ibh euismod
...laoreet dolore
...am erat
...t wisi enim ad
...strud exerci
...ipit lobortis
...mmodo
...vel eum iriure
...lputate velit
...t, vel illum
...facilisis at vero

SALT

*Lorem ipsum dolor sit amet cons
ectetuer adipiscing e sed diam
nonummy nibh euismod*

Keeping
calmer
karma

Eros et accumsar
issim qui blandit
zzril delenit augu
gait nulla facilisi.
sit amet, consect
sed diam nonum...

The logo is shown actual size.

SPECIFICATIONS

Format
8½ x 11in or A4

Grid
6-column
Space between – 1p2

Margins
l 4p1 r 4p10
t 4p1 b 4p10

Fonts
Garamond
Track loose
1 Body text
 9/10½pt
2 Headlines
 18/20pt
3 Logo
 18pt small caps

Arquitectura
Track force justify
4 Title
 120pt
 condensed to 80%

BRIEF The Salt Council, an organization responsible for countering adverse publicity regarding salt, requires an advertising and PR campaign. It is acknowledged to be a challenging task, for research has shown that people's perception of salt is primarily conditioned by its association with heart disease, and very little is known of its beneficial properties. The advertisements will appear in a wide variety of magazines, and in some newspapers.

SOLUTION A series of full-page, bleed, color advertisements featuring little known uses for, or attributes of, salt has been selected. The historical associations contrasted with present-day applications make interesting reading, and the layout is based on a six-column grid, which is broken up into a number of small features to give a somewhat editorial feel. In addition to the existing Salt Council identity, the distinctive title treatment will be a powerful unifying element throughout the campaign. The choice of Garamond for headlines and body text completes the typographical specification.

2 Abc

Butem vel eum iriure do lor in hen
1 dre rit in vulp utate velit esse illum

The title, SALT, has been set in 120pt Arquitectura, condensed to 80%, and force justified to a width of 11p2. The horizontal ellipse prints 10% black, and is a single text column wide and 5p6 deep.

It is intended that readers will be attracted by the intriguing variety of visual images, and that it will not therefore be necessary to have to rely on one dominant image.

The strapline is contained within a 20% black tint panel.

The headings are ranged left to the width of one text column, or shorter if they are placed next to a photograph.

These spaces are visually equal.

This cut-out photograph breaks out of the box and bleeds off the bottom of the page.

The italic introductory text is centered and set within an 8pt broken ruled box, tinted 20% black.

An 8pt horizontal rule, tinted 20% black, separates the features.

The oval frame also has a 1p drop-shadow, which combines with the one that surrounds the page.

The close proximity of the self-portrait of Leonardo da Vinci to the Salt Council logo has the effect of endorsement. Even if it is somewhat spurious, it will be of benefit to the PR campaign to associate the Salt Council with such a respected figure.

The three-column text grid permits the body text to run around small inset photographs. These are of variable size, and do not fit to any grid line.

The ½pt vertical column rules align with the top and bottom of the x-height of the adjacent text.

The logo is set in 18pt Garamond caps and small caps, the latter being 80% of the full size.

A 1p drop-shadow extends beyond the ½pt ruled box that surrounds the page.

A brief history of Salt from the primordial soup to the present day

 Lorem ipsum dolor sit amet, consectetuer adipiscing elit, sed diam nonummy nibh euismod tincidunt ut laoreet dolore magna aliquam erat volutpat. Ut wisi enim ad minim veniam, quis nostrud exerci tation ullamcorper suscipit lobortis nisl ut aliquip ex ea commodo

Consequat uis autem vel eum iriure dolor in hendrerit in vulputate velit esse molestie consequat, vel illum dolore eu feugiat nulla facilisis at vero eros et accumsan et iusto odio dignissim qui blanditpra esentlupta um zzril delenit augue duis

Lorem ipsum dolor sit amet cons ectetuer adipiscing e sed diam nonummy nibh euismod tincidunt laoreet dolore magna aliquam erat volutpatwisi enim

Keeping calmer karma

Eros et accumsan et iusto odio dign issim qui blandit praesent luptatum zzril delenit augue duis dolore te feu gait nulla facilisi. Lorem ipsum dolor sit amet, consectetuer adipiscing elit, sed diam nonummy nibh euismod erat volutpat. Ut wisi enim ad minim veniam, quis nostrud exerci tation

Helping to keep Tiffany in the swim

Dolore te feugait nulla facilisi. Lorem ipsum dolor sit amet, consectetuer adipiscing elit, sed diam nonummy nibh euismod tincidunt ut laoreet dolore magna aliquam erat volutpat . Ut wisi enim ad minim veniam, quis nostrud exerci tation ullamcorper suscipit lobortis nisl ut aliquip ex ea commodo consequat. Duis autem vel eum iriure dolor in hendrerit in

vulputate velit esse molestie consequat, vel illum dolore eu feugiat nulla facilisis at vero eros et accumsan et iusto odio dignissim qui blandit praesent luptatum zzril delenit augue duis dolore te feugait nulla facilisi. Nam liber tempor cum soluta nobis

Eleifend option congue nihil imperdiet doming id quod mazim placerat facer possim assum. Lorem ipsum dolor sit amet, consectetuer adipiscing elit, sed diam nonummy nibh euismod tincidunt ut laoreet dolore magna aliquam erat volutpa

First take a genius and then add salt

Ullamcorper suscipit lobortis nisl ut aliquip ex ea commodo consequat. Duis autem vel eum iriure dolor in hendrerit in vulputate velit esse molestie consequat, vel illum dolore eu feugiat nulla facilisis at vero eros et accumsan et iusto odio dignissim qui blandit praesent luptatum zzril

Salt, preserving the celluloid classics

Ut wisi enim ad minim veniam, quis nostrud exerci tation ullamcorper suscipit lobortis nisl ut aliquip ex ea commodo consequat. Duis autem eum iriure dolor in hendrerit in vulputate velit esse molestie lorem consequat, vel illum dolore ipsum eu feugiat nulla facilisis at vero eros et accumsan et iusto odio dignissim qui blandit praesent luptatum zzril delenit augue duis dolore te feugait nulla facilisi orem ipsum dolor sit

Amet, consectetuer adipiscing elit, sed diam nonummy nibh euismod tincidunt ut laoreet dolore magna aliquam erat volutpat. Ut wisi enim ad minim veniam, quis nostrud exerci tation ullamcorper suscipit lobortis nisl ut aliquip ex ea commodo consequat. Duis autem vel eum iriure dolor in hendrerit in vulputate velit esse molestie consequat, vel illum dolore eu feugiat nulla facilisis at vero

THE SALT COUNCIL
Lorem ipsum dolor sit amet, cons ectetuer adipiscing e sed diam

CLIENT

self-help group

mod tincidunt ut laoreet
am erat volutpat. Ut wisi
am, quis nostrud exerci
suscipit lobortis nisl ut
odo consequat.

MAKE IT

iriure dolor in hendrerit
sse molestie consequat,
feugiat nulla facilisis at
an et iusto odio dignissim
t luptatum zzril delenit
te feugait nulla facilisi.
um soluta nobis eleifend

option congue nihil imperdiet doming laud
mazim placerat facer possim assum. Lorem
ipsum dolor sit amet, consectetuer
adipiscing elit, sed diam nonummy nibh
euismod tincidunt ut laoreet dolore magna
aliquam erat volutpat. Ut wisi enim ad minim
veniam, quis nostrud exerci tation ulla
mcorper suscipit lobortis nisl ut aliquip ex
ea commodo consequat.

Duis autem vel eum iriure dolor in hendrerit
in vulputate velit esse molest consequat.

The logo is shown actual size.

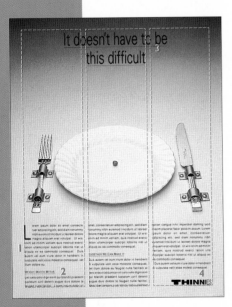

SPECIFICATIONS

Format
8½ x 11in or A4

Grid
3-column
Space between – 1p2

Margins
l 2p5 r 2p5
t 4p7 b 2p5

Font
Helvetica Light
Track very loose
1 Body text
8/12pt
Subheads
2 8/12pt
small caps
3 Headlines
48/52pt
condensed to 70%
4 Logo: see opposite

BRIEF The national weight-watchers organiza-
tion Thinnies sponsors local self-help groups for
people who want to lose weight. To increase
awareness, an advertising campaign, targeted on
health and fitness magazines, is planned. The
image the campaign presents is very important. It
will not make sensational claims or recommend
eccentric diets. Thinnies offers sensible realistic
advice, and the design of the advertisements
should reflect this.

SOLUTION A series of single-page black and
white advertisements, each using a commissioned
still-life photograph to support the headline
theme, has been chosen. A large, central
image that allows plenty of space above for the
headline to be effective, combined with three
columns of body text below and set in a light,
sans serif face, result in a subtle, understated
layout, which will attract the target audience,
many of whom have been alienated by the over-
blown claims of Thinnies' competitors.

3 Abc

1 Butem vel eum iriure do lor in hen
dre rit in vulp utate velit esse illum

The isolated position of the centered headline reinforces the photographic image of the single pea in the middle of the plate.

The headline is set in Helvetica Light, condensed to 70%. The small distortion of the letter forms is acceptable here, but take care not to corrupt letter forms without good reason.

The hairline rules sit 7pt below the headline.

Light sans serif faces always result in a cleaner look to the page than a similar sized serif face. However, when there are large amounts of text – as in a newspaper – a serif face is considered more readable. Helvetica Light, set in 8/12pt, very loose track, provides the understated effect required in this layout.

Subheads have been used to break up the body text. The simplest way of positioning them is to leave one line space above and none below. A more visually satisfying alternative, however, is to have 70% line space above and 30% below. This can be tricky, to specify and will depend on the DTP / typesetting system and method of measurement you are using. Here the leading is 12pt (one pica), so 0.70 pica space is added above and 0.30 pica space below. The combined total should be equivalent to one line, so that adjacent columns align.

The progressively slimming logo is created by using Helvetica Black, Bold and Light and distorting the characters. No face is sufficiently bold to make the "T," so this is formed from two solid rectangles. The remaining letters are as follows:
Helvetica Black
H – 170%
I – 130%
Helvetica Bold Condensed
N – 200%
N – 150%
I – 70%
Helvetica Light
E – 90%
S – 60%.

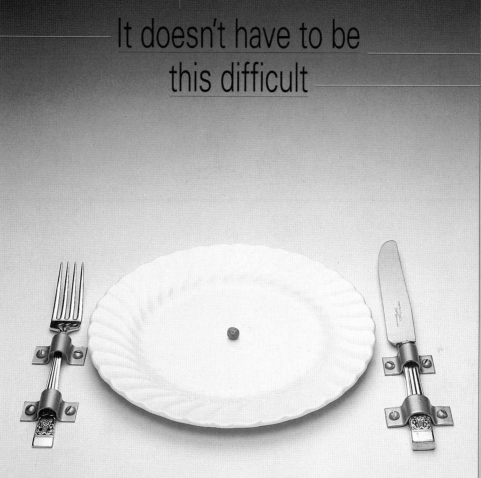

It doesn't have to be this difficult

Lorem ipsum dolor sit amet consecte tuer adipiscing elit, sed diam nonummy nibh euismod tincidunt ut laoreet dolore magna aliquam erat volutpat. Ut wisi enim ad minim veniam quis nostrud exerci tation ullamcorper suscipit lobortis nisl ut aliquip ex ea commodo consequat. Duis autem vel eum iriure dolor in hendrerit in vulputate velit esse molestie consequat, vel illum dolore eu.

WEIGHT-WATCH MYTHS

Let iusto odio dignissim qui blandit praesent luptatum zzril delenit augue duis dolore te feugait nulla facilisi. Lorem ipsum dolor sit

amet, consectetuer adipiscing elit, sed diam nonummy nibh euismod tincidunt ut laoreet dolore magna aliquam erat volutpat. Ut wisi enim ad minim veniam, quis nostrud exerci tation ullamcorper suscipit lobortis nisl ut aliquip ex ea commodo consequat.

TOGETHER WE CAN MAKE IT

Duis autem vel eum iriure dolor in hendrerit in vulputate velit esse molestie consequat, vel illum dolore eu feugait nulla facilisis at vero eros et accumsan et iusto odio dignissim qui blandit praesent luptatum zzril delenit augue duis dolore te feugait nulla facilisi. Nam liber tempor cum soluta nobis eleifend

option congue nihil imperdiet doming iuod mazim placerat facer possim assum. Lorem ipsum dolor sit amet, consectetuer adipiscing elit, sed diam nonummy nibh euismod tincidunt ut laoreet dolore magna aliquam erat volutpat. Ut wisi enim ad minim veniam, quis nostrud exerci tation ulla mcorper suscipit lobortis nisl ut aliquip ex ea commodo consequat.

Duis autem vel eum iriure dolor in hendrerit in vulputate velit esse molest consequat.

THINNIES

The drop cap, like the headline, is condensed to 70%.

A hairline rule, added after the subheads are positioned, sits 3 points below the type.

Although it is set in a nominal 18pt, some small adjustments to the type size may be needed visually to match the cap heights of the three fonts.

CLIENT

interior design store

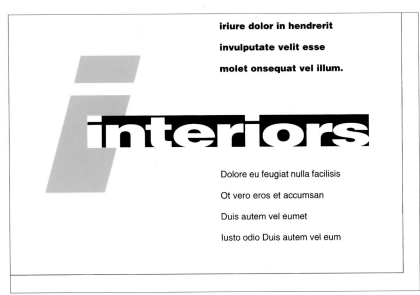

iriure dolor in hendrerit

invulputate velit esse

molet onsequat vel illum.

Dolore eu feugiat nulla facilisis

Ot vero eros et accumsan

Duis autem vel eumet

Iusto odio Duis autem vel eum

The logo is shown actual size.

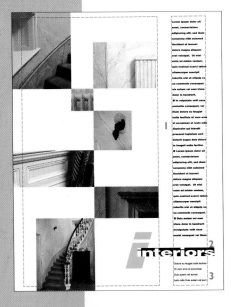

SPECIFICATIONS

Format
8½ x 11in or A4

Grid
2-column
Space between – 4p1

Margins
l 2p2 r 4p1
t 2p2 b 2p2

Fonts
Helvetica Black
Track normal
1 Body text
7/16pt
2 Logo
33pt
expanded to 160%

3 **Helvetica**
Track normal
Address 7/16pt

BRIEF A chain of franchised up-market furniture and interior decoration stores, which advertises regularly in a number of glossy home-interest magazines, requires a new look. The design must accommodate within the confines of a strongly identifiable single corporate image the marketing requirements of the individual stores.

SOLUTION The uncompromising layout style establishes immediately that this is a design-led business. The strong single column of text will be a constant factor. The photographs will be the variable element, although they will always be arranged in a checkerboard fashion. The logo features an italic "i," the only graphic element on the page that is not vertical. This device is essential to the dynamics of the layout, drawing the eye towards the Interiors logo, in a page that otherwise has no dominant visual feature. All the advertisements will be single-page, full-color bleeds, and the high print quality of the publications makes possible the use of smaller color photographs.

1 **Butem vel eum iriure do lor in hen dre**

rit in vulp utate velit esse illum

The arrangement of the photographs is variable, and does not conform to a grid. Care must be taken to balance the space between and around them.

The unusual layout has no headline. This works for the paradoxical reason that the pictures do not tell the story either, so the reader has to peruse the body text to find out more. This approach would not work for a more mundane subject.

The use of a bold sans serif face is required to strengthen this side of the layout. Large amounts of leading are usually associated with more avant garde designs, but here the leading is needed to make the long, narrow column – 7p11 wide – easier to read.

Lorem ipsum dolor sit amet, consectetuer adipiscing elit, sed diam nonummy nibh euismod tincidunt ut laoreet dolore magna aliquam erat volutpat. Ut wisi enim ad minim veniam, quis nostrud exerci tation ullamcorper suscipit lobortis nisl ut aliquip ex ea commodo consequat uis autem vel eum iriure dolor in hendrerit.

■ In vulputate velit esse molestie consequat, vel illum dolore eu feugiat nulla facilisis at vero eros et accumsan et iusto odio dignissim qui blandit praesent luptatum zzril delenit augue duis dolore te feugait nulla facilisi.

■ Lorem ipsum dolor sit amet, consectetuer adipiscing elit, sed diam nonummy nibh euismod tincidunt ut laoreet dolore magna aliquam erat volutpat. Ut wisi enim ad minim veniam, quis nostrud exerci tation ullamcorper suscipit lobortis nisl ut aliquip ex ea commodo consequat.

■ Duis autem vel eum iriure dolor in hendrerit invulputate velit esse molet onsequat vel illum.

In contrast to the pictures, the text column is very rigid. To further reinforce the strong vertical emphasis, no paragraph indents are used because they would break into the line. Instead, square bullets are used to indicate the paragraph breaks.

White space is always an important tool for the designer, and here it is as dominant as the photographs themselves. Some of the photographs must bleed off the page. If they did not, the white space would flow all around the margins, weakening the design.

interiors

Dolore eu feugiat nulla facilisis
Ot vero eros et accumsan
Duis autem vel eumet
Iusto odio Duis autem vel eum

White space appears to flow in and out of the logo. If the black panel had been larger, fully enclosing the word "interiors," it would have conflicted with the rest of the design.

Cropping photographs sympathetically is always an important responsibility for the designer. The photographer has composed the shot within a given format – 8p5, for example – and departing from this must not ruin the composition. However, extreme cropping can add a dynamic quality to a layout.

As the only non-vertical element, the italic "i" disrupts the balance of the page that has been so painstakingly built up. When this is done deliberately, it can add to the drama of a layout.

advanced
ADVERTISEMENTS

specialist clothes retailer

The logo is shown actual size.

SPECIFICATIONS

Format
8½ x 11in or A4

Grid
2-column
Space between – 1p10

Margins
l 4p10 r 2p11
t 4p4 b 2p11

Fonts
Gill Bold
Track very loose
1 Body text
9/11½pt
2 Encounter
24pt

Gill Sans
Track force justify
3 Brief
60pt
4 Subhead
17/40pt
condensed to 70%
5 The Genuine Article
24pt

BRIEF Brief Encounter is a highly original business that scours the country for second-hand 1940s clothes. These it refurbishes and sells at premium prices in its small number of exclusive shops. It sells exclusively on image, and the advertisements, which appear in fashion magazines, must not only evoke the 1940s, but also stress the uniqueness of each garment.

SOLUTION The company's identity includes the name, the liner device, the slogan in the circle, and the use of Art Deco colors. A large, single photograph from a specialized picture library has been chosen rather than a commissioned pastiche. The customers are looking for "the genuine article," and so this is more appropriate. The layout reflects, without slavishly imitating, the typographic style of the period.

4 ## Abc

1 **Butem vel eum iriure do lor in
hen dre rit in vulp utate velit**

The word "Brief" is set in 60pt Gill Bold, force justified to a width of 37p5, which gives the desired large letter spacing.

The word "Encounter" is enclosed within a panel, 2p11 x 22p1, and set in 24pt Gill Bold, force justified to a width of 18p2.

The panel butts flush to the photograph.

The effectiveness of this layout does not rely on the body text. Because it is close in tonal value to the background color, and also partially obscured by the Genuine Article device, the text is not perfectly legible. Making it more prominent – white, for example – would have altered the focus of the design. A successful layout is often a trade-off between the aesthetic demands of the designer and the communication requirements of the copy. Only in exceptional circumstances should the latter be compromised.

BRIEF

ENCOUNTER

The liner device has been drawn from sea level looking upwards. Illustrations or photographs created from a low or high vantage point normally look more comfortable when they are positioned at the top or bottom of the page, respectively. This particular illustration works better on the right side, coming into the page, than it would on the left, facing out.

REDISCOVER

FABULOUS '40s

STYLES. EVERY

GARMENT IS

RESTORED TO

ITS ORIGINAL

CONDITION

The subhead text is set in 17/40pt Gill Bold, condensed to 70%, ranged left, and butted to horizontal 4pt rules.

GENUINE ARTICLE

The circles of the Genuine Article device are formed from 4pt rules. The outer circle has a diameter of 22p7, and the inner circle has a diameter of 14p7.

Lorem ipsum dolor sit amet ex consectuer adis adiscing nonummy nibh euismod ticidunt ut laoreet dolore magna aliquam erat volutpat. Ut wisi enim ad minim veniam, quis nostr. Ullamcorper suscipit lobortis nisl ut aliquip ex ea commodo molestie consequat, vel illum dolore. Feugiat nulla facilisis at vero eros et accumsan et iusto odi dignissim qui blandit praesent luptatum zzril delenit augue duis dolore feugait.

Lorem ipsum dolor sit amet, consectetuer adipiscing elit, sed diam nonummy nibh euismod tincidunt ut laoreet dolore magna aliquam haerat volutpat ult wisi enim ad Minim veniam, quis nostrud exerci tation ullam corper suscipit lobortis nisl ut aliquip ex ea commodo consequat.

The dominant elements of the layout should be positioned with care. Here, the right, left, right axis of the liner, main photograph, and Genuine Article device create a pleasant harmony.

Note that the center of this circle is on the corner of the photograph. This reinforces the strong vertical line that has been established by the right edge of the main photograph.

advanced
ADVERTISEMENTS

CLIENT

shoe manufacturer

dolore eu feugiat nulla facilisis at vero eros et accumsan et iusto odio dignissim qui blandit telum praesent luptatum zzril delenit augue duis dolore te feugait nulla facilisi sorem ipsum dolor

Sit amet consectetuer adi piscing elit, sed diam nonummy nibh euismod tincidunt ut laoreet dolore magna aliquam erat volutpat. Ut wisi enim ad minim venam

quis nostrud exerci tation ullam corper suscipit lobortis nisl ut aliquip ex ea commodo conquat.

Duis autem vel eum riu dolor in hendrerit in vulputate vesse otil molestie consequat vel illum dolore eu feugiat nulla facilisis at vero eros et accumsan et iusto odio dignissim quitar blanditos praesent luptatum zzril

Kwanga Rapids Safari Park Family Admission

Smith Shoes

The logo is shown actual size.

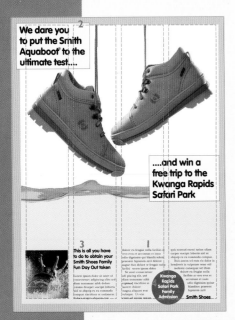

SPECIFICATIONS

Format
8½ x 11in or A4

Grid
4-column
Space between – 1p2

Margins
l 2p7 r 2p7
t 2p7 b 2p7

Fonts
New Baskerville
Track loose
1 Body text
8/10pt

VAG Rounded bold
Track loose
2 Main headline
26/29pt
3 Subhead
13/15pt
4 Text in circle
12/14pt

BRIEF Smith Shoes, a children's footwear manufacturer that sells its products primarily from its own chain of shops, requires an advertising campaign to promote a new product, the Aquaboot, which is claimed to be totally waterproof and virtually indestructible. Although the company is successful and well-known for its existing range, the Aquaboot is very important to its future, and it is looking for a strong idea to boost sales.

SOLUTION A tie-in promotion with a theme park has been arranged to promote the waterproof claim. A still-life photograph has been commissioned to support the watery theme, and a location photograph from Kwanga Rapids is dropped into the first of the four text columns. The headline conveniently splits into two, which allows the two boots to be arranged satisfactorily. The advertisement sits within a bleed tint border.

2 **Abc**

1 Butem vel eum iriure do lor in hen dre rit in vulp utate velit esse illum

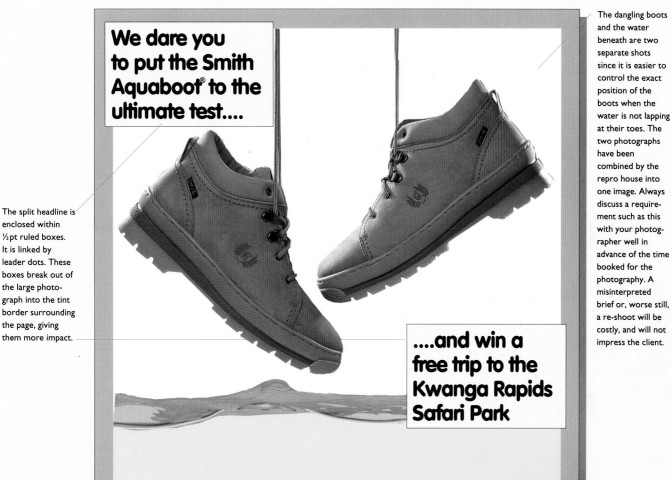

We dare you to put the Smith Aquaboot® to the ultimate test....

....and win a free trip to the Kwanga Rapids Safari Park

The split headline is enclosed within ½pt ruled boxes. It is linked by leader dots. These boxes break out of the large photograph into the tint border surrounding the page, giving them more impact.

The dangling boots and the water beneath are two separate shots since it is easier to control the exact position of the boots when the water is not lapping at their toes. The two photographs have been combined by the repro house into one image. Always discuss a requirement such as this with your photographer well in advance of the time booked for the photography. A misinterpreted brief or, worse still, a re-shoot will be costly, and will not impress the client.

This block is restricted to the bottom one-fifth of the page. It could spread into the space above, but this would lessen the impact of the main photograph and the headline.

This is all you have to do to obtain your Smith Shoes Family Fun Day Out token

Lorem ipsum dolor sit amet ul consectetuer adipiscing elito sed diam nonummy nibh dolore euismo dcorper suscipit lobortis nisl ut aliquip ex ea commodo conquat tincidunt ut umlaoreet dolore magna aliquam erat

dolore eu feugiat nulla facilisis at vero eros et accumsan et iusto odio dignissim qui blandit telum praesent luptatum zzril delenit augue duis dolore te feugait nulla facilisi sorem ipsum dolor

Sit amet consectetuer adi piscing elit, sed diam nonummy nibh euismod tincidunt ut laoreet dolore magna aliquam erat volutpat. Ut wisi enim ad minim venam

quis nostrud exerci tation ullam corper suscipit lobortis nisl ut aliquip ex ea commodo conquat.

Duis autem vel eum riu dolor in hendrerit in vulputate vesse otil molestie consequat vel illum dolore eu feugiat nulla facilisis at vero eros et accumsan et iusto odio dignissim quitar blanditos praesent luptatum zzril

Kwanga Rapids Safari Park Family Admission

Smith Shoes

The body text is set in 8/10pt New Baskerville and run around the inset token graphic. Some text editing will be required here to avoid unpleasant line breaks. The text overprints the photograph of the water.

The location shot has been dropped into the main photograph. The hands breaking out of the squared-up frame both add to the overall impact and balance with the token graphic, which dips below the body text and breaks into the tint border.

The Kwanga Rapids token graphic is set within a 7p8 diameter circle.

CLIENT

business executives club

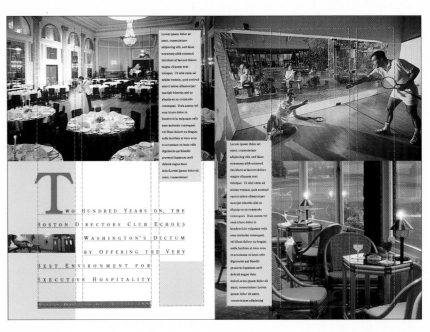

A subsequent spread.

SPECIFICATIONS

Format
8½ x 11in or A4

Grid
3-column
Space between – 2p2

Margins
l 2p11 r 2p11
t 2p11 b 2p11

Font
Century Old Style
Track very loose
1 Caption text
8/18pt
Track force justify
2 Quotation
14/38pt
Track very loose
3 Attribution
9pt
4 Drop cap
150pt

BRIEF The Boston Directors Club is an influential and wealthy organization run for business executives. Its functions include lobbying legislators, organizing seminars, and providing a suitable environment for business meetings and corporate hospitality. The club relies on its membership to finance its operations, and it has commissioned an advertisement to run in selected business magazines to encourage new members to join.

SOLUTION Printed with the rest of the magazine, this six-page advertising feature, comprising a single page followed by two spreads and a final single page, is made possible through the collaboration of other advertisers. These include a shop, a gym and other sporting facilities run by outside contractors, a wine importer, and a sports goods manufacturer. The theme chosen stresses the social benefits of membership, and starts on page 1 with a well-known quotation by George Washington. The abundance of space offers an opportunity for a suitably elegant layout.

2 A B C

1 Butem vel eum iriure do lor in hen dre

rit in vulp utate velit esse illum

The six pages allow for the first one to act as a cover, and the strong design style will ensure considerable impact within the publication

The focal point of page 1 is the typographically manicured quotation by George Washington. The face, Century Old Style, is set in 14/38pt, force justified over four different measures, with a raised cap and inset pictures occupying the spaces that are left. This technique requires great care. Lines of the same width must have a similar number of characters or spaces, and all the lines must end up with more or less equal letter spacing, otherwise the result will be a mess. It is set in caps and small caps, the small caps being 80%.

The main photograph is overlapped by a caption, set in a tinted panel. This panel aligns with, and is the same width as, the illustration of George Washington at the bottom of the page. Establishing a visual relationship of this kind is an important factor in bringing order to a complex layout.

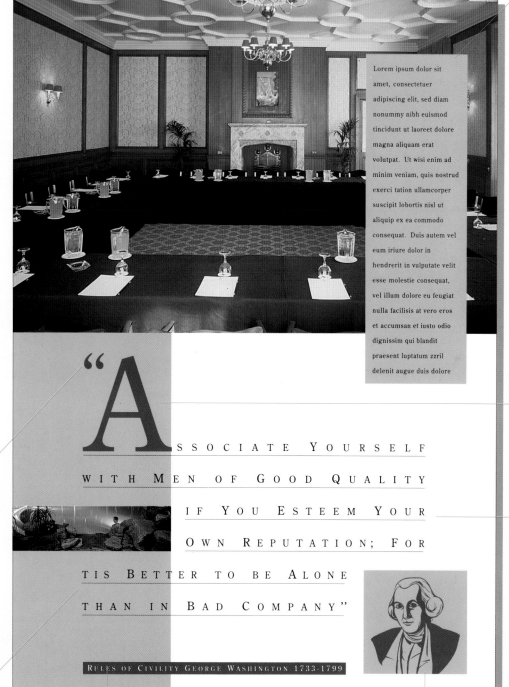

Lorem ipsum dolor sit amet, consectetuer adipiscing elit, sed diam nonummy nibh euismod tincidunt ut laoreet dolore magna aliquam erat volutpat. Ut wisi enim ad minim veniam, quis nostrud exerci tation ullamcorper suscipit lobortis nisl ut aliquip ex ea commodo consequat. Duis autem vel eum iriure dolor in hendrerit in vulputate velit esse molestie consequat, vel illum dolore eu feugiat nulla facilisis at vero eros et accumsan et iusto odio dignissim qui blandit praesent luptatum zzril delenit augue duis dolore

The quotation marks are set in 70pt, not 150pt as the capital letter, which would be overpowering.

The raised cap is set in 150pt Century Old Style.

"ASSOCIATE YOURSELF WITH MEN OF GOOD QUALITY IF YOU ESTEEM YOUR OWN REPUTATION; FOR TIS BETTER TO BE ALONE THAN IN BAD COMPANY"

RULES OF CIVILITY GEORGE WASHINGTON 1733-1799

This tinted panel is purely a stylistic device – it fulfills no practical purpose such as separating two pieces of text. It is, however, part of the complex interrelated layout. The quote could simply have been centered under the main picture. This layout endeavors to make a more interesting page by insetting the raised cap and pictures into the text, and forcing it to run around them.

A hairline rule is set to the width of each line and sits 6 points below the text. If you are using a DTP system, an easy way to position the rules is to draw them directly onto the baseline of each line then to select the rules (but not the text) as a group and drag them down into the correct position.

The attribution of the quotation is set within a 60% tint panel to a very loose track, and is caps and small caps, the small caps being 80%.

The illustration of George Washington is centered visually within a tint panel.

published
ADVERTISEMENTS

Advertisement features combine the problems of creating a free-standing advertisement with the difficulties of devising a brochure. As these examples show, a busy but well-ordered layout is required. The crucial elements are the large cut-out photographs and the text within the cream-tinted panels, which establish the theme of each spread. The 800-number must always be easily locatable but should not be given undue prominence. To add visual interest, the blocks of text are run around the cut-out photographs, and the whole spread is contained within a decorative border.

MECHANIC (Warner),
s Bronson, February 1
A Star, Norman Wisdom,

NORSEMAN (Rank), Lee
s, 5
ountain, Spencer Tracy, 7
ATION CROSSBOW
), George Peppard, 7

Grampian
THE MECHANIC (Warner),
Charles Bronson, February 1
Union Station, William Holden, 2
Touch Of Love, Sandy Dennis, 3
THE NORSEMAN (Rank), Lee
Majors, 5
The Trollenberg Terror, 7

Adams
THE
Majors
THE N
ley Ba
HELL
Reeve

THE
Charle
Man
More,
THE N
Majors
The G
Howar

York
THE
Charle
Friend
THE N
Majors
SABO
Homol

Chan
Fortun
kins, F
The G
Dougla
Dracul
i
A KI
EMI),
The Fl
BOAR
Ruth G
Cracke
Prince
Accou
Privile

VIDEO PRESENTATIONS
director John Holloway has been
helping the Central Electricity
Generating Board make sense of
its flow charts with a three-minute
silent video which was shown at
the World Energy Conference in-
ternational symposium in Rome.
The video was used as a visual

guide to the Board's 16ft long dis-
play of charts and other material
on "Management of Thermal
Plant Availability" and was shown
in successive English, French and
Italian captioned versions.
Advanced Video Hire, VP's
associate company, provided the
necessary screening equipment.

THERE'S SOMETHING ▶▶

VERY SCARY ▶▶

ched to
was su
thousan

CV

A LIG
sulation
video i
rate u
which
minute
Insulat
The
scriptw
er of C
on a hu
repeati
duct pr
more i
to high

Sp
AN
market
Akenh
praise
directo
the Ins
effectiv
in mar
The

out £200,000 in September.
Gains have also been reported
in Italy and Ireland, while de-
liveries to West Germany have
been maintained at a high
level.
An encouraging feature has
been the rise in sales to the
US: Deliveries to that market

to that country moved up by
40 per cent to over £1.8m. By
volume, deliveries to that
country were well maintained
and showed a marked growth
to nearly 600,000 units.
Another important market
has been Holland where sales
went up by about five per cent

nine t
By
ports
nounc
tered
agains
month
have r
priced
The
tape h
in Sep
aroun
not the
user,
margin
but,
tapes
ger sh
recent
This
be do
delive
amoun
Septem
have d
by 12
Augus
Som
ern su
active
particu
Sales
market
80 per
and ac
312,00
Som
pliers
ground
particu
Sales
reache
which
compa
of nu

BY STEPHEN KING ▶▶

OUT SOON ON VIRGIN VIDEO ■

roving and marke d w v n w
more for themselves and
the producers.
Recent successful deals include:
A Chorus Line: look out for all
kinds of mentions and shots of
Revlon make-up and don't be sur-
prised at the movie's featuring on
the company's labels and in its
adverts.

California Raisin Company paid
$25,000 and a plug for the film on
every packet for a couple of shots
of one of its posters on a bus-stop
in the film and the hero eating its
raisins. When that scene was cut,
the company asked for its money
back. And got it.
The Goonies: is it by chance that
the kids are seen reading *Mad*

And
the
ET:
bein
som
its s
Roc
reca
the
the
Priz
of th
com
for a
plug
shot
appe
truct
proc
And
Des
San
nald
prom
for o
one
N
spre
low-
plug
razo
resis
$5,0
your
film
□□
With
fore
mem
not
seas
a ma
R
cost
Cen
been

10

PAGE 14

PAGE 18

PAGE 20

Above: A well-
designed advertise-
ment needs neither
color nor a full
page to attract the
reader's attention.
This sequence of
black and white
advertisements
appeared in a
magazine. They
are comparatively
small—across two
columns—and
appear on con-
secutive left-hand
pages. The white
space serves a dual
purpose: on the
first page it draws

attention to the
incomplete nature
of the image, but
on subsequent
pages there is
room for the hair
to rise. Note how
the double arrow is
used on the first
three advertise-
ments to alert the
reader that there is
more to follow, but
in the final
advertisement this
becomes a small
square—visual
shorthand for
"the end."

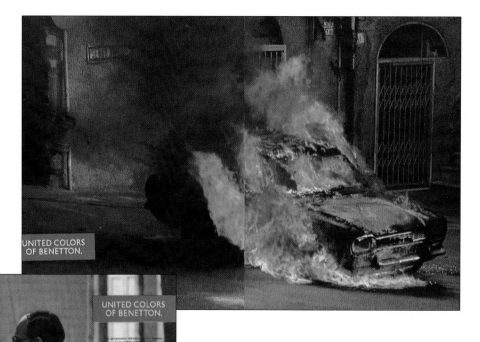

Left and above:
These double-page
color advertise-
ments have been
criticized on the
grounds that they
exploit their
subject matter.
They are, however,
superb examples of

the potency of a
large and powerful
photograph and a
simple layout. The
copy is set to a very
small size beneath
the headline, which
is enclosed within a
panel, colored in
the company's

corporate green.
The panel bleeds off
at the side, and has
been deliberately
kept away from the
focal point of the
photograph.

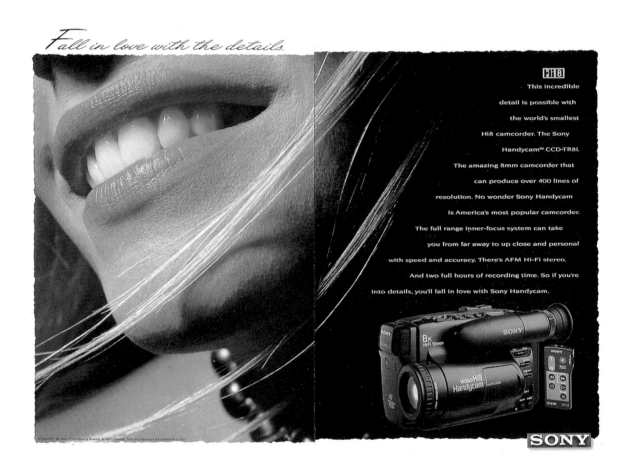

This double-page advertisement is dominated by the close-up photograph of the face that has been cropped leaving a rough edge. This technique combines with the small copperplate headline and extra wide margins to give the effect of a hand-finished print. The right-hand page fades to dark (with the aid of some retouching), allowing the text to be dropped-out white. The text, following the shape made by the hair, is set ranged-right but staggered by the introduction of variable-size indents which give it a less formal feel. The product shot is adjacent to the logo which just breaks out of the picture into the margin.

Left: The dynamics of this layout derive from the combination of a dramatic photograph and a headline that is positioned at the extreme bottom right of the page to emphasize the "will he, won't he catch it" theme.

Right and below: Cropping off an apparently essential part of an illustration can sometimes focus the reader's attention in the direction the designer wants. In these instances, the cropping draws attention to the heart and to the mouth, and allows the remaining portions of the pictures to be reproduced even larger and so to have more impact. If this technique is used in a campaign it should be applied consistently, so that the truncated image becomes associated with the product.

BOY SCOUTS OF AMERICA

Before It Goes Here.

It Has To Come From Here.

This Is What You Need To Earn A New Patch.

The patch is the Donor Awareness Patch, and all you do to earn it is talk.

Talk to your Mom and Dad. Ask them what organ donation means. Ask them why it's important.

Once you've had your talk, you've earned your patch. You've also learned more about organ donation. And learning is what Scouting's all about.

To receive your patch, send a self-addressed, stamped envelope to Donor Awareness, The Boy Scouts of America, P.O. Box 7143, Charlotte, North Carolina 28241-7143.

Donor Awareness.
The patch everyone's talking about.

For more information about organ donation send a self-addressed, stamped, legal size envelope to A.C.T., P.O. Box 1709, Dept. BSA, Alexandria, VA 22313-1709. All courtesy of W. K. Kellogg Foundation grant.

Organ donation. It's worth talking about.

And the Boy Scouts of America is offering a new patch to families who take time to discuss it.

If you're interested in receiving the Donor Awareness Patch, talk to your family about donation. Keep in mind, we're not looking for a commitment. We just want you to know what organ donation is and how it can benefit lives of others.

And for just becoming more aware, you'll earn a patch that lets people know your heart is in the right place.

Donor Awareness
The patch everyone's talking about.

index

acknowledgments

Quarto would like to thank the following for providing photographs, and for permission to reproduce copyright material. While every effort has been made to trace and acknowledge all copyright holders, we would like to apologize should any omissions have been made.

Key: t—top, b—bottom, l—left, r—right, c—center

page 10t Taylor and Browning Design Associates, Toronto (Illustrator: Rene Milot), b Triom design; 11 Taylor and Browning Design Associates, Toronto; 12t and b Dennard Creative; 13l Grace and Rothschild Advertising, r Eisenberg and Associates; 18 Ken Cato, Cato Design Inc; 21t The Inkshed; 22t Bradbury and Williams, b Eisenberg and Associates (Designer: Tiffany Taylor); 23t Taylor and Browning Design Associates, Toronto, c and b Wolf Olins, Client Royal Mail; 29bl USTTA, Audience Planners; 34t London

Contemporary Dance Theatre, br Graham Davis; 35 Graham Davis; 36 London Contemporary Dance Theatre; 37 London Contemporary Dance Theatre; 40t and b USTTA, Audience Planners; 49t USTTA, Audience Planners; 52t and l Evenson Design Group (Art Director: Stan Evenson, Designer: Angie Boothroyd, Client: Managed Health Network), tr and br © Railfreight Distribution, Pearson Young Ltd; 53tl and tr Art Centre College of Design (Editor: Stuart I Frolick, Photography: Steven A Heller, Design: Kit Hinrichs, Terri Driscoll and Karen Berndt), bl Emerson Wajdowicz Studios Inc. (Art Director/Designer: Jurek Wajdowicz, Client: Bedford Communications Inc.), br Bull Rodger (Design: John Bull and Lisa Hemus, Copy: Paul Rodger); 54tr and br Emerson Wajdowicz Studios Inc. (Art Director/Designer: Jurek Wajdowicz, Client: The

East West Round Table, l © SPNM, Society for the Promotion of New Music (Designer: Jonathan Cooper); 55tl and tr Ariel BBC Magazine (Designer: Gill Hiley,), bl and br Emerson Wajdowicz Studios Inc. (Art Director: Jurek Wajdowicz, Designers: Jurek Wajdowicz and Lisa LaRochelle, Client: International Council for Co-ordinating Cancer Research); 59 BUPA, br Moira Clinch; 75 Jon Wyand; 76t Quarto Publishing Plc, b Jon Wyand; 78tr Moira Clinch; 79tl Moira Clinch; 82tl, cl and b Bull Rodgers (Design: Laurence Grinter, Art Direction: Paul Rodger and Jos Cook, Copy: Paul Rodger, Photography: Peter Higgins), cr Taylor and Browning Design Associates, Toronto; 83tl, tr and b Taylor and Browning Design Associates, Toronto, © Eisenberg and Associates (Creative Director: Arthur Eisenberg, Art Director/Designer: Brent Anderson, Illustrator: Brent

Anderson, Copywriter: Tiffany Taylor); 84 Ken Cato, Cato Design Inc.; 85 Taylor and Browning Design Associates, Toronto; 110t Bull Rodger (Design/Typography: Laurence Grinter, Illustration: Paul Rodger), b Dennard Creative Inc. (Art Director: Bob Kennard, Designers: Bob Kennard and Ken Koester); 111 Rod Dyer Group Inc. (Art Director: Rod Dyer, Designer: Steve Twigger, Illustrator: Paul Leith); 112 Eisenberg and Associates; 113 Bradbury & Williams, b Eisenberg and Associates (Creative Director: Arthur Eisenberg); 119t Eugene J Smith, b Alton Towers; 138 Retail Reporting Corp.; 139t Bull Rodger (Art Direction/Illustration: John Bull, Copy: Paul Rodger); 140 Retail Reporting Corp., 141 Retail Reporting Corp., c and b Eisenberg and Associates (Designer: Tiffany Taylor).

Quarto would also like to thank C.P. Hart & Sons Ltd and Clarks Shoes.